杨吉魁画集

Yang Jikui's Paintings

人民美术出版社

序 言

妙造天趣　生意盎然——杨吉魁和他的写意花鸟画

中国书法家协会理事、山西省书法家协会名誉主席　赵望进

20 世纪 60 年代初，在山西大学中文系就读时，我就与杨吉魁相识相处，至今已半个世纪。

最近，杨吉魁要出画集了，又请我作序。他说："给我的画集写序，非你莫属，因为你太了解我了。"1991 年，我曾为他出版的第一本画集写序。时隔二十年，他的画作已有了一个飞跃，面貌一新，妙造天趣，生意盎然，令人欣慰。

杨吉魁在画坛中并非科班出身，而是地道的中文系毕业。在校时，他的爱好首先被中文系的教授姚奠中先生发现，便把他推荐给齐白石的女弟子杨秀珍先生（1909 — 2008）。几年中，他勤奋刻苦，学有所成。1963 年春，竟有两幅作品参加了山西太原市举办的迎春画展。这也是他首次参加画展，一时间，在校园引起不小反响。这无疑给他增添了信心，自此从师学画，矢志不移。

大学毕业后，他被分配到（山西临汾地区）山区吉县中学任教。不到一年，恰逢"文革"开始，他趁乱躲进宿舍里头作画。后来，虽遭到"向逍遥派大呵一声"大字报的警告，但他依然不放画笔。1973 年，他又有两幅作品入选山西省中国画展览。1974 年 3 月，作为"专门人才"，临汾地区宣传部把他调下山来，成为临汾地区展览馆的一位专职美术干部，使他如愿以偿。

不料，1979 年的"教师归队"之风，又把他调入山西师范大学中文系任教。但是，杨吉魁在完成了教学任务之余，总能集中精力点染丹青。

也许是天道酬勤，在改革开放的环境中，吉魁的作品被一些留学生作为礼物带到国外。1988 年，经赴日留学生介绍，在山西师范大学校长陶本一的支持下，经文化部批准，他应日本茨城县美术振兴协会与水户市日中友好协会的邀请，作为"齐派"传人，在日本成功举办了个人画展。画展被日方定为"日中和平友好条约缔结十周年纪念展"。日本媒体予以隆重报道。日本内阁自治大臣梶山静六也从东京致电祝贺。

从此，命运改变了杨吉魁的人生轨迹。他被学校从中文系调到艺术教研室，并协同筹建艺术系。1990 年，艺术系建成招生，他便在艺术系教授"中国美术史"、"写意花鸟画"和"民间美术"等课程。鉴于杨吉魁的成就，1995 年经省教育厅批准，山西省教育学院院长陈茂林调他到山西教育学院艺术系担任系主任，一年后，他被晋升为美术教授。一位学中文的人，却驰名画坛，继而被评聘为美术教授，这在山西省是独一无二的，在全国恐怕也属少例。

1999 年，杨吉魁退休，他集中精力进行创作。这也到了他创作的"黄金期"和丰收期。一些丈二匹、四米、五米的大幅作品多在此时面世。2000 年 5 月，他的百幅作品亮相太原市的山西文艺大厦，得到热烈反响。接着，他又数次赴美讲学办展。2003 年，被美国马萨诸塞州的布里奇沃特学院聘为艺术系特等荣誉教授。2009 年

10月，他在美国哥伦比亚大学作"画坛巨匠齐白石的传奇人生和绘画艺术"专题讲座，又在美国纽约曼哈顿亚洲文化中心隆重举办了个人画展，名曰"都市与自然的对语——著名花鸟画家齐白石传人杨吉魁大型画展"。美国网络电视台、美国纽约 NYTV8 电视台专访并播出。新华社以及中新社等媒体驻纽约记者均发通稿予以报道。全球艺术家联盟还为他颁发了"终身成就奖"。面对如此诸多的成绩荣誉，杨吉魁泰然处之，不骄不躁，更加勤奋，笔耕不辍。

中国画是一门综合性艺术，有深厚的民族文化底蕴。优秀的画家无一不是融"诗、书、画、印"于一炉的高手。画画就是画文化、画修养。学文的杨吉魁悟性很高，长于格律声韵。在他看来："画中有诗情，诗中有画意，诗画相得益彰方为上品。"这既是他的感受，也是他的追求。所以，其得意之作往往境界高远，神韵无穷，充满着诗情画意。

杨吉魁入门齐派，在齐白石亲传女弟子杨秀珍几十年的悉心教诲下，进步很快。固然这与恩师授徒得法有关，更与他的潜心悟道、勤奋好学、转益多师、取法乎上和融会贯通分不开。齐白石曾说："学我者生，似我者死。"杨吉魁深悟其理。他不愿意穷其一生在绘画风貌上追风逐影，苦求毕肖，而是苦苦求索属于自己的绘画语汇。在山西，他学赵延绪的笔墨，学王绍尊的奔放，学朱焰的清丽；放眼全国，他更倾心于吴昌硕的古拙，齐白石的厚重，潘天寿的奇崛，李苦禅的雄劲，还尊恩师姚奠中先生的点拨，偏爱任伯年的灵秀。对传统技法的汲取与研究，对诸家的广取与兼收，使他既得传统笔墨之精髓，又开阔了眼界，使自己的艺术修养得到不断积累。

艺术贵有个性，也贵在创新。当一个画家有了自己的面目、自己的风格时，才能标志着在艺术上的成熟。杨吉魁作画常在"变"中。以"变"求进、求新，进而再"变"，"变"而又新，在"变"和"新"中彰显自己画作的个性特点：品味纯正，自然清新，气韵雄辉。

杨吉魁出生于山西芮城一个农家，从小就浸润在黄河岸边迷人的花鸟世界里。花鸟画是他最熟悉、最得心应手的创作题材。鸡、鸭、鹰、雀、虫、鱼、虾、蟹、白菜、南瓜、茄子、萝卜等，都是他着力描绘的内容。中国花鸟画从来就不是刻板地去画图形、画标本，而是得之于形，达之于意，赋物象以生命，寄托着画家的思想感情。杨吉魁所醉心的正是通过富有生命和情感的花鸟形象，来表露对自然界的体验和认识，表现自己的内心世界、艺术精神和倡导人类与自然的和谐。所以，他笔下的花鸟画，描绘的不仅是花鸟动态之美，更抒发着自己的情怀，乃至乡土气息、民风民俗。这就是"写大自然之性亦写吾人之心"、"对花写意将人意"、"迁想妙得"、"缘物寄性"。

杨吉魁的作品题材广泛，内容丰富，善于运用象征、寄托、谐音、寓意等中国传统文学的手法去进行创作，以此表达出对人民美好生活的善良愿望。如画牡丹、瓶梅，取"牡丹富贵"，"瓶"和"平"谐音，祝愿人民生活富裕、幸福、平安；画桃子、松鹤、梅菊等，象征健康长寿，抒发作者愿老者延年益寿的思想情感；画荷花的亭亭玉立，用来比喻贞洁和一尘不染的品格。所有这一切都给人以联想、以启迪、以教益。

笔墨是中国绘画的精髓、脉络和生命线。杨吉魁的作品非常讲究笔势墨趣，注重功力深厚，技法娴熟，用笔沉着雄健，用墨浓淡相宜。他始终认为："一幅画，没有了笔墨，就什么也没有了。"在他看来，笔墨和笔墨结构不同。笔墨是基本功，笔墨结构则是画家以自己的创作愿望，特别是用自己的感悟修养去提炼、概括出来的硕果，是画家完善创作的意象境界和艺术形态。如果没有画家的立意构思或意在笔先，即使是刻意涂上几笔，也算不得有笔墨。所以，笔墨结构是画家的至高境界。笔墨结构，各有各的风格，不会雷同、不可取代。齐白石就是齐白石的，张大千就是张大千的。因此，笔墨结构的创新才是真正的中国画创新。

近年来，杨吉魁在笔墨运用的手法上不断求变求新。他用笔着力于线条的质感，以中锋、侧锋的交替运用，表现出不同线条的柔性、弹性和韧性。他用墨妙在用水，来活化墨的灵气和韵味。他用笔设墨大胆灵活，写

意、勾勒、泼墨、重彩、白描、没骨相互变通，或交替，或结合，尽精微，致广大，表现出恢宏、明丽、清新自然的不同风貌。特别是写意和勾勒相结合，泼墨与重彩相结合，以勾填、重彩显现细部，以泼墨形成体势，既有整体气势，又有重点精神。他的大幅《荷花》就是这样的精心巨制。娴熟的齐派技法，深厚的笔墨功力，都得以精彩体现。用笔纵横挥洒，用墨鲜活透亮，节奏错落有致，格调雄浑壮美，以强大的视觉冲击力动人肺腑，以完美的艺术感染力发人深思。面对此作，不由让人联想到周敦颐《爱莲说》中的佳句："出淤泥而不染，濯清涟而不妖，中通外直，不蔓不枝，香远溢清，亭亭净植，可远观而不可亵玩焉。"读完他的《荷花》，我把这句话题于他画面的左上方，以补白点睛，颂扬荷风，托物寓志。

他画的牡丹、梅花、菊花以及鸡鸭、松鹤等，笔墨技法也十分考究。画牡丹的用笔泼辣洗练，用墨浑厚华滋，放笔求神，挥洒自如，色墨融汇；画梅花、菊花，或勾勒，或点染，以少胜多，简中求繁，极重形式意趣，墨韵、墨色和线的律动互为表里，使作品意趣盎然，充满活力。画鸡是他的偏爱，《丁丑大吉》、《富贵大吉》都是他的得意之作。他借物抒情，状物言志，以纯熟的笔墨技艺，把公鸡描绘得形神兼备，活灵活现，极有轩昂向上、雄奇奋发的动势。

杨吉魁有着很强的造型能力。他画的鹤、鸭、鸳鸯、褐马鸡和孔雀等，在其造型的表现上，善于捕捉禽鸟灵动自如的神态和"两心合影共依依"的亲情，传达出一种特有的、富有人情味的比兴神韵。这与他数年的观察、写生积累分不开。他说："胸罗万象，才能为万虫写照，为百鸟传神。"此话不假。

杨吉魁淡泊名利，不肆张扬。他从来不参加任何形式的书画大奖赛。他为人友善，与世无争，甘愿默守孤独寂寞，埋头笔耕，潜心治艺，对未来充满了自信和希望。去年，他以题目《自寿》写的一首诗，表达出他的心态和精神境界。诗曰：

苦尽甘来自有期，
流香翰墨见神奇。
稀龄已过天心胜，
艺不惊人到老时。

VIBRANT AND JOYFUL NATURE THROUGH MAGIC BRUSHWORK
(About YANG Jikui and His Expressive Flower and Bird Painting)

By ZHAO Wangjin
Honorary President, Shanxi Society of Calligraphy Artists
Executive Board Member, China National Calligraphy Association

I have now known YANG Jikui for half a century, ever since we both were enrolled in Chinese literature studies at Shanxi University of China in the early 1960s.

A new edition of Yang Jikui's art book is being produced, and I have the privilege once again to contribute a chapter for the preface."You owe a preface for the new book because you have known me all too well", he insisted. It was 1991 when I wrote the preface for his first book. Now two decades later, his art has dramatically advanced to a higher plane and whole new horizon, and I feel truly gratified that he has flourished in his magic to depict the joy and vibrant life of nature.

Yang Jikui is extraordinary in his achievement in art, given that he started out as an amateur artist and was a major in classic Chinese literature during college.During that time,his artistic talent was discovered by his literature professor Yao Dianzhong, and Professor Yao immediately introduced him to renowned artist Yang Xiuzhen (1909 - 2008), who was in turn a favorite mentee of Qi Baishi (1863 - 1957),a colossal icon in modern Chinese art history.

Given this fantastic opportunity to receive Chinese brushwork training from a great master, Yang Jikui's steady effort made tremendous progress merely within a few short years. Remarkably,by spring 1963,two of his paintings qualified for the Taiyuan Spring Art Expo in Shanxi province.This was his first presence in a major art exhibition, on par with other elite artists in the capital city.As a college student, his achievement inevitably elicited enormous reactions across the campus.This initial success further fueled his confidence and steadfast determination to excel in professional art.After college,he was dispatched to a mountainous region to serve as a teacher in Jixian High School.Less than one year later, the notorious political storm of the 'Cultural Revolution'had started, and amid this time of tumult, all classes were cancelled.He then devoted this complete block of time to work on his painting by hiding himself inside a dormitory. Before long, his inactivity in the political movement drew some wall poster warnings against him about the consequence of being a revolutionary laggard, but he did not waiver in his art pursuit.In 1973, another two pieces of his brushwork were selected for the annual provincial Chinese art exhibition. He was then quickly discovered as 'Special Talent' by the Publicity Bureau of Linfen Administrative Region and appointed as a full-time art officer of the Linfen Regional Gallery of Art in March 1974.It was finally a dream come true for him to fulfill as a professional artist.

An abrupt change in national policy occurred in 1979, and a refreshing wind was blowing all over China,advocating all teachers to return to their original roles and he was again back to the forefront of education. This time around, he was assigned to serve as a faculty member for the Chinese Literature Department at Shanxi Normal University. Certainly, Yang Jikui would never put aside his ink and brushes.Whenever time permitted following his teaching obligations, he devoted himself to further developing his artistic skills.

Perhaps God always finds a way to reward non-quitters.The era of Chinese reform and opening to the outside world began in the late 1970s.Some Chinese students going aboard for education were carrying his paintings as precious gifts and his art works started to scatter outside the country.In 1988, a Japanese art association in Ibaraki, from a Chinese student studying in Japan, discovered Yang Jikui's art with immense interest.He was therefore officially invited as an artist in the direct lineage of Qi Baishi to visit Japan for his solo exhibition. The event was co-sponsored by the Japan-China Friendship Organization in the city of Mito, was specially endorsed by the Chinese Ministry of Culture, and naturally received enthusiastic support from his own institution president, Tao Benyi of

Shanxi Normal University.The exhibition was a resounding success as it was deemed by the Japanese side as an important event for commemorating the tenth anniversary of the Declaration of China-Japan Friendship. Major Japanese media devoted extensive coverage.The exhibition received a congratulatory wire from Japanese Cabinet Minister for Home Affairs Seiroku Kajiyama in Tokyo.

Upon his return from Japan, Yang Jikui's life experience and career path was forever changed.He was moved from his faculty position in the department of Chinese literature and was appointed head of the start-up art program at Shanxi Normal University.He was therefore instrumental in founding the University's art program.The art department started its first enrollment of undergraduate art students in 1990.He initiated lecture courses such as 'Chinese Art History','Expressive Brushwork' and'Chinese Folk Art'.In 1995, as another recognition of his artistic achievement, he was persuaded by President Chen Maolin of Shanxi Education College in the capital city Taiyuan to head the Institution's art department, a move facilitated by the Shanxi Provincial Commission of Higher Education. One year later, he was promoted to a full professor of art.Originally started out in the specialty of Chinese literature, he has ultimately made his impact in art circles and transformed himself into an art professor.His story is unique in Shanxi province, and is probably also rare nationally.

In 1999, Yang Jikui retired academically, and became free of all teaching and administrative duties. This enabled him to focus entirely on innovative art work, and there started a golden era in terms of both his innovation and productivity.Some of the giant paintings were accomplished during this time, and they measured about 4 or 5 meters ,13 or 17 feet, in size.In May 2000, one hundred pieces of his brushwork were exhibited in the Art and Culture Pavilion of Shanxi Province, and it was an astonishing event.Thereafter, he has repeatedly held art exhibitions in the US and delivered lectures on Chinese art. In 2003, he was conferred the title of Distinguished Honorary Professor by Bridgewater State University in Massachusetts.In October 2009, he served as a guest speaker at Columbia University Teachers College in New York City and presented the lecture "The Legendary Life and Art of Extraordinary Chinese Master Qi Baishi".In the mean time, Yang Jikui's art exhibition took place in Manhattan's Asian Cultural Center, entitled "Resonance between Metropolitan and Nature: Brushwork by Distinguished Chinese Master Yang Jikui as a Qi Baishi Art Inheritor". The event received extensive media coverage including an official wire report by the New China Global News Network and special feature interviews that were aired on NY-TV8 network and other TV networks.During the opening ceremony, a coalition of global artists in New York presented him the honor of"Lifetime Achievement Award".Despite all the awards and recognitions, Yang Jikui continues with his usual and unrelenting quest for even higher expressive achievement in his art.

Chinese painting is a comprehensive style of art, deeply rooted in the profound Chinese culture.Most great masters of the past were also adept in Chinese poetry,calligraphy,as well as seal-carving.Brush painting is all about culture and intellect.Yang Jikui, who originally specialized in literature and poetry,commands a special advantage and insight for this traditional Chinese art.In his own words,"Painting and poetry always come hand in hand, and are inseparable companions of art, and certainly serve to augment each other to achieve the supreme quality of artwork."This has been the principle of his own pursuits.Naturally, his favorite artworks are those both striking in artistic effect, while being vividly poetic.

Yang Jikui has a cherished inheritance from the Qi Baishi school of art, given the multi-decade long training he received from master Yang Xiuzhen, who was likewise directly mentored by Qi Baishi.Yang Jikui's success certainly owes a great deal to the excellent teaching from his mentor, but much of his achievement is undeniably attributed to his own efforts, his insight, high expectations he set for himself, wisdom he gained from a host of other teachers, and his masterful integration of everything he learned through the process.Qi Baishi once remarked:"Students who learn the true spirit of my work will flourish, while those who blindly imitate me will be doomed".Yang Jikui certainly understands the truth behind the forefather's instruction.He has never aimed at imitating his mentors in every detail, and he has keenly focused on developing his own artistic vocabulary.Given his significant lineage to Qi Baishi's art, he has still gone great lengths to study from other Chinese masters.In the local sphere of his home province Shanxi, he studied with renowned painter Zhao Yanxu for his brushwork techniques, he has also

incorporated the open and bold style of master Wang Shaozun, and he also had opportunity to study with Zhu Yan known for his simple beauty in utilizing colors.On the national scene, he adored the heavy and ancient style of Qing Dynasty master Wu Changshuo's strokes, the profound impact of Qi Baishi's work, the peculiar and bold style of contemporary Pan Tianshou, as well as that appeal of Li Kuchan's tough and overpowering brushwork.He complemented his literature mentor Yao Dianzhong, who particularly favored the brilliant and splendid style of Qing Dynasty celebrity Ren Bainian's art. All in all, given the scope of his study, broad adoption of the traditional techniques, and his artistic integration of various masters, Yang Jikui has acquired the true spirit of traditional Chinese brushwork.He constantly expands toward newer and higher intellectual and artistic horizons.

Brushwork art is all about uniqueness and innovation. An artist can only successfully establish himself when he has defined his own artistic personality and style.Yang Jikui has been tireless in seeking to renew his brushwork. Progress and innovation comes through growth and change, and in this process, he has developed the unique art of his own making. His brushwork is characteristically classic and genuine, refreshingly beautiful, poetic and imposing.

Yang Jikui was born in a rural family in Ruicheng, a southern county in Shanxi province, and he grew up in the splendid world of birds of flowers in the Yellow River valley.Thus, life of birds and flowers is the theme of natural instinct for his innovative brushwork.From roosters,ducks, eagles, sparrows,to insects, fish, shrimp and crabs,together with cabbage, squash, purple eggplant and red turnips all constitute the favorite subjects of his painting. Freehand brush painting is never about precise delineation of the form of a subject, differing from drawing a specimen.Instead, it seeks to convey the artist's spiritual wishes through the spirit and images of natural objects.Yang Jikui has excelled in revealing his observations and nature experience through depicting vibrant creatures with personality and emotional life, and he uses his art to further express his own inner world,his artistic spirit,and his aspiration for human harmony and world peace.Therefore, his brushes not only record the harmonic birds and flowers, but also unravel his personal feelings as well as the celebrated country life and folk culture.In his words, it is all about "simultaneously singing about life in nature and my own emotional revelations","associating our human feelings with those flowers and things","imaginations and magic effects".

Evidently, Yang Jikui's brushwork is diverse in subject matter and rich in content, frequently with symbolic implications behind the images themselves. One of his favorable methods of conveying his message is to paint a subject pronounced the same way as for another Chinese word carrying the hidden meaning behind.For example,he paints a peony to symbolically reflect wishes for people to attain affluence and happiness, he portrays a flower vase to long for peace, as"vase" and"peace" share the same pronunciation in Chinese language.Peach, crane, plum and chrysanthemum flowers are his usual symbols wishing elders for longevity. He is especially a master of painting the brisk lotus plant to imply purity and integrity of human character.All of these artistic effects are invariably thought-provoking, inspirational and instructive.

The spirit and foundation of Chinese brush painting lies in an adept use of ink and brush. Yang Jikui's brushwork pays special attention to the flow of brush strokes and effects of ink.His techniques are marvelous to watch, and his brushes move like a running dragon,in steady and rhythmic flows.His ink spreads out in just the right thickness and a spectrum of coloration is accomplished.He always advocates the subordination of brush and ink techniques to artistic conception, and emphasizes the importance of establishing the conception before any painting work should begin.The skillful use of brush and ink is a basic prerequisite, and on top of that an artist can then compose to produce original brushwork that is reflective of his intellectual leaning.Every remarkable brush painting artist always distinguishes himself with a unique style of brushwork.Whether it's master Qi Baishi or master Zhang Daqian, the features of their brushwork are readily distinguishable.Therefore, only innovation in one's style and feature of brushwork is considered to be a genuine advance in the art of Chinese painting.

In recent years, Yang Jikui has continued to be innovative in his brushwork techniques. His skillful use of brushes allows him to delicately control properties of different lines, through alternate uses of both brush tip and lateral edges,to yield lines of varying flexibility, elasticity and tightness.His magic is how to properly dilute ink

with water, and how to use wash to bring out the brilliance and artistic effect of ink. He is bold and flexible in ink application, ranging from free and expressive to styles such as sharp delineation,splashing,strong coloring,simple drawing, or unstructured applications.He may choose to perform these tasks collectively or in sequence.While attentive to important finer details, he never loses focus on the overall quality and effect of the painting.That is why his brushwork has always achieved its magic effect, spectacular and refreshing, regardless of the variety of images he portrays.During painting, he especially enjoys alternating free-hand with delineation techniques, splashing together with heavy coloring. While fine details are addressed with sketching and gap filling, ink splashing is used for painting large areas. Thus, his painting when finished is automatically imposing overall, while it also retains considerable compositional focus.The giant painting "Lotus" was precisely such a remarkable feat.His adept techniques from the Qi Baishi school and his profound brushwork training were all vividly displayed.I was present to observe the making of that painting.His graceful and rhythmic flow of brush strokes, dynamic and translucent ink effect, and the final impact and elegance, are all visually captivating, gorgeous and artistically inspiring.While watching the making of this painting, I could not help reciting the magnificent poem "Love for Lotus" by the Song Dynasty poet Zhou Dunyi:"Lotus plant emerges from the mud in deep water, but it stays untainted of mud; it's flourishing in clear water, exquisite but not flirtatious. Its stem is hollow, but can always extend straight up nonetheless.It neither sprawls nor branches, but its refreshing aroma can transcend the distance.It only allows you to enjoy from afar, and you have no easy access to get close to touch it".I therefore calligraphically inscribed this poem on the top left blank area of his painting to help enlighten the lotus spirit and to better convey the artist's wishes.

He is noted for his special techniques for other subjects as well.These include peony, plum and chrysanthemum flowers, roosters and ducks, pine tree and crane, etc.His peony painting blends black ink superbly with other colors, his ink is heavy and rich, but when finished, its vibrant beauty and grace is instantly exhibited.When he paints plum and chrysanthemum flowers, he makes it plain and simple by painting sparsely, but can nevertheless achieve an impression of exuberance.Painting a rooster is one of his top specialties, and the two rooster paintings illustrated within this book are both his personal favorites. His rooster paintings are a vivid demonstration of his profound techniques in portraying an object both in form and spirit, and these roosters under his brushes appear in full animation, and alive with vigor and aggression.

When he depicts a wide range of birds such as crane, duck, Mandarin duck, peacock, Hema chicken, which is a giant chicken species of Chinese local origin, he is particularly mindful in capturing communication between birds, their gestures, delight and mutual love.This comes from his many years of sketching and cumulative observations of nature.In his words, "one can only portray a wide variety of insects and birds and reveal their special lives after you have seen it all from nature".This is certainly true to his art.

Yang Jikui is always indifferent to superficial honors and commercial promotions, and he has never engaged himself in any competitions for commercial purpose.He is confident in his own intellectual capacity and artistic quality.He cherishes his friendships and habitually indulges in his unrelenting pursuit of artistic creation.He never quits. Last year, he composed a beautiful poem, namely,"Celebrating Own Birthday".It perfectly reveals his own state of mind and his unyielding spirit.The poem goes:

Fruition ultimately comes from painstaking pursuit;
Magic will then arise out of a sea of aromatic ink.
My passion for excellence won't abate with high age.
I will persist in my quest for striking art till eternity.

超越国界的艺术：我对杨吉魁水墨画的跨文化赏读

美国马萨诸塞州布里奇沃特州立大学美术学和美术史教授　罗杰·邓恩博士

我与杨吉魁已有近 25 年的友情了，这次为他的画集写序，实为荣幸。我们一直热衷于相互的友好情谊，考虑到彼此既不会讲也不会书写对方的语言，这更让人觉得了不起。这些年来，我们的交流无疑需要借助于自己的翻译，但我们有着共同享有的一种语言，那就是视觉艺术，这足以缔结我们由来已久的深厚情谊。完美地表明艺术可以超越这许许多多的政治和文化鸿沟，无论这些年来我们两国都发生了多么惊天动地的变革。艺术是让人们走到一起并取得共鸣的强大力量。

赵望进先生为这部著作撰写的前言慷慨激昂，因为他与杨吉魁有着更长久且交往更为密切的友谊，亲身目睹了杨吉魁的非凡人生以及他成就一个画家、诗人和书法家的每一步历程。赵教授的文章也帮助我对我的朋友有了更多的认识，所以，我对赵教授是心存感激的。他对杨吉魁教授的绘画艺术从题材、风格、技巧和成就等层面做了生动的讲述，这些精妙绝伦的深层解析，对写我自己的评论也是很好的借鉴。他感人肺腑的前言，委实出于对画家的敬仰。

我第一次结识杨吉魁是 1988 年 10 月，我前往位于临汾市的山西师范大学做访问。他当时还是中文系教师，但已经受委担任该校艺术系的筹建和领导工作。当年，山西师范大学和布里奇沃特学院（现称大学）建立有校际学术和文化交流。作为布里奇沃特学院艺术系教师，我曾经担任过 3 届系主任，我的访问正是这一交流项目的一部分。布里奇沃特大学位于麻州波士顿南面约 20 英里。两校的交流项目是在当年中美关系逐步回暖的形势下中美高校之间的校际学术合作之一。我们两所院校之间有很好的理念进行交流，皆为高等师范院校，以师资培养为宗旨。事实上，布里奇沃特大学在 1840 年建校时的校名为布里奇沃特师范学校，是全美第一所致力于师资培养的院校。

我去山西的任务是为了展出我系教师的美术作品。这是继山西传统戏剧艺术和民间艺术在布里奇沃特成功地访问展出后的一次回访。这里有必要先说说我自己的艺术背景，读者就可以感受到像我这样一个首次到中国之前对中国艺术文化一无所知的美国人，在认识这个杰出画家以后给我带来的重大转折。我的研究生教育是西方绘画和美术史，目前，我已经在这方面执教 31 年。从小学开始，20 世纪 50 年代至 60 年代前后，我们的常规教育内容基本上是有关欧美历史及艺术成就。后来，我才知道我们早期有关世界其他文化的教材其实只属于当初那些西方扩张贸易和殖民思潮的刻板思维，根本没有从其他文化的角度去研究其文化。那时候，中美政治敌对，长期隔绝，我们对现代中国甚至对中国共产党革命成功之前的近代中国社会都了解甚少，我们两国双方都对彼此有着大量的误读。

1988 年，在中国的一个月是我一生中最难忘的一段经历，让我大开眼界。该校的接待人员带我走访了北京、西安、太原以及其他地方，让我有机会感受城市和乡村的生活、文化、建筑以及其他艺术和古迹。让我印象最深刻的莫过于中国人民的慷慨、亲切和积极向上。我的接待人员极为周密地安排了我的日程，其中的一项就是执意要我到杨吉魁家中参观他的画室。尽管这次拜访是预先安排好的，他们也事先通知了我，但还是能很明显地感觉到他们对自己的同僚非常敬仰并引以为豪。杨吉魁非常热情地接待了我。

在拜访过程中，我有幸亲眼观摩了杨教授现场创作。我至今依然保存着杨教授当时准备在纸上下笔作画

的照片（我每个学期都会在我的亚洲艺术课堂上展示这张照片）。看着他挥着毛笔一笔一画，蘸着浓墨或稀释的墨汁，螃蟹和鱼虾顿时跃然纸上，我感到真的很神奇。他不但捕捉到了它们的神态，连它们的动态都被很逼真地画了出来。整幅画确实让人感到神气活现。这些在纵向纸面的海洋生物，让人联想到它们在水中自然状态下的情景，同时，依靠改变这些实物的透视角度以及墨色的浓淡相宜，表现出它们在立体空间中的相对方位。白色的纸面就让人想象到周围的水景，根本不需要多余的笔墨去刻意营造水中幽深的真实感。我不太记得那天他一共画了多久，感觉很快就画好了。没有看到他作画时有丝毫的迟疑，虽然疑虑在艺术创作中是常见的情况。显而易见，他作画时的挥毫自如完全出自于他多年的功力。正如多年后杨吉魁在布里奇沃特学院现场向一群学生做同样演示时所说："看上去我作画时下笔又轻松又快捷，其实每一笔都花了三十多年的功夫才能画得这样精准。"

西方人可能首先会被杨教授作品的神韵和独特的笔墨所吸引。我自己在大学和研究生的绘画训练是在20世纪60年代，那时，这个抽象表现主义的美国格调主导着整个美国甚至欧洲的画法。这种风格强调的是个人的绘画技巧，其中要兼有美学修养和表现主义能力，这在西方艺术中仍然是个新概念。用颜料在画面上进行题材创作时更多强调的是抽象，每个画家的绘画技艺则被看作是非常个性化的东西。抽象表现主义可谓美国第一个原创的艺术风格，这方面的西方大师级人物有杰克逊·波洛克、威廉姆·德库宁、弗朗茨·克莱恩。尤其应该认识到的一点是，抽象表现主义是第二次世界大战后美国人开始与东亚（尤其是日本）有密切往来之后才发展形成的。一些年轻的艺术家（包括上面提到的几位）开始迷恋日本绘画及其对笔法的侧重，当然，这一传统源于中国。实际上，这种东方影响到西方的情况可以追溯到更早之前。这绝不是巧合，比如印象派风格诞生之际正好是欧洲人同时开始真正了解和欣赏亚洲绘画艺术的时期。印象派艺术的这种更自由、更明丽的画法和色彩使用，让整个欧洲艺术世界相形见绌。

然而，杨吉魁的绘画没有局限在技巧层面，更不能说他的绘画技法单调。轮到要描绘他所热爱的繁茂大自然和写意各种花鸟虫鱼的风采，他的笔法、墨法和色彩技法会一起派上用场。一切由题材来决定运用何种技法或其他绘画手法。这一点，我从他2000年布里奇沃特学院的那次画展上才第一次充分地感受到。在那以前，我能看到的他的作品很有限，可这一次展出了各种题材，各种风格，琳琅满目，让人眼花缭乱。画展吸引了全校师生、各部门行政人员以及社会各界。他把一幅鲜桃作品作为正式礼物赠送给了主办的院方，用以比喻学院培养的毕业生 "桃李满天下"。外形圆润的桃子给人以质地柔软、熟得很透的感觉。笔墨并没有太用力的地方，也没有僵硬的线条，而是根据桃子的外形特点运用了柔软和宽厚的笔法，其中加一些暖调的颜色，不禁让我想起了几个世纪前南宋大师牧溪的那幅柿子名作。与之相比，画展中的另有一幅立轴，正好是我的一幅个人收藏，描绘的是一只孔雀倚在梅花丛畔，整个画面大部分都被孔雀的丰羽所垄断。孔雀的尾部羽毛是由短而有力的笔画画出的，而孔雀的身体则以柔和的成片淡墨涂出，这样就把体部羽毛的丰盈状态画了出来。大面积运用的是墨色，同时，巧妙地掺进蓝色和橙红色，就成功地营造出一种五彩缤纷的视觉效果。尤其引人注目的是孔雀的姿态和头部，巧妙地展现了一个王公孔雀的高傲和不可一世。

1988年，我第一次观看杨吉魁作画，很惊奇他画海生动物类的时候对这些题材的形态和神韵处理的那样得心应手，根本不需要看着实物去画。在西方，自意大利文艺复兴以来，画家一直都是一边看着静物，一边创作。我这才明白，原来中国画并没有这个传统。中国画家往往在下笔之前，就已经对题材认真地做过研究并完全掌握。题材的主要特征都已经在他们的脑海里了。掌握这一手段是体现精湛绘画技巧的一种最好的证明。从这种意义上讲，杨教授的艺术非常卓著，他的题材洋洋大观，但都画得入木三分，样样都神气活现。这确实是他的艺术魂宝，这也在赵望进的文章中获得了精辟的阐述。

我第一次访华期间，就结识了杨吉魁这样一位既代表着中国画的传统力量，又反映独特的现代写意潮流

的画家，这大大拓展了我对中国艺术的视野。我的亲身经历诱发了我对亚洲艺术的浓厚兴趣。当时第一次的中国之行，我也在日本做过短期停留。我开始认真研究中国和其他亚洲传统艺术。当我们系里那门东亚艺术科目出现了任课教师短缺的情况下，我便自告奋勇地担当了。2002年后，我每个学期带两个班，这成了我最喜欢教的一门课。这要归功于杨教授的鼓舞，我才能达到现在的水平。正是他的画作让我感触到何谓最佳的艺术。他的作品继承传统，甚至在近代大师齐白石的成就上有所发展，同时，兼容了现代艺术特色，创造和发展了个人对题材的独特处理和表现手法。

2004年，我有幸再次访华，怀着激动的心情又一次与我的朋友相逢并共进晚宴。中国在我1988年首次访问后发生了翻天覆地的变化，对我这又是一次全新的震撼。我在那里所看到的也正是杨吉魁作品中所透射的：对传统的全新继承和发扬光大，却充满着惊人的时代精神。正如他的艺术，我充分感受到新时代的中国人民所焕发出的繁荣昌盛和他们对生活的热爱。就和中国一样，杨吉魁的艺术在动态中不断变化，他的国际影响也越来越大。2009年，他的纽约大型画展以一个新的境界呈现了画家的丰硕作品和艺术成就。为了能够取得和我的朋友在一起的时间，我决定在星期的中间从波士顿前往纽约观展，考虑到这个时间应该比开幕式和画展头几天的客流量有所下降。然而在我抵达展厅参观时，仍然看到川流不息的艺术家和亚洲文化爱好者，其中有不少敬仰他的艺术界知名人士，包括一些西方和亚洲的艺术家以及联合国官员。从这些客人所展现出的兴致，可以明显联想到整个画展期间的热烈情景。

他的纽约画展给我的第一震撼就是那些巨幅新作，尤其是那幅孔雀和其他大幅作品给人的那种亲近感。这幅孔雀是我前面所讲述的那幅孔雀的又一新作。这次它的盛大气势在整个庞大展厅中抢了风头。画幅好几尺大，加上与其他展品相比占据了得天独厚的位置，因而统领了整个画展。相比之下，其他作品的构图则采用了传统的扇面或斗方形式，以便于单人近距离欣赏。也有很多我早前第一次就看到过的海洋生物类作品，但这次都出现在全新的构图中四处爬行和游动。花卉的制作都体现出了老练的手法和对其形态的偏爱。我拍了大量的照片，看到我镜头里大幅作品中很多局部细节，其惟妙惟肖的程度堪比西方艺术展览中一些最优美的抽象派画作。

我的朋友杨吉魁深深地植根于他的祖国，他的艺术在题材和技术方面，无论是从传统角度，还是从划时代的意义上，都反映出诸多成就。现在，他又已经轻车熟路地到访美国好多次了，尤其是当前国际艺术市场越来越关注东方艺术，他在美国的影响也与日俱增。曾有将近两个世纪，西方艺术的价值取向都是那种不以为然地大尺度背弃传统。近几十年，人们才开始越来越重视以往的传统价值。以传统的方式来鼓舞和孕育新生的艺术力量，并在艺术表现手段上取得不断创新，杨吉魁就走在这一新思维的最前沿。最有意义的是，他的花鸟画给我们重现了经久不衰的大自然美景，并让我们能够怀着一样的情感共同欣赏。

ART THAT TRANSCENDS BORDERS: A PERSONAL CROSS–CULTURAL APPRECIATION OF THE PAINTING OF YANG JIKUI

By Dr. Roger Dunn
Professor of Art and Art History
Bridgewater State University
Bridgewater, Massachusetts, USA

It is an honor to have the opportunity to write about the work of Yang Jikui, with whom I have shared a friendship for almost a quarter century. Ours is a fond and dedicated relationship, made all the more amazing since neither of us is fluent in the other's verbal and written language.While our communications over the years have been aided by our own translators, the only language we truly share is that of visual art, which has been more than enough to create a strong and lasting bond.It demonstrates how art can transcend so many differences in culture and politics, even the dynamic changes that such forces have undergone in both of our countries during the period of our friendship. Art is a potent means of bringing people together and creating understanding.

Zhao Wangjin's eloquent preface to this publication is based on a longer and closer friendship of more frequent contact, with a fascinating survey of Yang Jikui's remarkable life and development as a painter, poet and calligrapher.I have learned much more about my friend from Prof. Zhao's essay, and wish to express my gratitude. He provides such an impressive discussion of the subject matter, qualities of style, technique, and other achievements of Prof. Yang's art that my own comments depend heavily on Prof. Zhao's brilliant insights and discussions.His preface is a moving and worthy tribute to the artist.

I first met Yang Jikui in October 1988 during a visit to Shanxi Normal University in Linfen where he was a faculty member in literature, but already looking ahead to his role in developing and heading an art department. My trip was part of an exchange of faculty, students and cultural exhibitions that had been established between Shanxi Normal University and Bridgewater State College now a university where I am a faculty member of the Art Department, in which I also served three terms as chairperson.BSU is located about twenty miles south of Boston, Massachusetts.This exchange was one of the earliest academic collaborations between an institution in mainland China and one in the U.S. that transpired during the gradual warming of relations between our two countries.There were logical reasons that our two institutions should build a relationship. Both had been established as institutions of higher education dedicated to the training of teachers. In fact the original name of BSU was Bridgewater Normal School, founded in 1840 as the first program in the U.S. dedicated to teacher education.

My role in going to Shanxi was to bring an exhibition of art by our faculty.This followed a successful exhibition at Bridgewater of artifacts from the traditional Chinese opera and other art sent from Shanxi.I think it is meaningful to put my own artistic background into context, so that the reader will eventually see what a transformative effect his art had on an American who had little knowledge of Chinese art and its cultural context before my first trip to China and my first encounter with this outstanding artist.My own graduate education was in both painting and art history, areas I have taught for the past 31 years.Overall my education from elementary school onward, as was typical in the 1950s into the 1970s, was focused on history and achievements in Europe and America. I have since realized that those early studies of other parts of the globe were fixed in the mindset of Western exploration, trade and colonialism rather than a study of these cultures on their own terms. Because of the bitter political divide and enmity between our governments, study of modern China—or even pre-Communist China—was very limited during this time, and gross misconceptions were propagated, as was true on both sides.

My month in China in 1988 was the most remarkable and eye-opening experience of my life. Members of the University took me to Beijing, Xi'an, Taiyuan, and many other sites to experience the urban and country life, the culture, the architecture and other artifacts. Most impressive, however, was discovering the generosity, graciousness and positive attitudes of the Chinese people.As part of this, my attentive hosts made certain that I had the opportunity to visit the home and studio of Yang Jikui.The considerable respect and pride they felt for their

colleague was evident even as they informed me of this planned visit. I was received there with great warmth and hospitality.

During this visit I welcomed Prof. Yang's offer to demonstrate Chinese brush painting. I still have a photograph of him poised over the paper about to begin, which I show each semester to my classes in Asian Art.I was amazed as every stoke of the brush, using just black or diluted ink, brought to life crabs, shrimp and fish.Not only did he capture the essence of their forms but also their movements rendered with sureness and accuracy.Indeed, the composition conveyed a great sense of animation. The placement of these life forms on the vertical sheet of paper evoked their natural location in the water, and the angle of forms and shading of ink established their location in three-dimensional space.The white of the paper became their fluid environment, though no further detail was needed to give a realistic sense of the watery depths.I don't remember how much time passed as I watched him paint, though it seemed very fast.There was no uncertainty or hesitation as is so often witnessed in artistic creation. What was evident instead were the years of experience that had created such determined direction and confidence. As Yang Jikui was to tell a group of art students watching a similar demonstration years later at Bridgewater:"While the brushstrokes look fast and easy, each one took me more than thirty years to do correctly"[as translated].

Westerners might easily respond first of all to Prof. Yang's bravura and individuality of brushwork. My own training in painting in undergraduate and graduate school occurred in the 1960s during which artistic teaching throughout the U.S. and even Europe was still dominated by the American style called Abstract Expressionism.This style emphasized the individual skills in brushwork as having aesthetic and expressive qualities in themselves—a very new concept in Western art.The abstraction created by fluid paint on a surface was given emphasis over subject matter, and an artist's technique was recognized as very personal to each artist. Regarded as America's first original artistic style, Abstract Expressionists include such icons of Western art as Jackson Pollock, Willem DeKooning and Franz Kline.An important consideration is that Abstract Expressionism evolved after World War II, when Americans came into close contact with East Asia, notably Japan.Some young artists including the names mentioned became fascinated with Japanese painting and its emphasis on brushwork, a tradition acquired of course from China.In actuality the East-to-West influence can be traced much earlier.It is no coincidence for example that the style of Impressionism emerged at the same time that Europeans were becoming much more familiar with, and appreciative of, Asian pictorial art.Impressionism scandalized the European art world with its freer brushwork and brighter colors.

However Yang Jikui's art is about much more than skillful technique.Nor can it be said that he has only one technical approach to his art.The technical means of brushwork, shading and color are in the service of an exuberant love of nature and expression of the glories of so many animal and vegetative forms. The subject matter determines the handling of the technical or formal elements.This realization came to me strongly during his exhibition at Bridgewater State College in 2000.Up until that time I had seen very few of his paintings. This showing, however, constituted an impressive display of versatility and range of themes and styles.It attracted a lot of interest from the campus community and administration as well as a larger public. A painting of peaches that he presented as a gift to the College was offered as symbolic of our graduates as the "fruit" of the institution.The rounded forms effectively communicate ripeness and the soft texture of the peach skin. The brushwork is not emphatic and linear, but soft and broad in the definition of forms. Though rendered in a few warm colors, it reminded me of Mu Qi's famous painting of persimmons from centuries before. In contrast, another painting from that exhibit, which I am proud to own, depicts a peacock perched against plum blossoms composed in a tall narrow format dominated by the display of tail feathers. These are rendered in a pattern of short defined strokes while the body of the bird is done in soft pools of ink to create the different textures of the plumage.Mostly in black ink, the colors of blue and red-orange are subtly incorporated to add to a very effective image that suggests many more colors.What is noticed above all is how well the pose and head of the bird express the haughty pride and arrogance of the male on display. Back in 1988 when I first watched Yang Jikui demonstrate his art, I marveled at the way in which the sea creatures were created with such knowledge and feeling for their forms and essence without working directly from the

subjects themselves.In the West since the Italian Renaissance the tradition has been for the artist to work with the subject matter in view during the process of rendering it.I have since learned that this is not the tradition of Chinese painting.The Chinese artist carefully studies and fully understands his subject before putting the brush to paper. The subject exists within his head in all of its essential qualities. The mastery of this approach is one of the most important demonstrations of artistic skill at the highest level.Prof. Yang's art is remarkable in this respect because he so adeptly depicts and celebrates so many different life forms with an in-depth and tender knowledge of each one.This is surely the poetry of his art, of which Zhao Wangjin writes with great insight.

My first visit to China and my encounter with Yang Jikui introduced me to Chinese art in the broadest sense, and to an artist who represents both the traditions of Chinese painting and the modern direction of individual expression.These first-hand experiences stimulated in me an abiding interest in Asian art. That first visit included a stop-over in Japan.I began to do considerable study of Chinese art and other Asian traditions.When our Art Department found itself without a scholar to teach the established course in East Asian Art, I eagerly offered to do it.Since 2002 I have taught two sections every semester, and it is the course I enjoy teaching the most.I credit Prof. Yang for the inspiration that has led me to this point.It is in his work that I recognize the best that art can be. In his work is a Chinese respect for tradition, even in advancing the achievements of a recent master like Qi Bashi, while following the modern course of defining and advancing one's own feeling for subject matter, and its expression in style.

I returned to China in 2004 and enjoyed a sensational reunion and banquet with my friend. The transformation that had taken place in China since my first visit in 1988 left me astounded in new ways.What I saw there is what is epitomized in Prof. Yang's art: a renewed reverence and perpetuation of tradition but with a remarkable spirit of being in the modern age. Like his art, I felt the people of modern China communicate an exuberance and embracing of life. Like China, Yang Jikui's art is dynamic and changing, and his international recognition continues to grow. His 2009 exhibition in New York City displayed the artist's work at a new level of productivity and artistic achievement.So that I could be sure to have time with my friend, I scheduled my visit from Boston during mid-week, at a time when it was expected that visitors to the exhibition would not be as many as had occurred during the exhibition reception and the subsequent days.However, during my visit I still witnessed a procession of distinguished admirers that included fellow artists ,both Asian and Western, several dignitaries from the United Nations, and others interested in art and/or Asian culture. The level of enthusiasm about his art expressed by these individuals made clear the overwhelming interest that took place during the full run of the exhibition.

What first impressed me in the New York City exhibition was the grand scale of some of the new works—a painting of a peacock in particular—and the intimate scale of others. The peacock was the heir to the one I previously described, but now its majesty demanded attention in a very large public space.It appropriately dominated the exhibition, spanning several feet. In contrast, other works were composed in the traditional fan or album page format intended for close personal appreciation.There were abundant examples of the sea creatures that I first saw in his art, but they crawled or swam across newly conceived compositions. Flowers were rendered with a well-honed understanding and love of their forms.I photographed extensively and found myself framing smaller details of larger compositions that could rank as some of the most brilliantly painted abstractions within a Western-oriented gallery.

My friend Yang Jikui is deeply rooted in his native China and his art reflects so many traditional and more recent achievements of materials, subject matter and technique.Yet he now is comfortable in his many sojourns in the U.S., where his art is receiving growing recognition particularly in a global art market that is increasingly looking to the East. For almost two centuries Western art has been valued based on its dramatic and often scandalous breaks from the past.In recent decades this has changed with more and more referencing to older traditions.Yang Jikui is within the forefront of a new understanding of how tradition can inspire and inform the art of new generations, and offer the capacity for increasingly original means of expression.Above all, his paintings remind us of the abiding beauty of the natural world and the gratitude that can be shared in experiencing it.

图版

画墨荷

横涂竖抹度春秋，
满纸烟云韵味求。
画面何须着色彩，
倾来醉墨写风流。

——杨吉魁

高　洁

138cm×68cm

丁丑初夏吉魁画于太原寓所品石斋

2

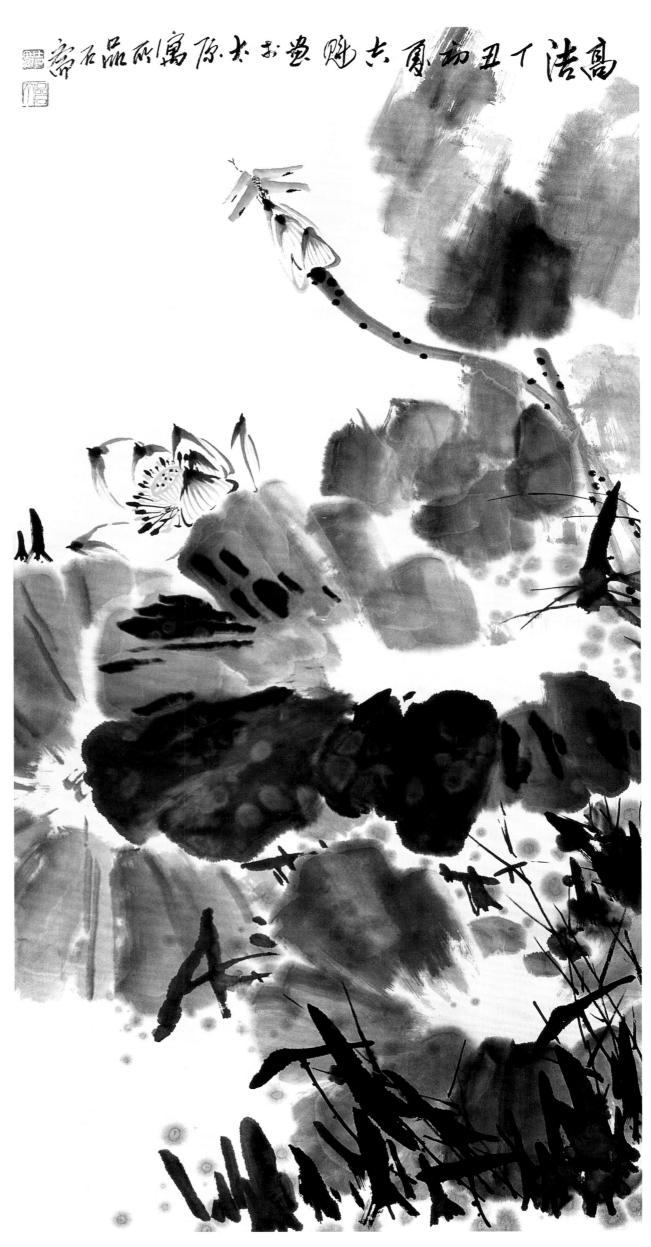

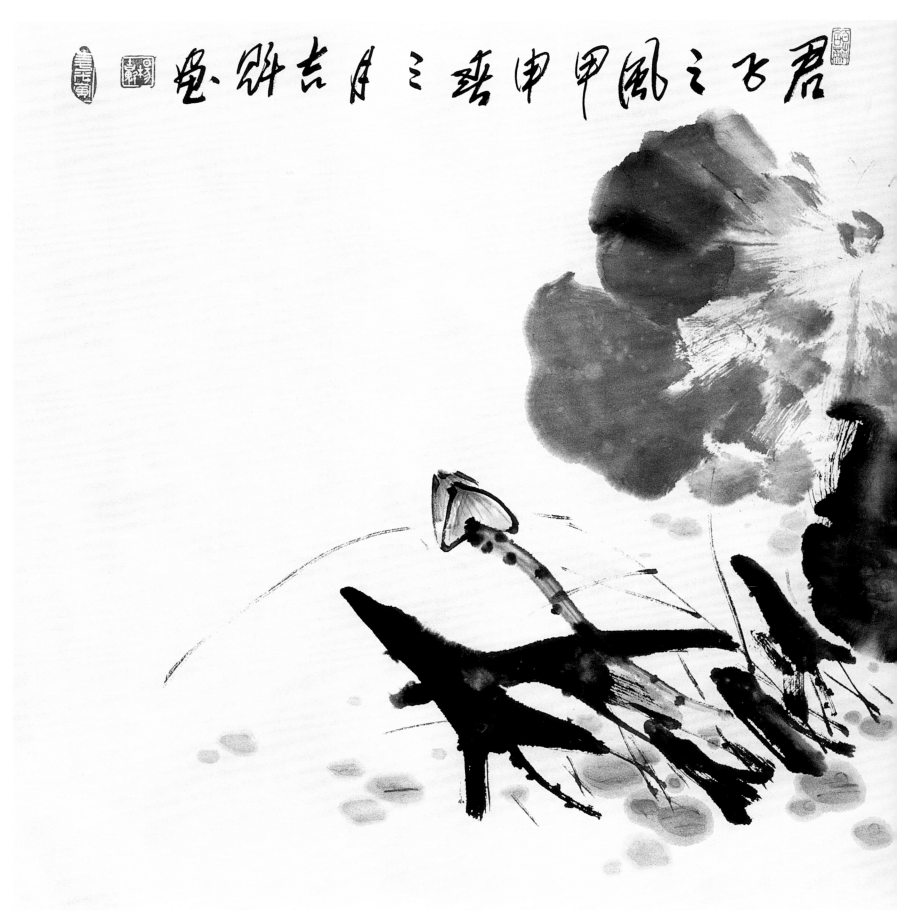

君子之风　　68cm×138cm　甲申春三月吉魁画

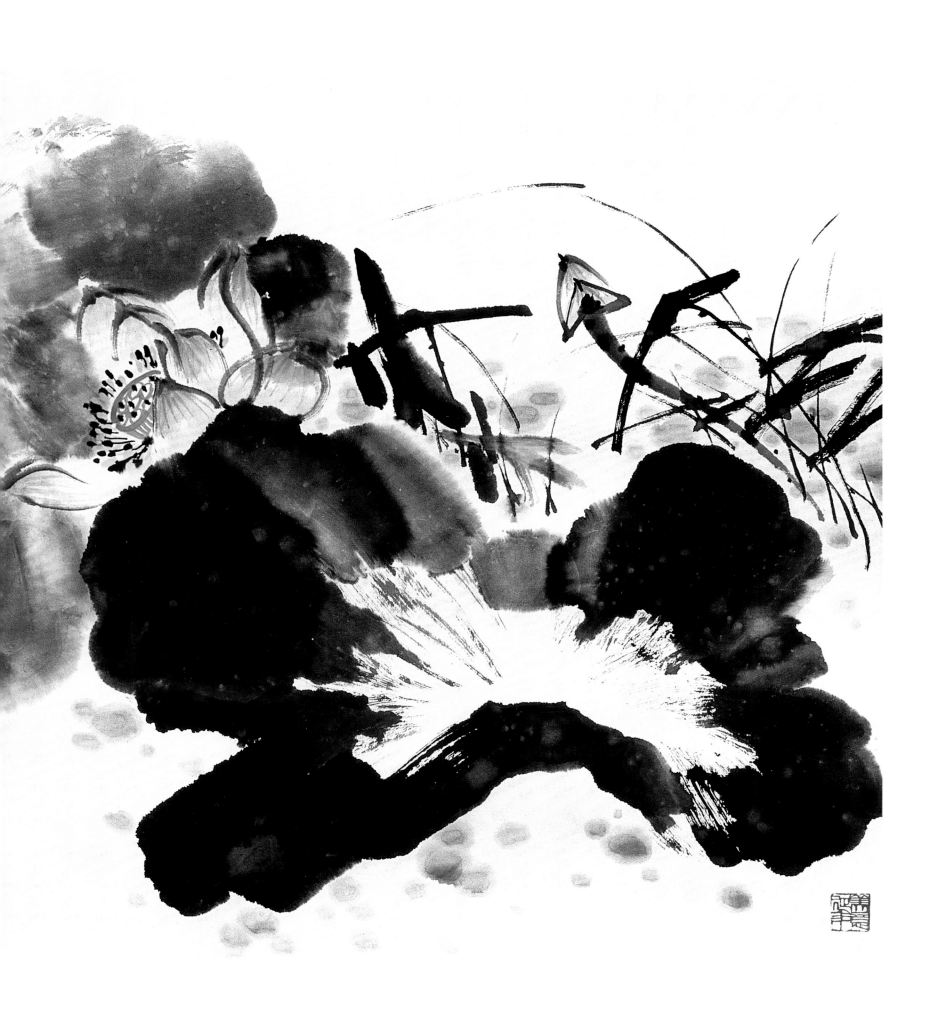

画荷

夕照荷花晚更红，
凌波取景画图中。
人生易老童心在，
觅趣金鱼水草丛。

——杨吉魁

香远益清

68cm×68cm
乙酉之冬月吉魁画于品石斋

6

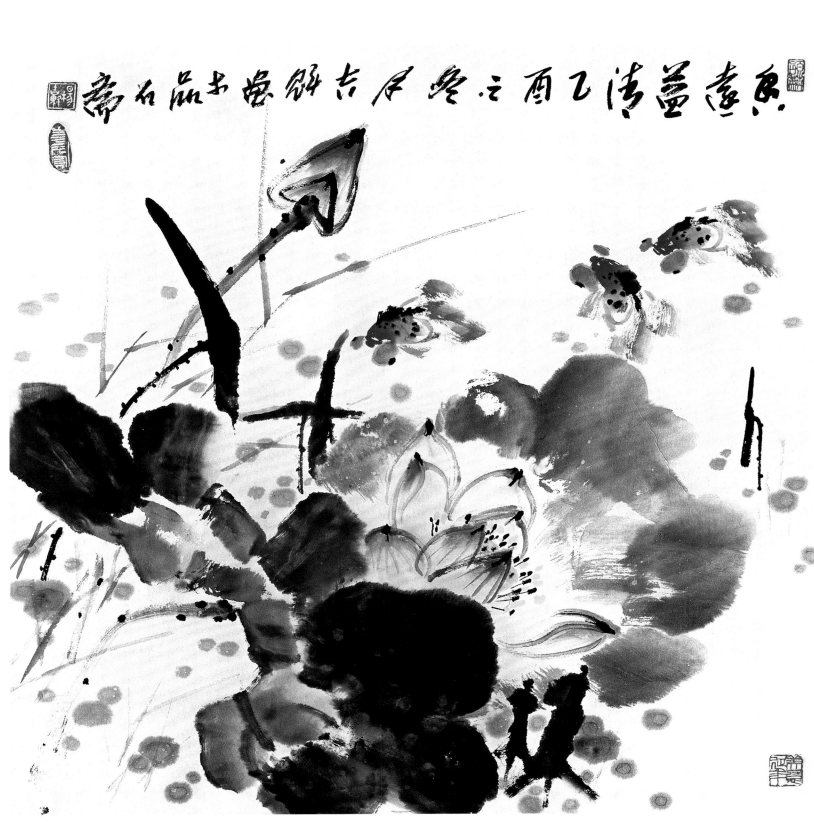

题画荷

凌波玉立满塘红，

碧水潜鳞趣未穷。

翠盖风翻香气远，

无垠美景画图中。

——杨吉魁

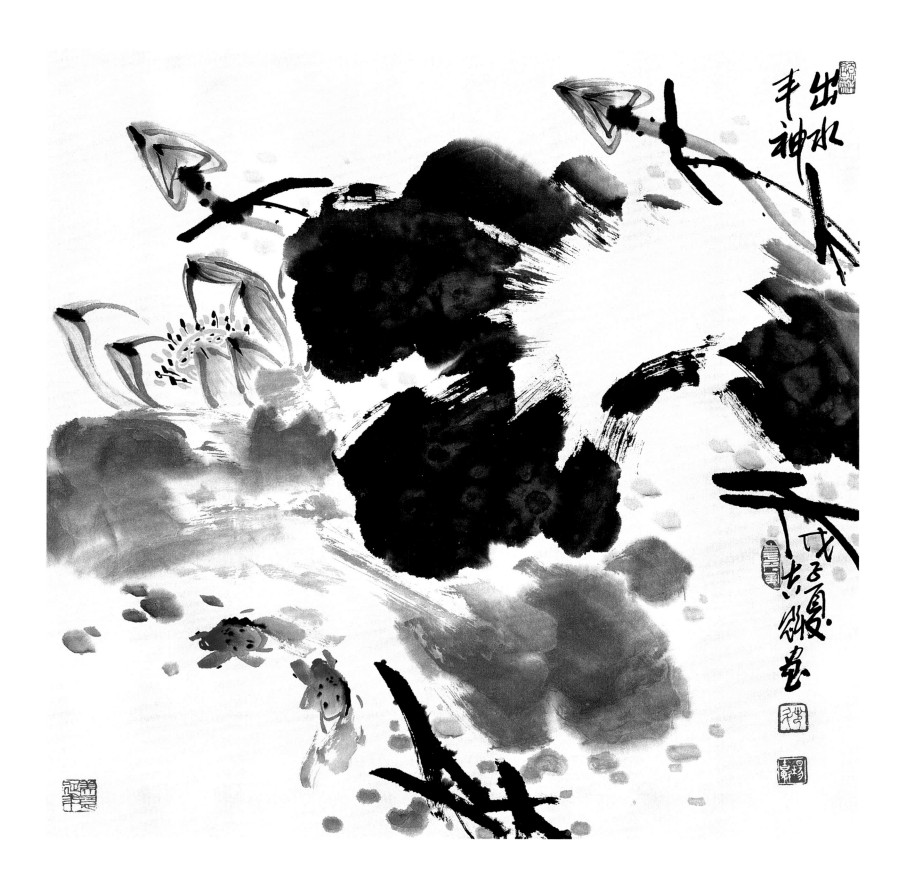

题画荷

绿满池塘气韵新，

亭亭玉立圣洁身。

清香漫绕游人醉，

不染人间半点尘。

——杨吉魁

香溢金塘

154cm×85cm

庚寅夏月吉魁画于并

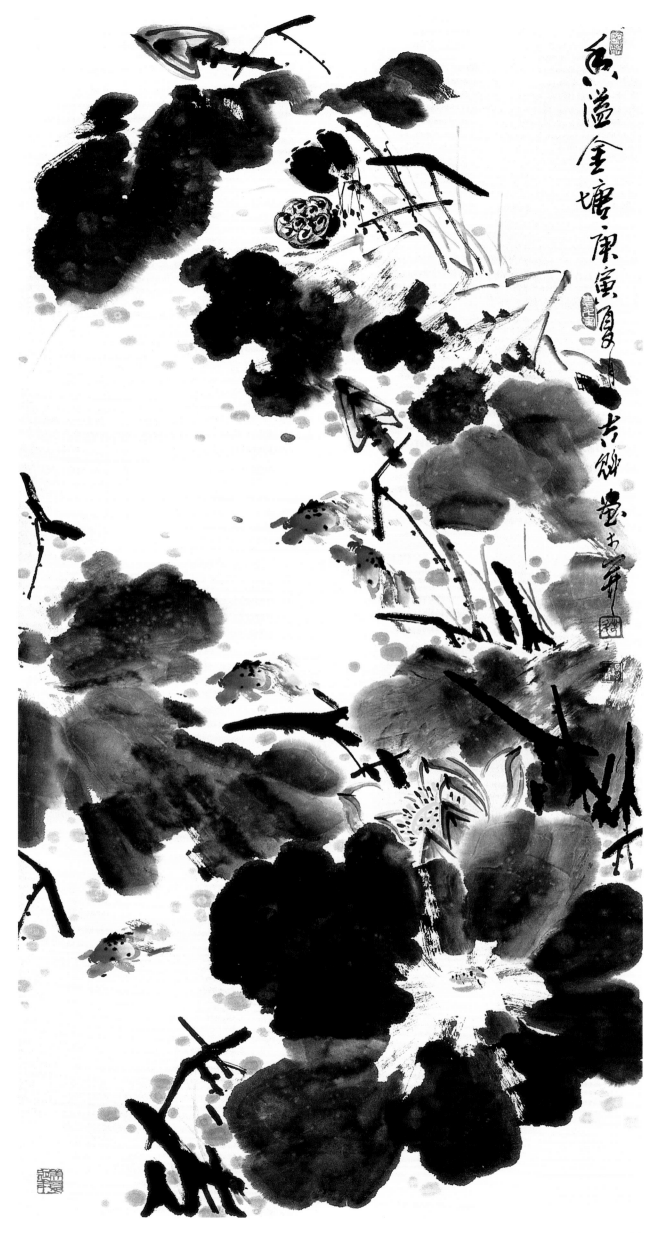

香远益清　碧水潜鳞　97cm×180cm　丙戌三月吉魁画于古并

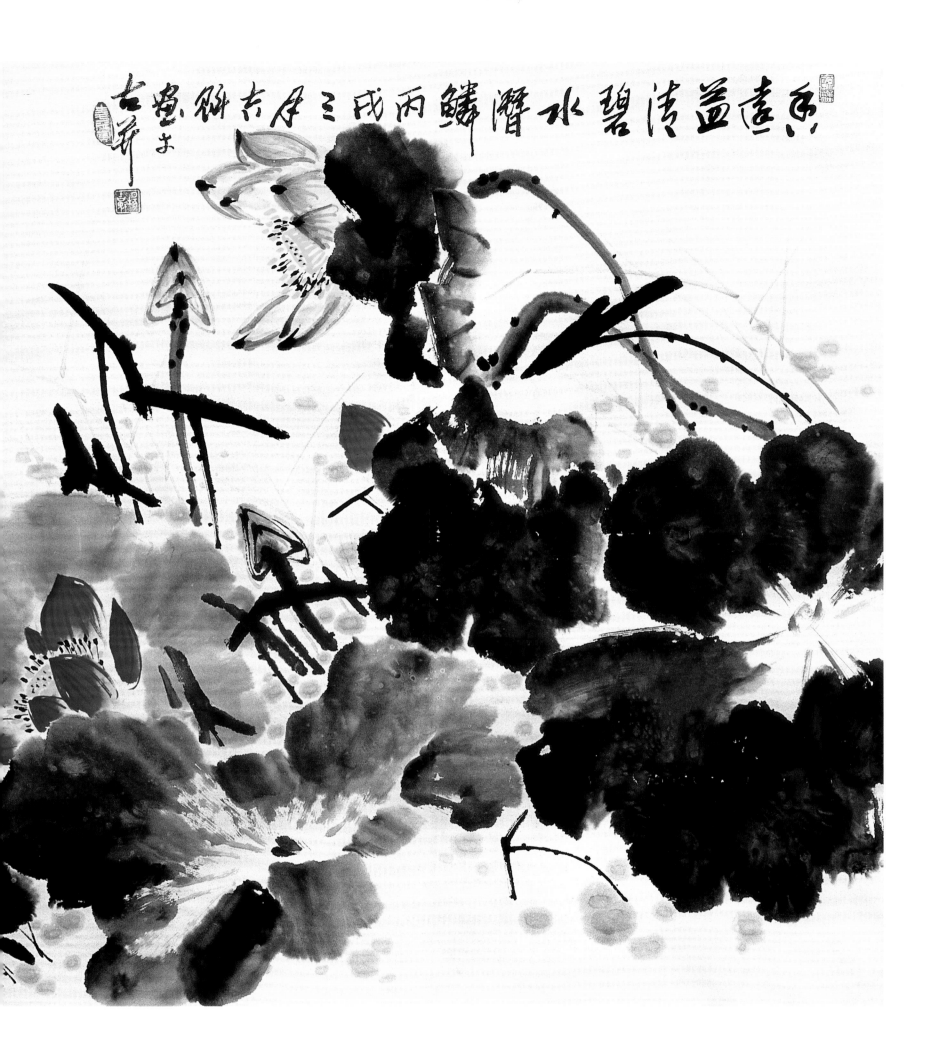

清气盖远 清水潜鳞 丙戌三月古月鲁石画

13

题画荷

污泥不染立塘中，
午赏荷花色更红。
观景成形香纸上，
留得趣境品无穷。

——杨吉魁

碧池清影　香溢金塘

70cm×137cm

庚寅夏月吉魁画于并

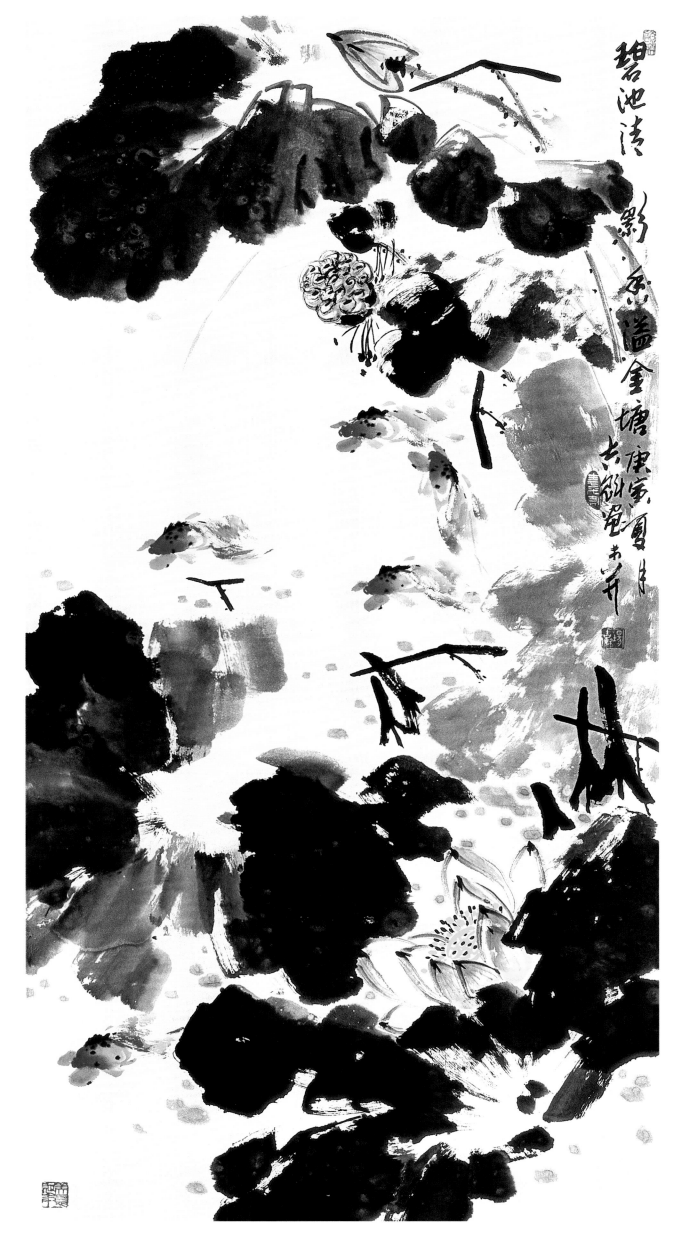

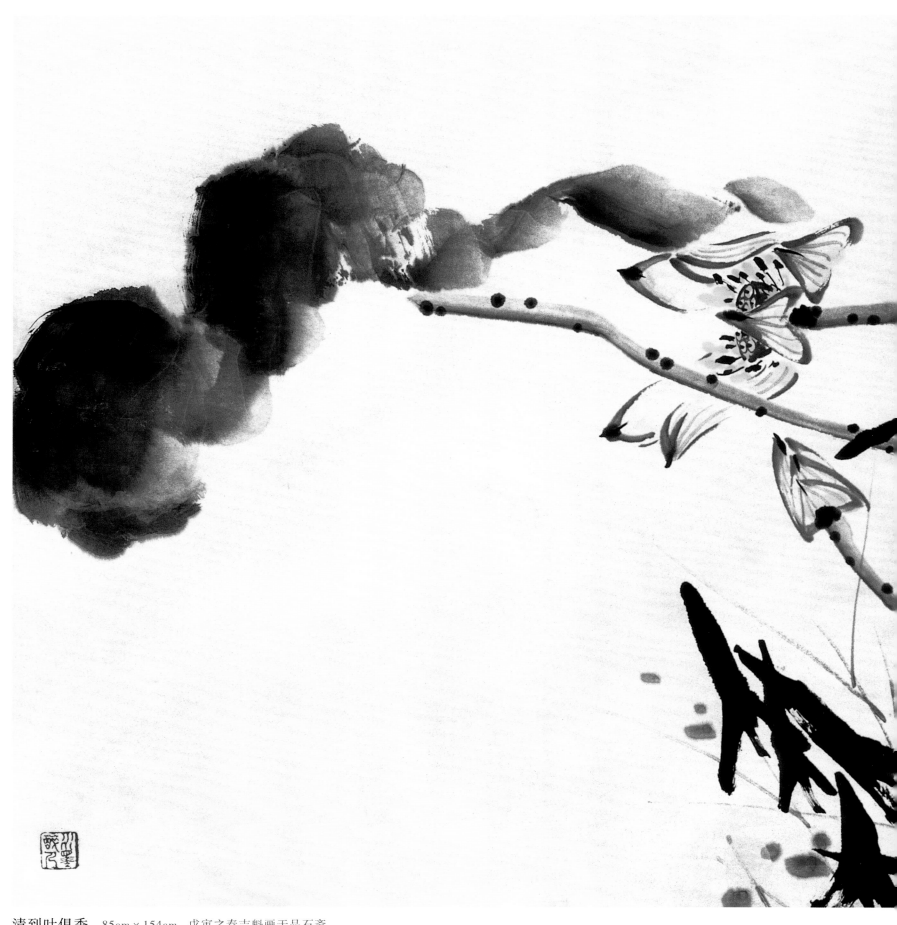

清到叶俱香　85cm×154cm　戊寅之春吉魁画于品石斋

清则叶俱远风之盛戏志之群芳品墨云不

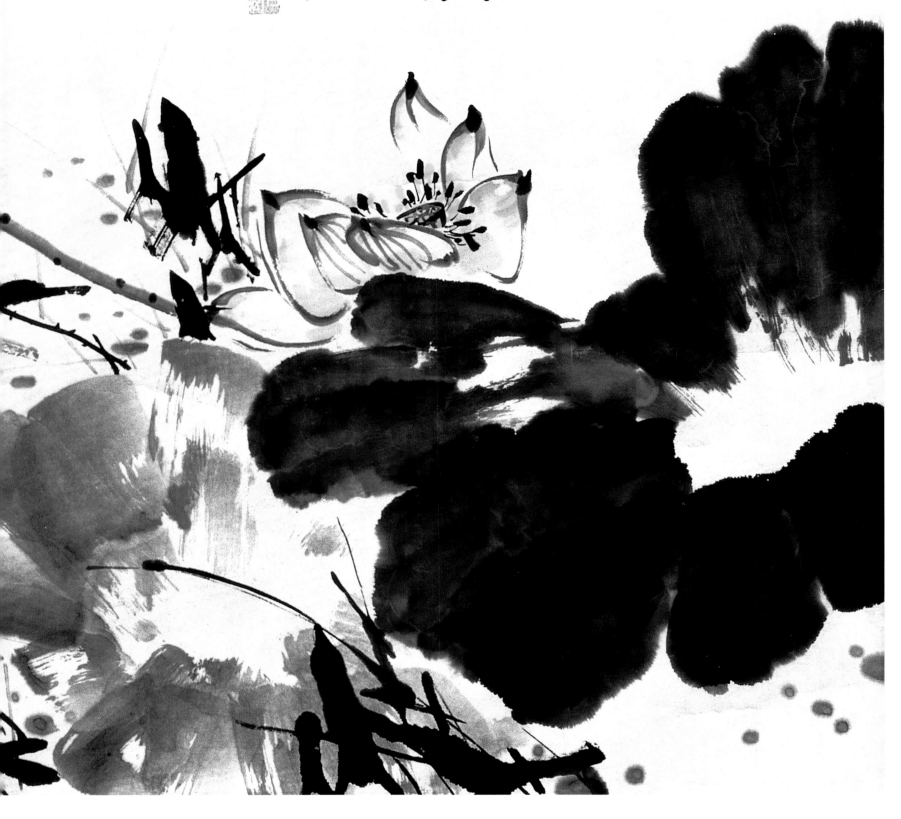

画荷

涉笔荷塘古趣多，

红花绿叶总相和。

焉知墨韵凭功力，

境不清幽奈若何。

——杨吉魁

荷

39cm×39cm

戊子春吉魁画

（选自册页）

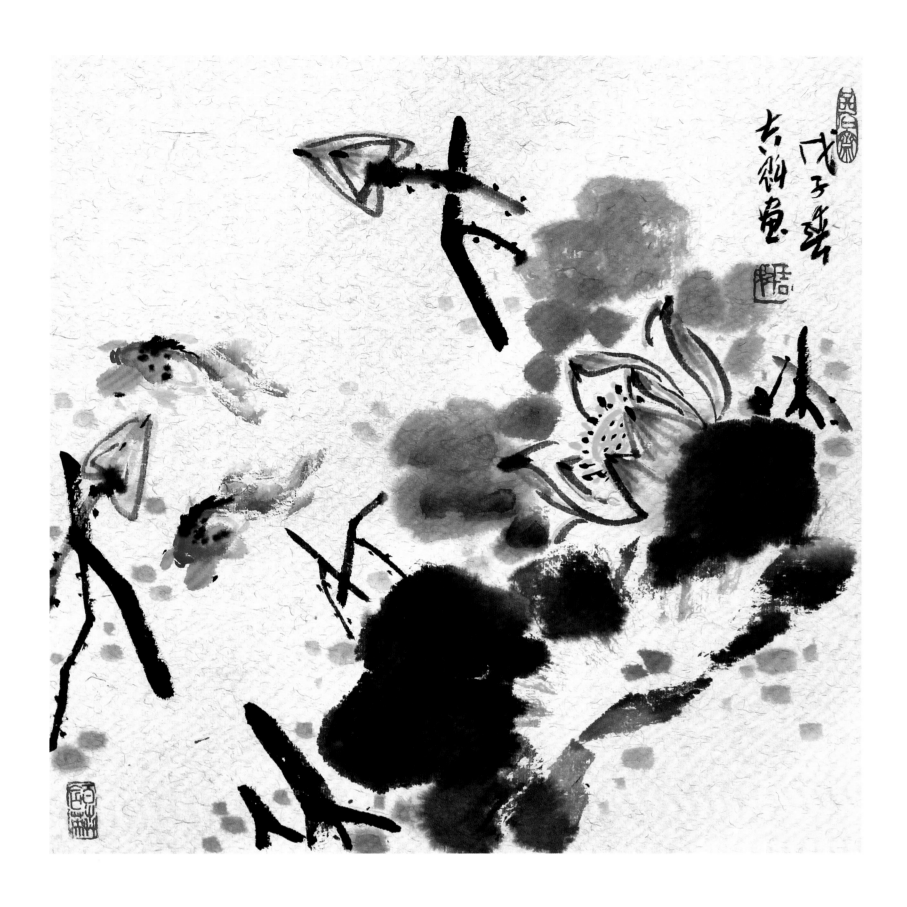

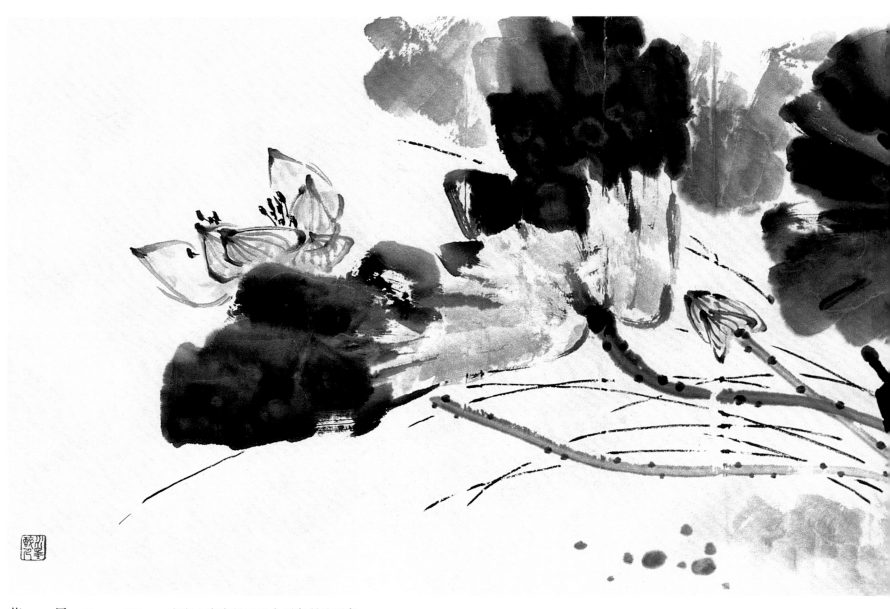

荷　　风　69cm×207cm　戊寅立春吉魁画于太原寓所品石斋

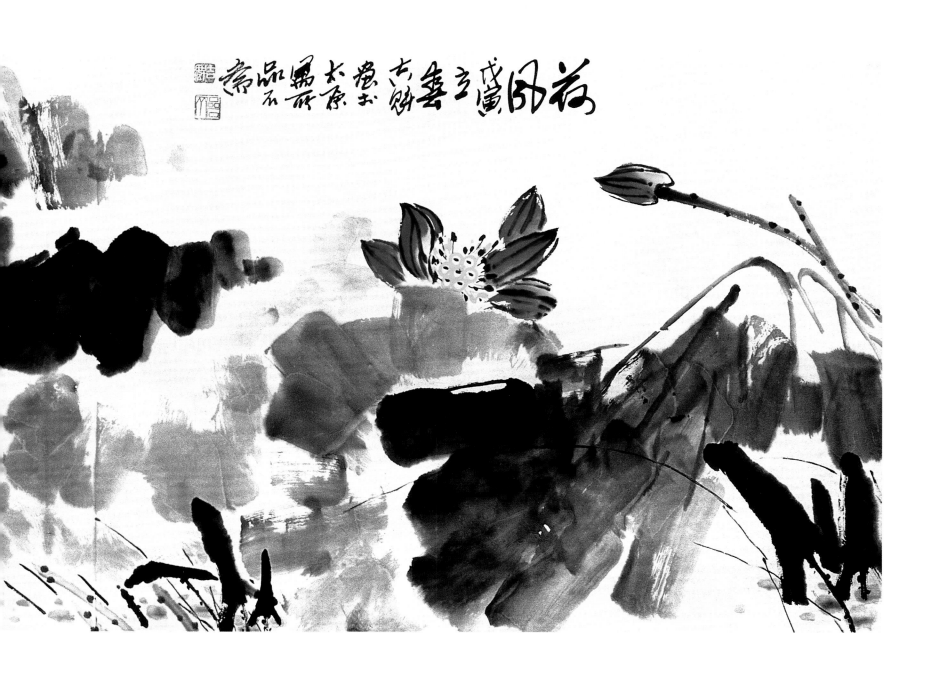

赏荷

荷塘荡漾藕花香，
诱使吾侪共品赏。
不染污泥君子相，
休嫌碧叶太无光。

——杨吉魁

荷香清暑

137cm×69cm

丙戌之夏吉魁画

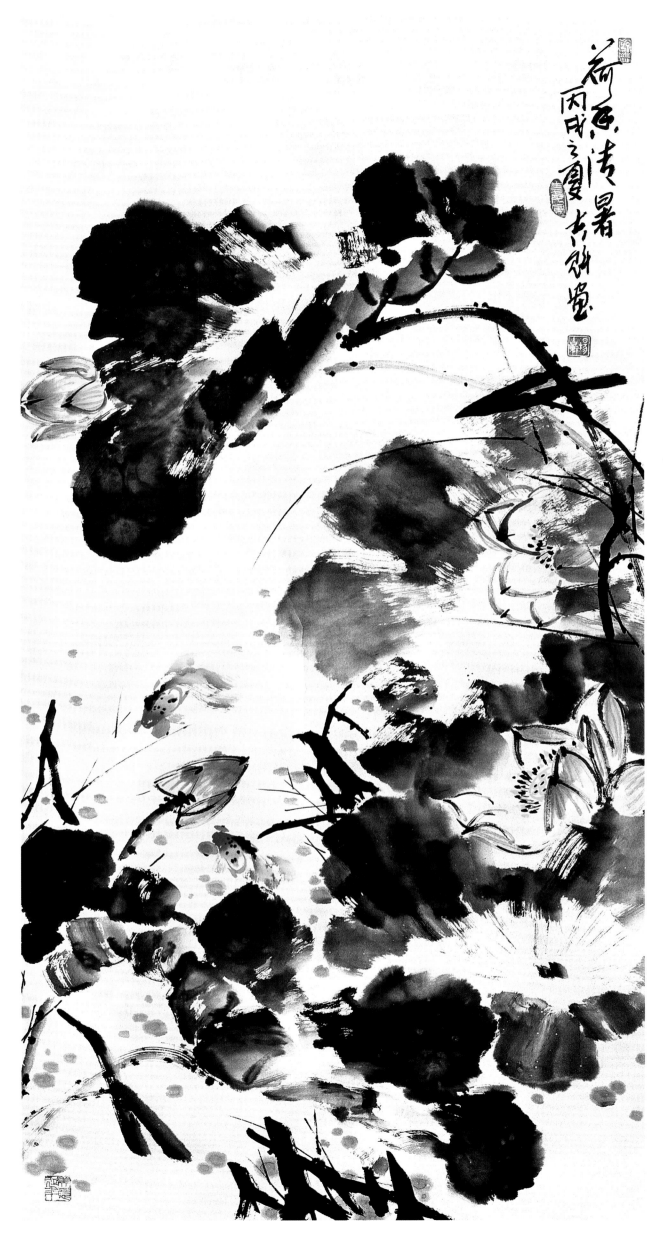

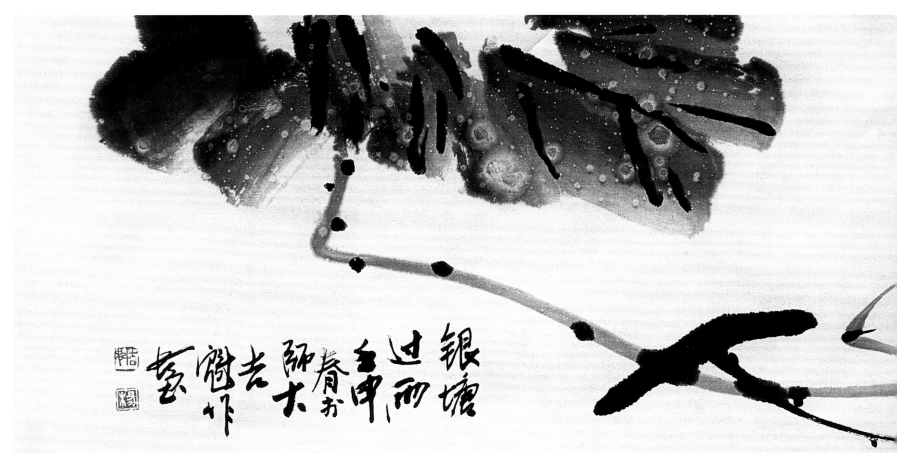

银塘过雨　42cm×154cm　壬申春于师大吉魁作画

题画荷

荷花两朵价千金，

信手拈来色最深。

万绿丛中红烂漫，

污泥不染见禅心。

——杨吉魁

荷

39cm×39cm

吉魁画

（选自册页）

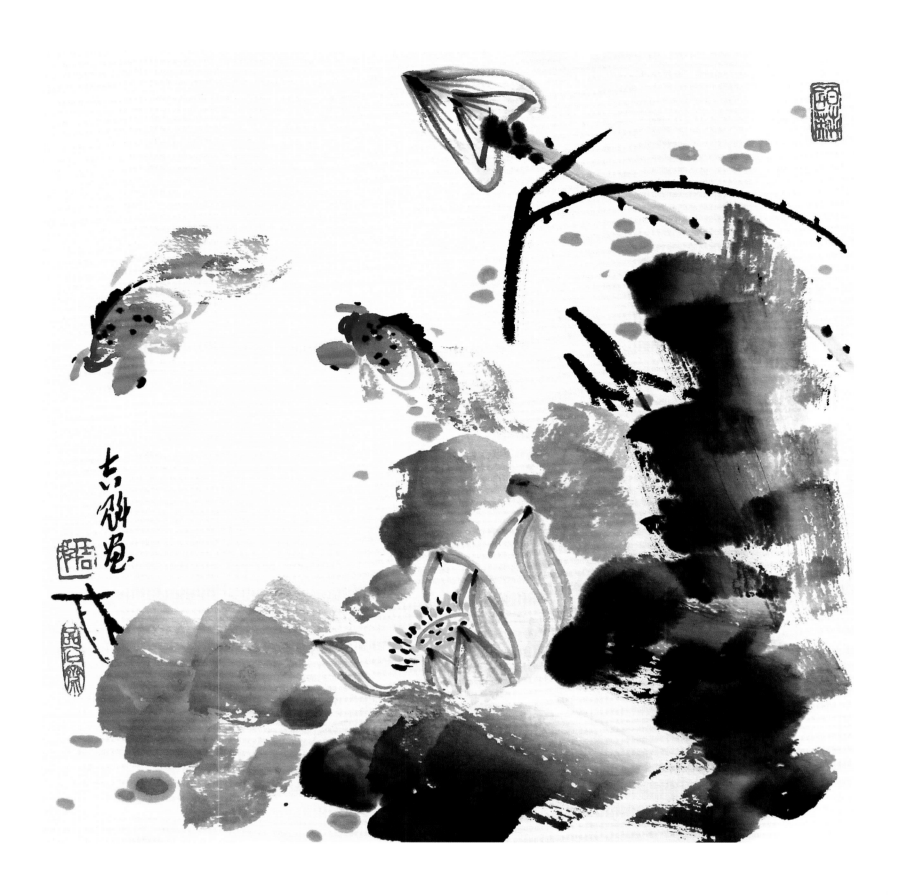

写意荷花

挥毫立意写荷花，
不老精神正可嘉。
兴致来时泼墨彩，
烟云满纸叶横斜。

——杨吉魁

碧塘清影锦浪生

137cm × 70cm

庚寅立秋吉魁画于并

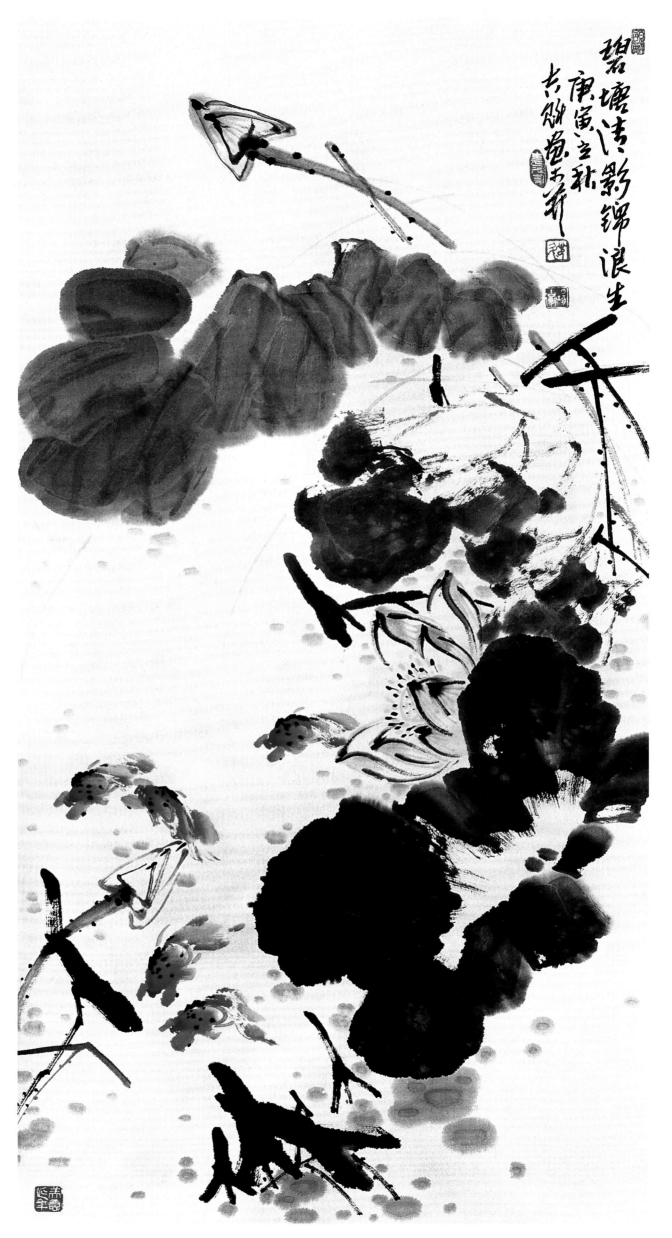

香远益清（局部）

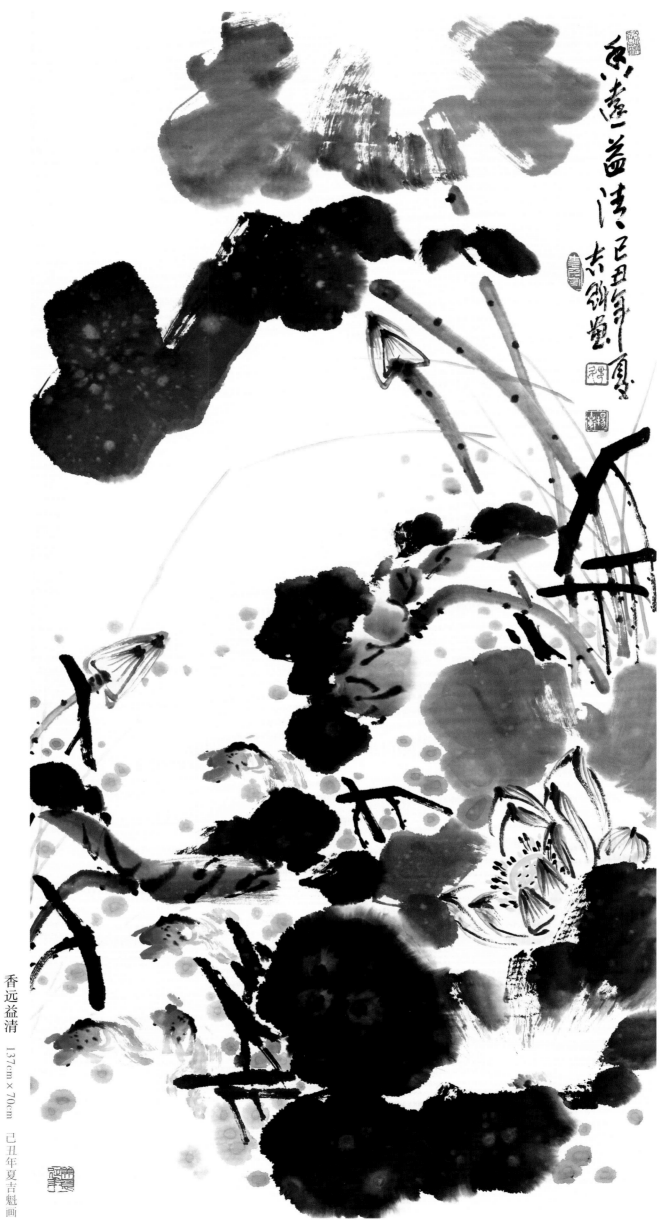

香远益清 137cm×70cm 己丑年夏吉魁画

画荷

醉态挥毫笑我狂，

朦胧落墨画荷塘。

田塍翠盖无尘染，

自在金鱼叶底藏。

——杨吉魁

清香溢远

137cm×70cm

癸未冬月吉魁画于并

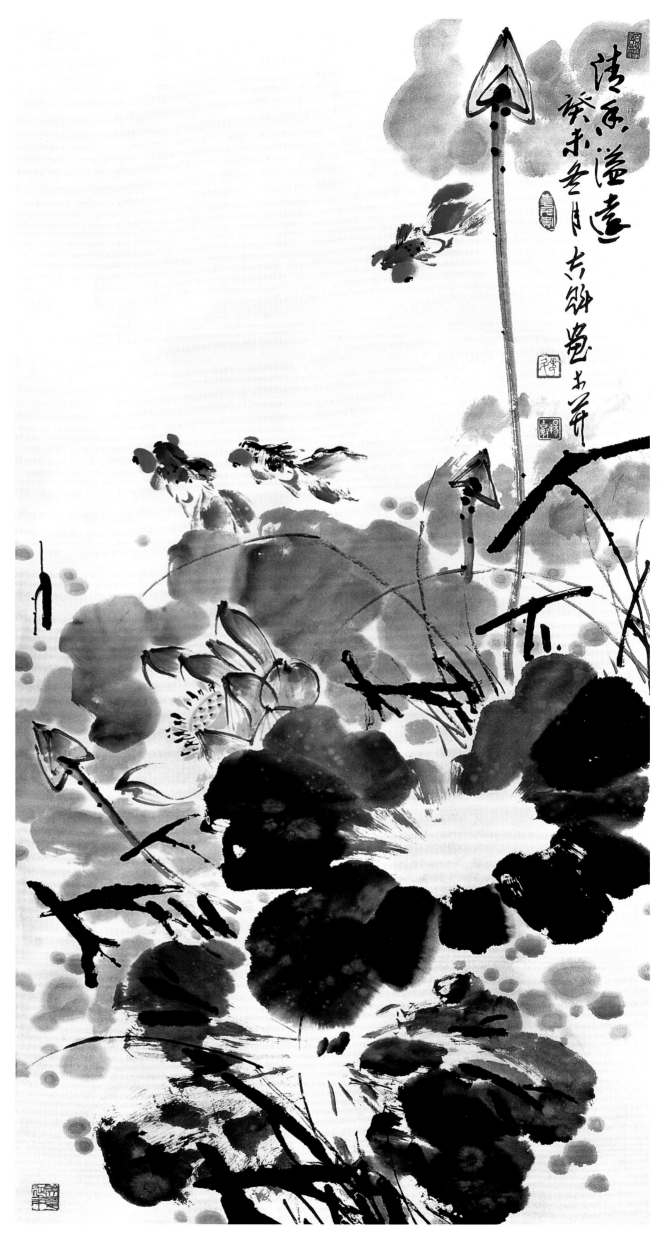

荷露清香（局部）

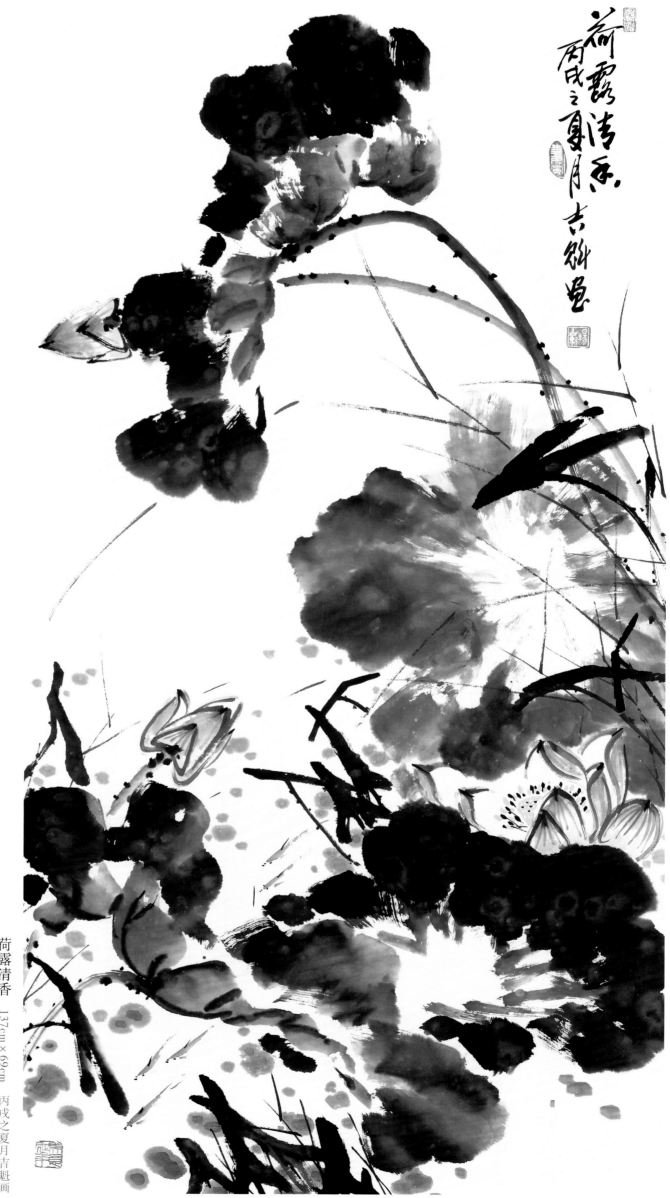

荷露清香　137cm×69cm　丙戌之夏月吉魁画

《捣练子·爱莲》

风景秀，

映红莲。

面对荣华世外仙。

尽态碧妍心里画，

爱君洁净叶田田。

——杨吉魁

荷

137cm×70cm

砚池水墨多　拈毫貌君子

有迹不染尘　亭亭谁得似

丙戌夏月画俞光蕙诗意吉魁于并

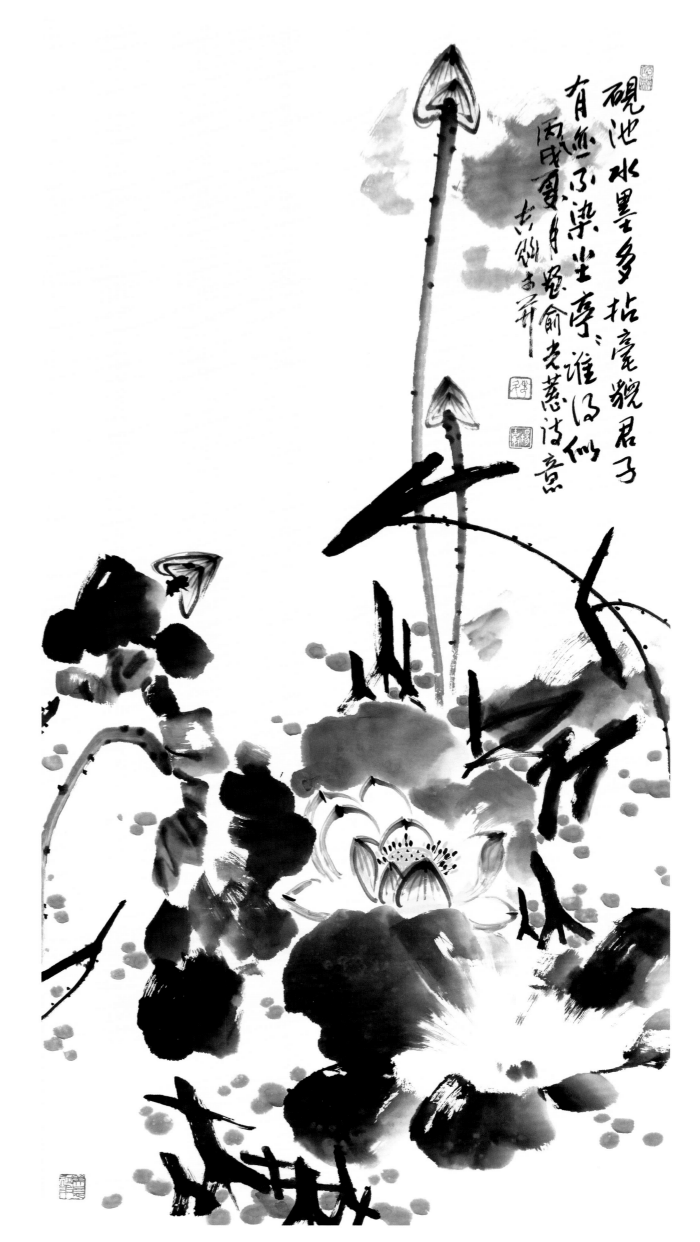

砚池水墨多拈毫貌君子
有焉不染坐亨谁调似
戊夏月遇俞老墓诗意
志翔并

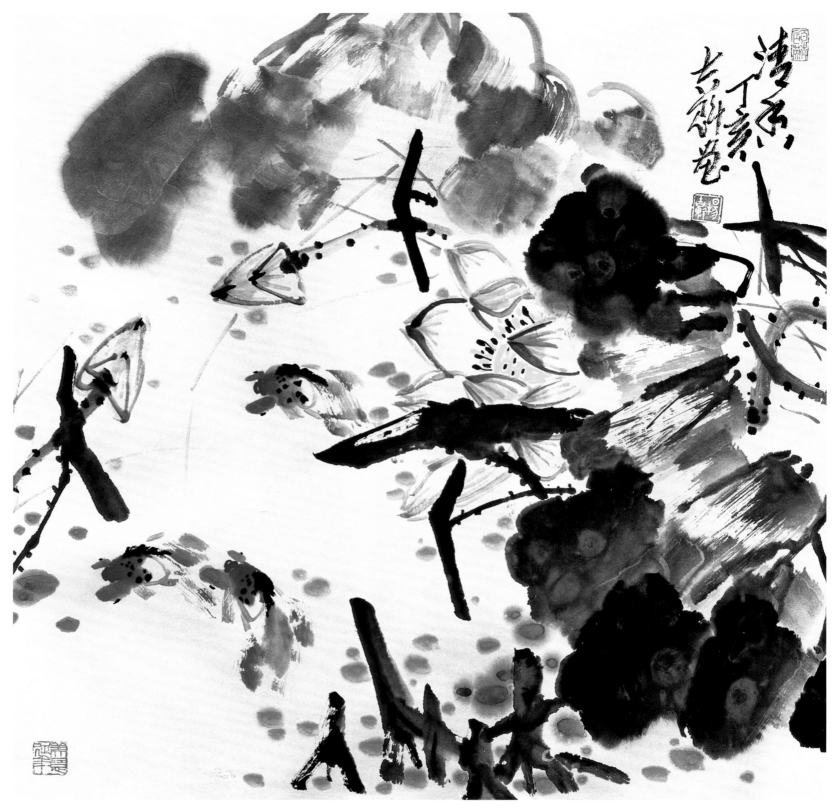

清　香　68cm×68cm　丁亥吉魁画

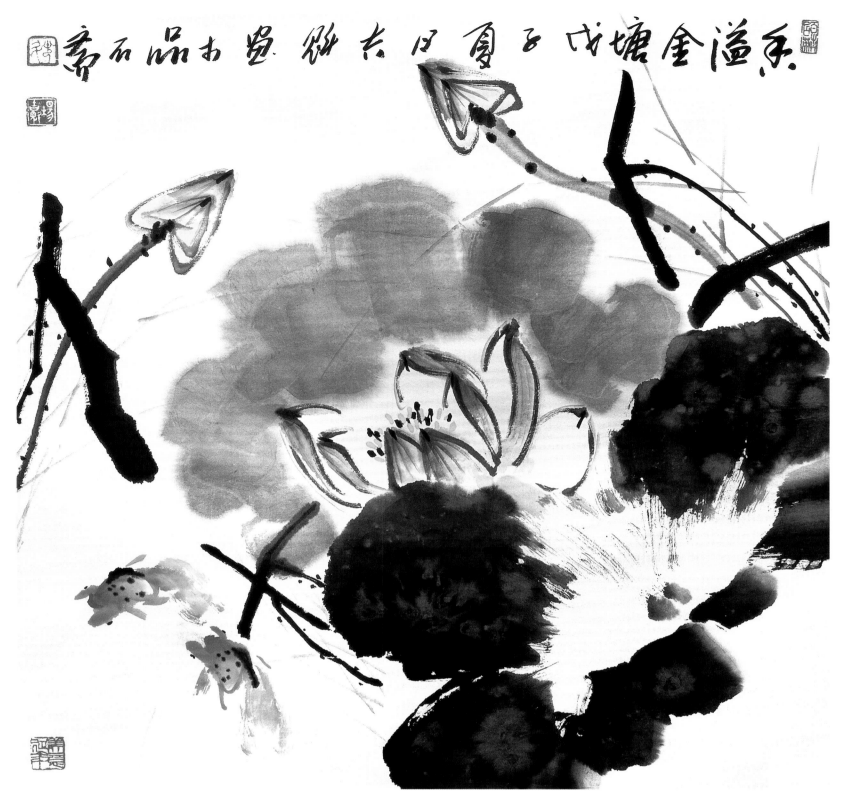

香溢金塘　68cm×68cm　戊子夏日吉魁画于品石斋

写荷

无言水墨度生涯，

画笔一支对晚霞。

满纸烟云多惬意，

通幅气韵见荷花。

——杨吉魁

香溢金塘

137cm × 69cm

庚寅夏月吉魁画于并

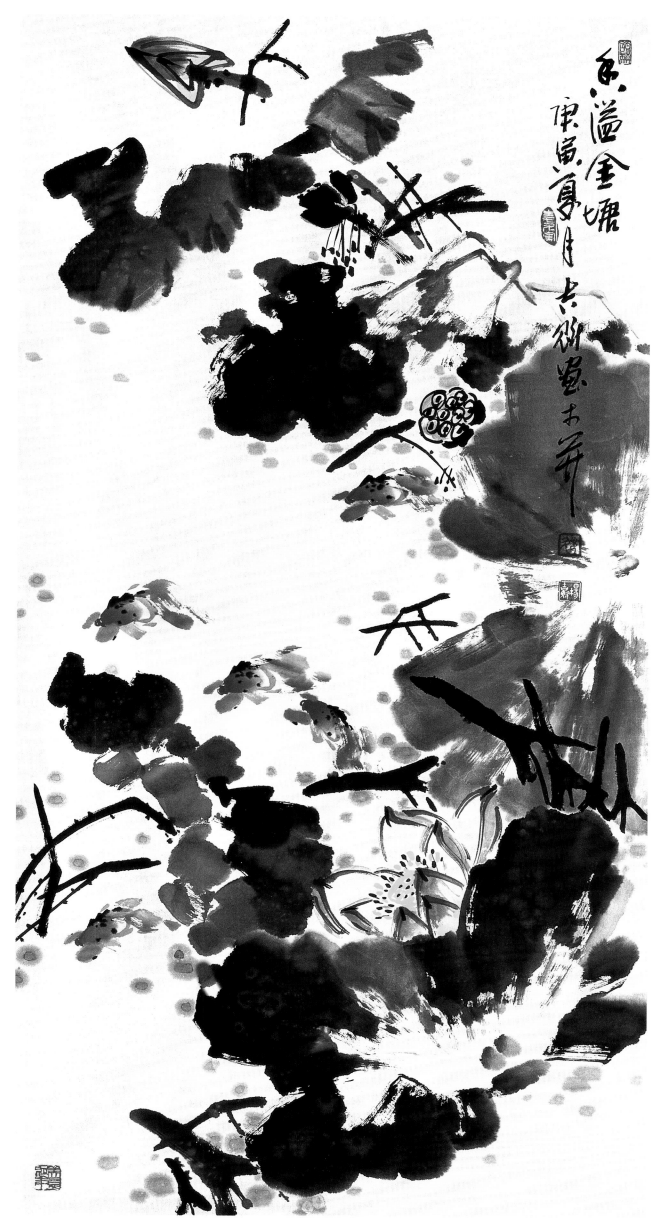

香远益清　97cm×180cm　乙酉夏月吉魁画于品石斋

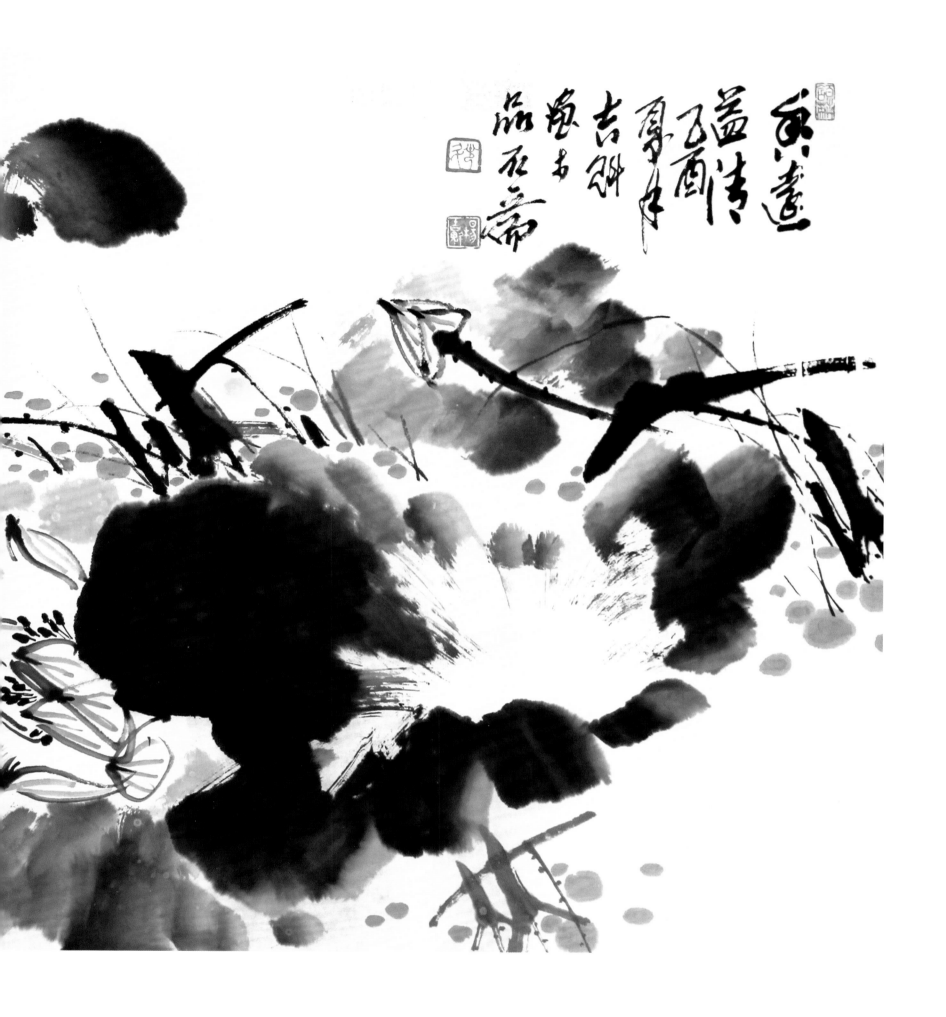

咏荷

新荷出水见丰神，

不染尘埃品性真。

乐道濂溪文采好，

爱莲自有后来人。

——杨吉魁

出水丰神

137cm × 70cm

丙戌之夏月吉魁

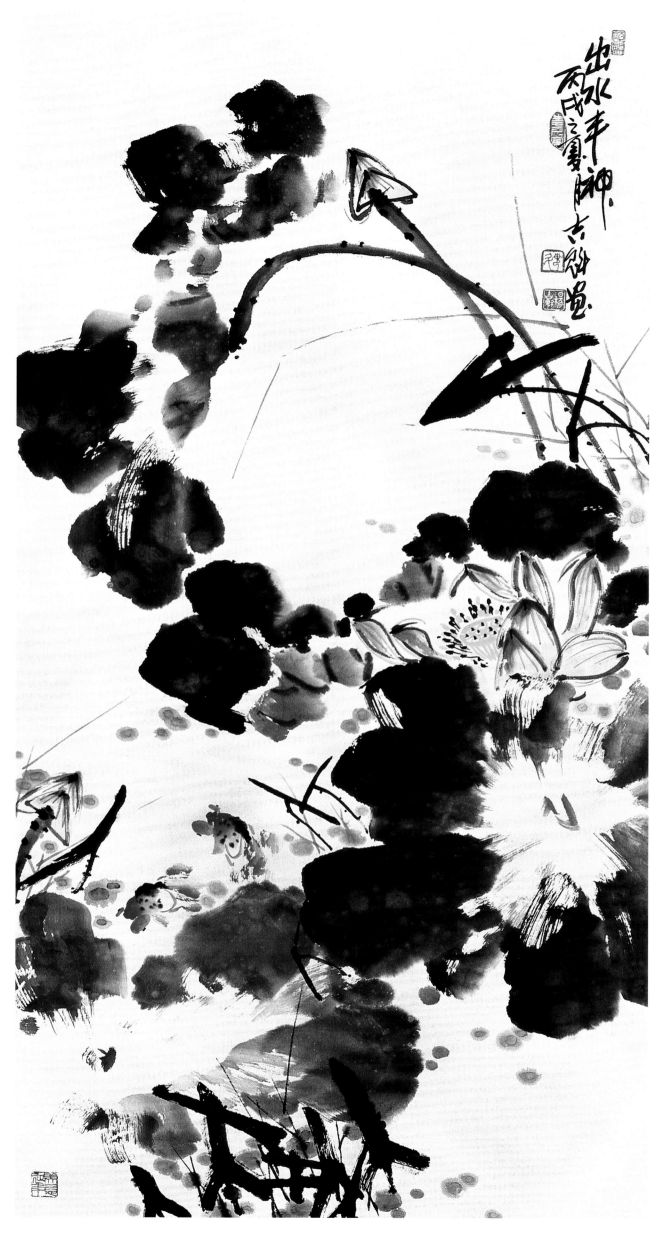

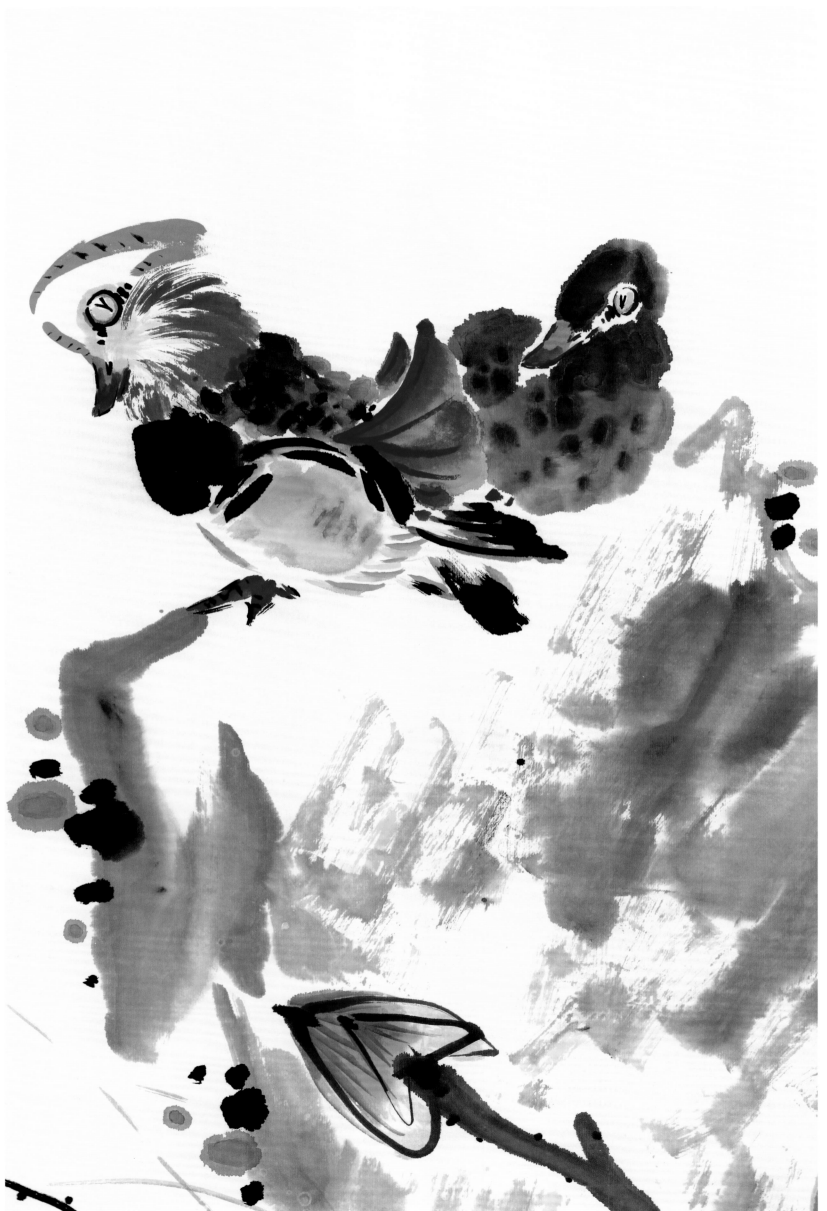

和合如意（局部）

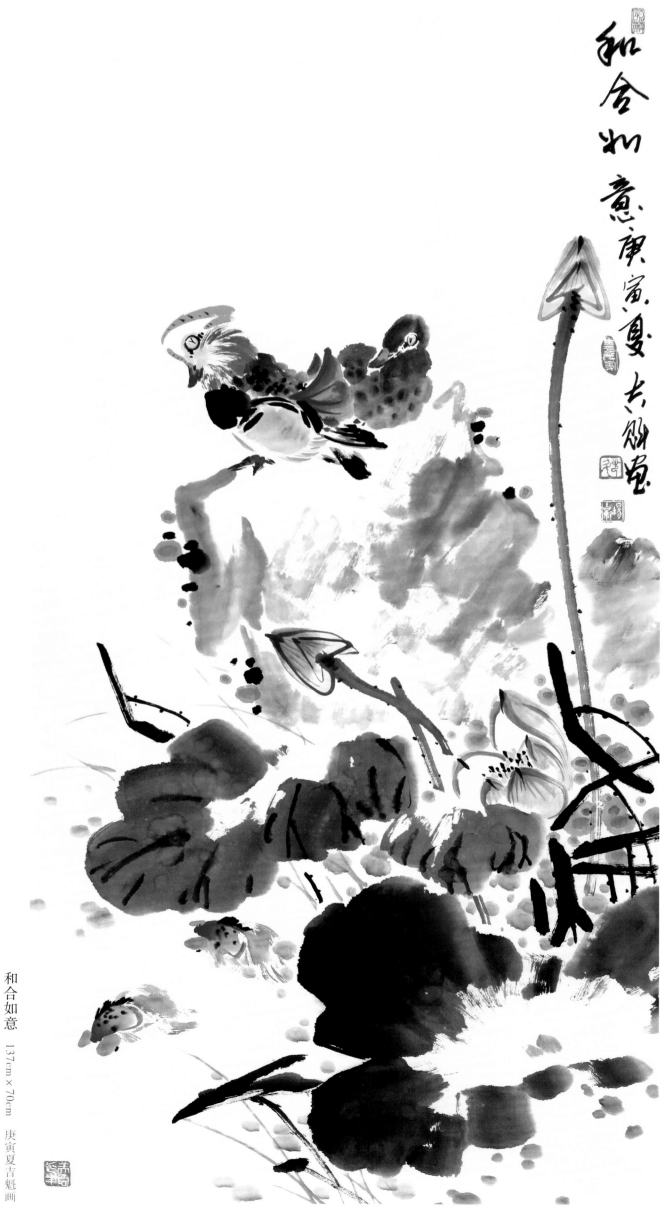

和合如意　137cm×70cm　庚寅夏吉魁画

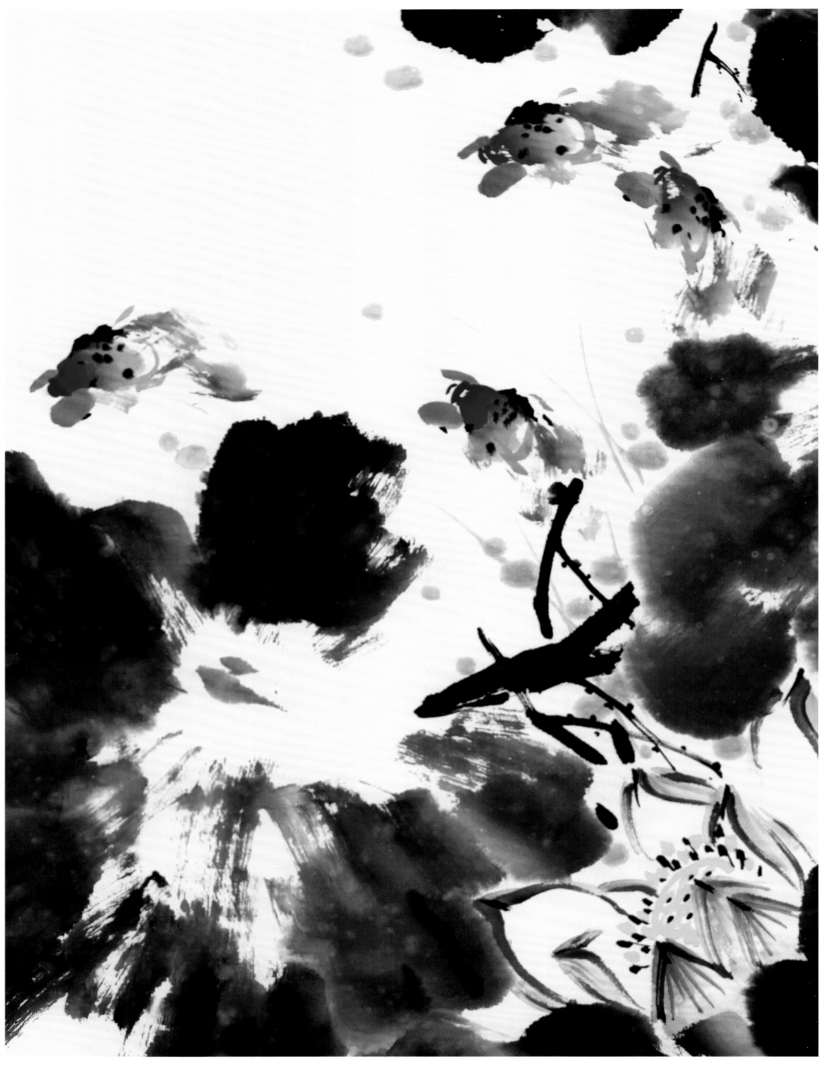

碧塘鳞影　荷露清香（局部）

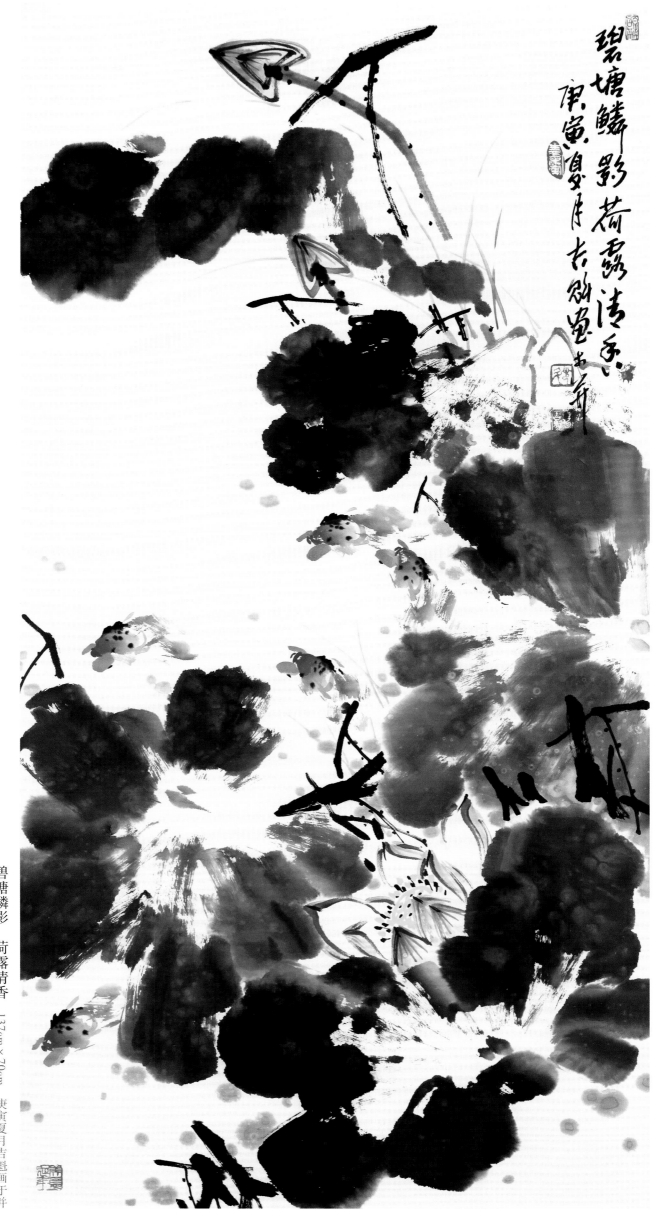

碧塘鳞影 荷露清香 137cm×70cm 庚寅夏月吉魁画于并

感悟

转益多师喜幸师，
博学览取在一时。
更须造化神来笔，
写尽人间秀雅姿。

——杨吉魁

碧塘清影　风荷双香

137cm×70cm

庚寅夏日吉魁画于并

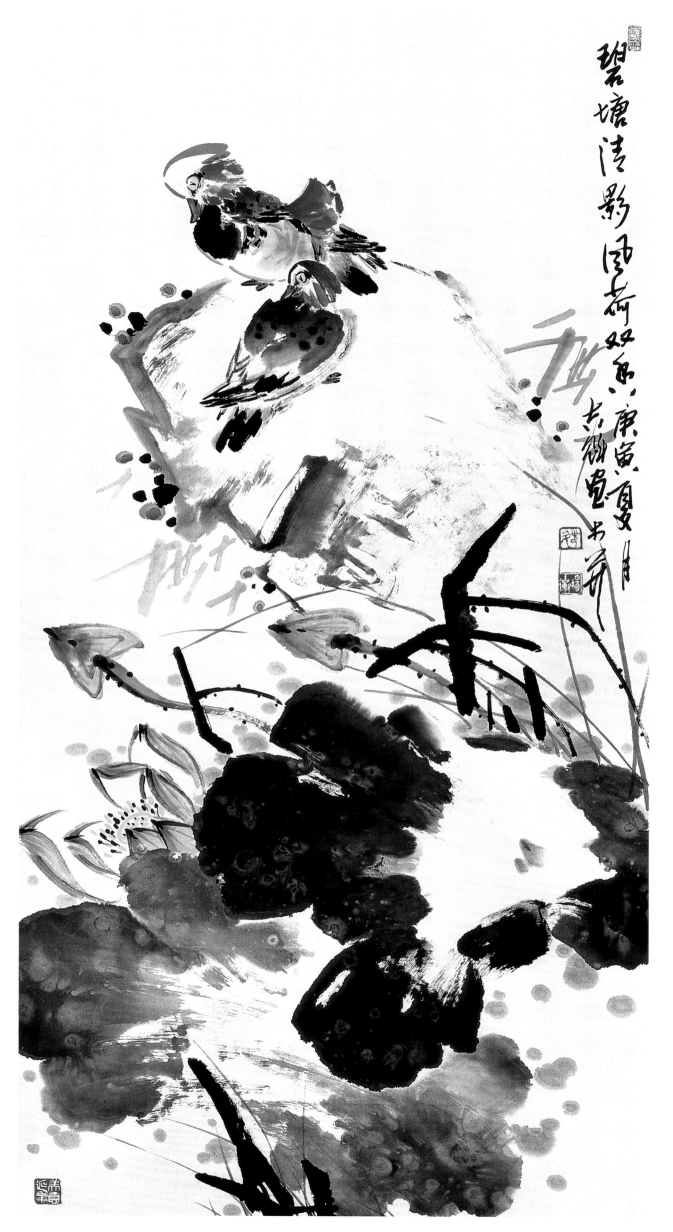

题画荷

接天碧叶总田田，
玉立亭亭画苑前。
不染污泥真雅士，
清香漫绕是花仙。

——杨吉魁

碧水潜鳞　香溢金塘

137cm×70cm

庚寅夏月吉魁画

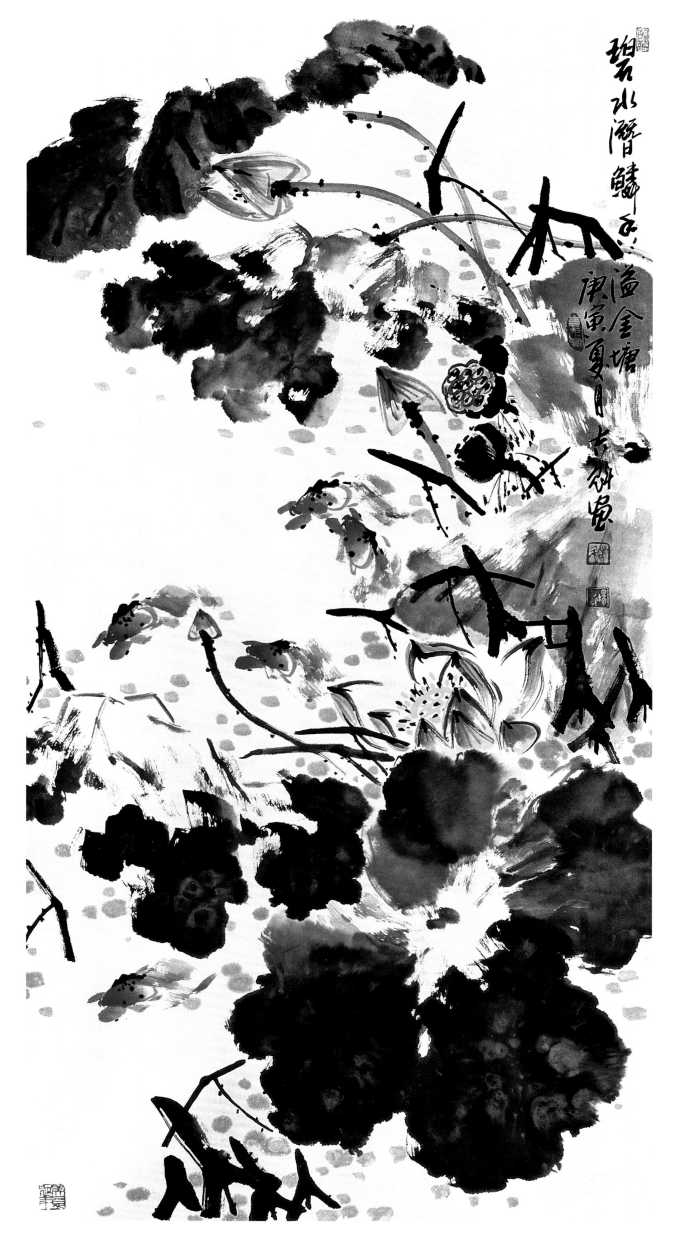

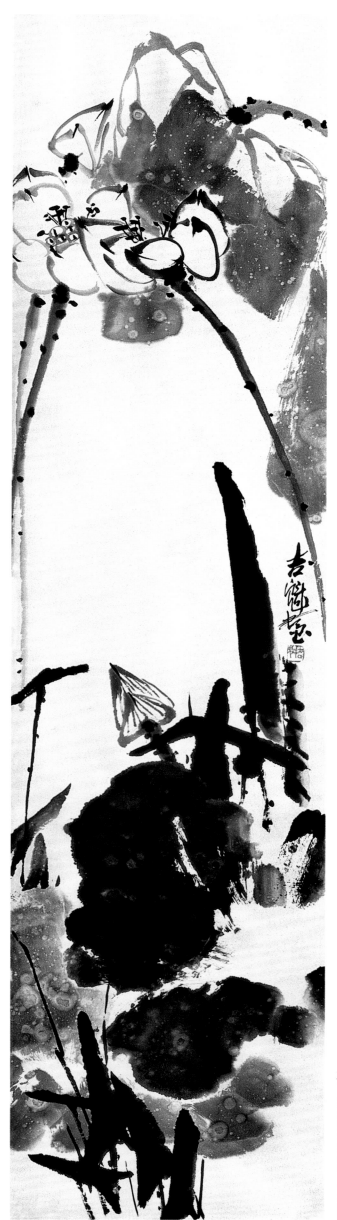

荷　137cm×35cm　吉魁画

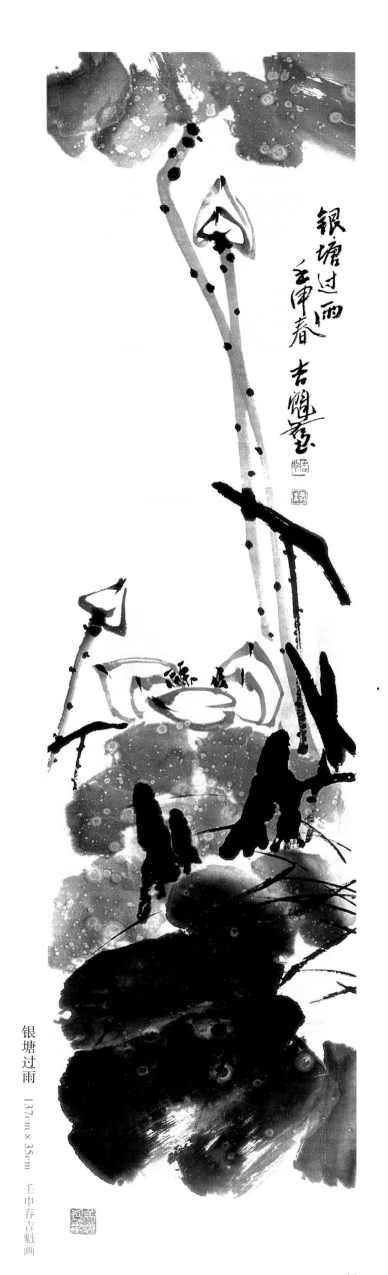

银塘过雨

壬申春

吉魁

银塘过雨　137cm×35cm　壬申春吉魁画

爱莲

亭亭玉立见精神，
挺秀高洁爽自身。
绝世清姿尘不染，
同余爱好是何人。

——杨吉魁

新　荷

137cm×70cm

辛已夏月吉魁画于品石斋

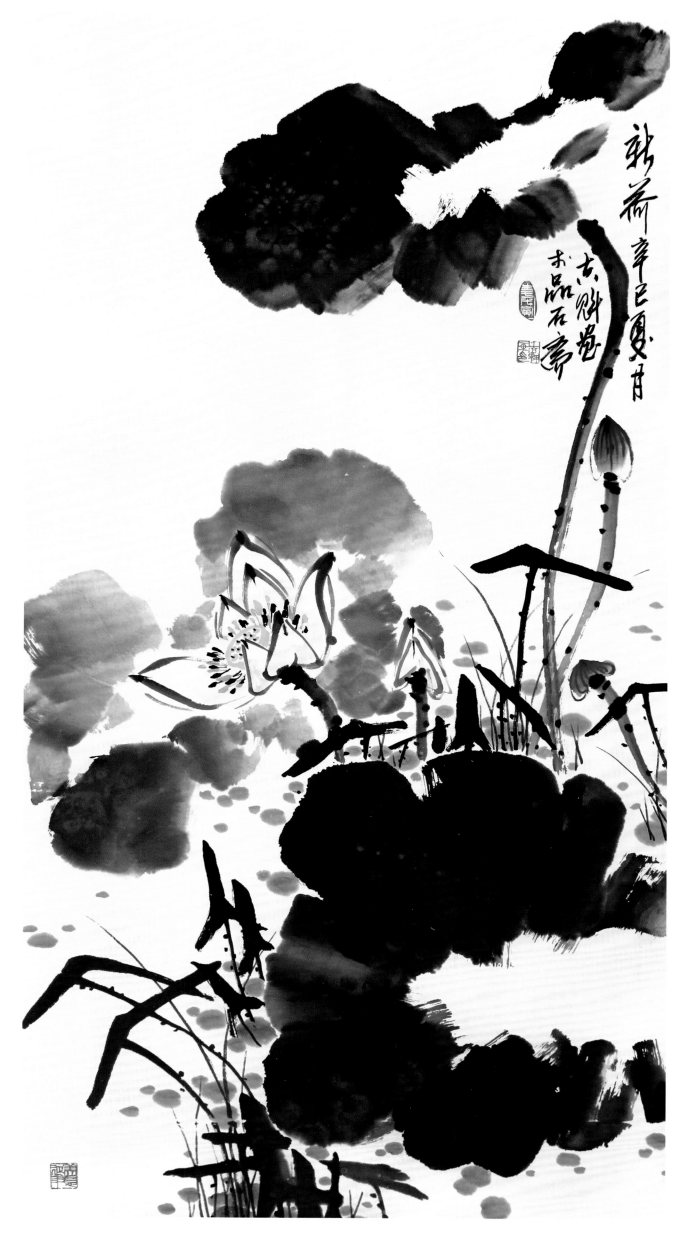

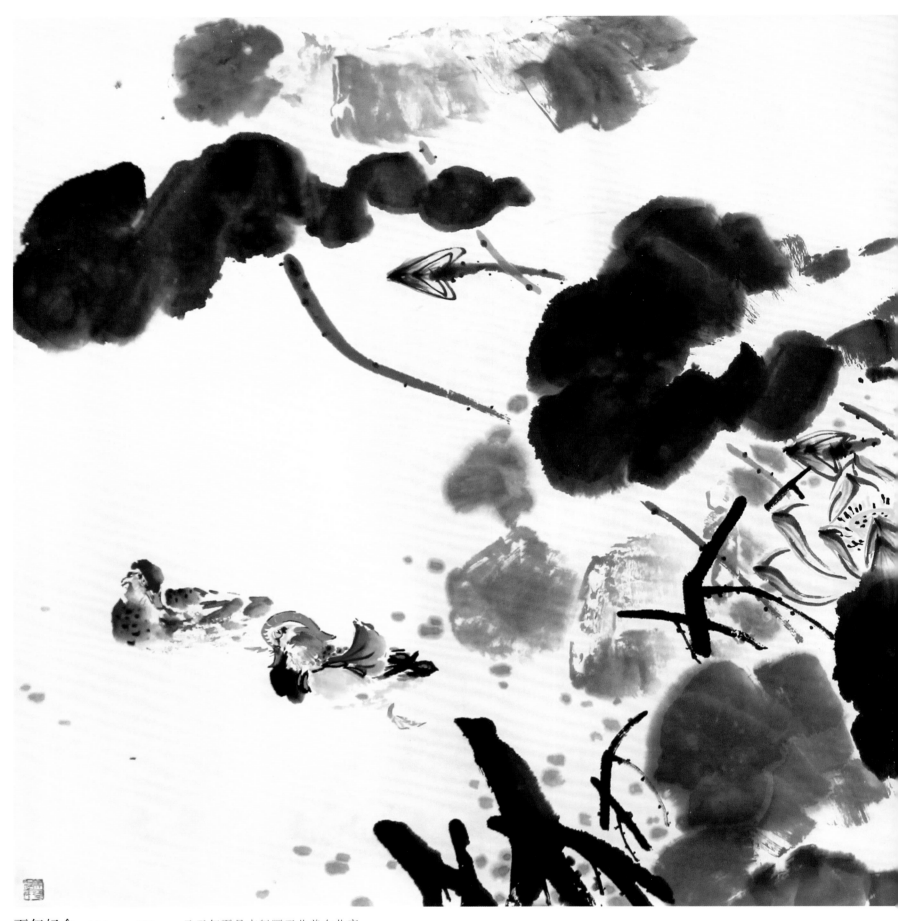

百年好合　124cm×280cm　乙丑年夏月吉魁画于北美女儿家

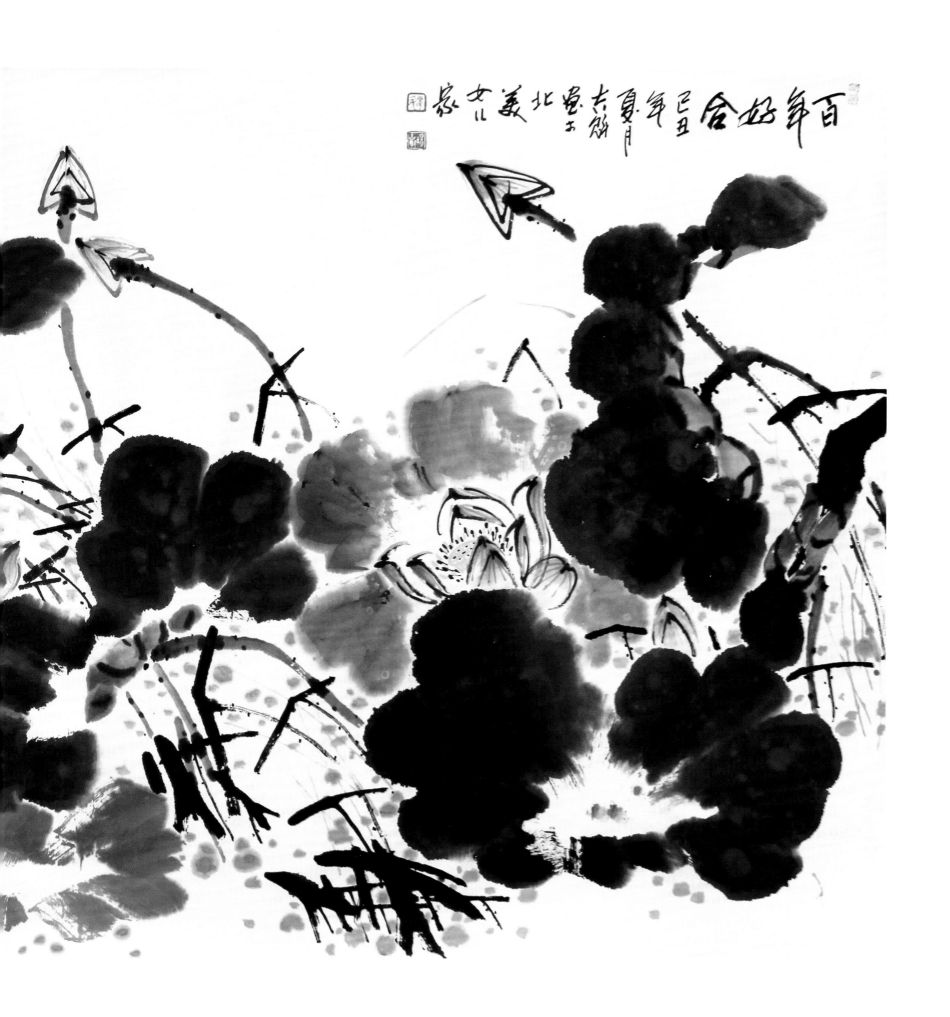

百年好合 己丑年夏月 志龄 北雪堂美女儿家

59

画荷

荷花大写有精神，
满纸烟云见立新。
世尚将莲称雅士，
污泥不染好洁身。

——杨吉魁

馨　香
137cm×70cm
戊子夏吉魁画

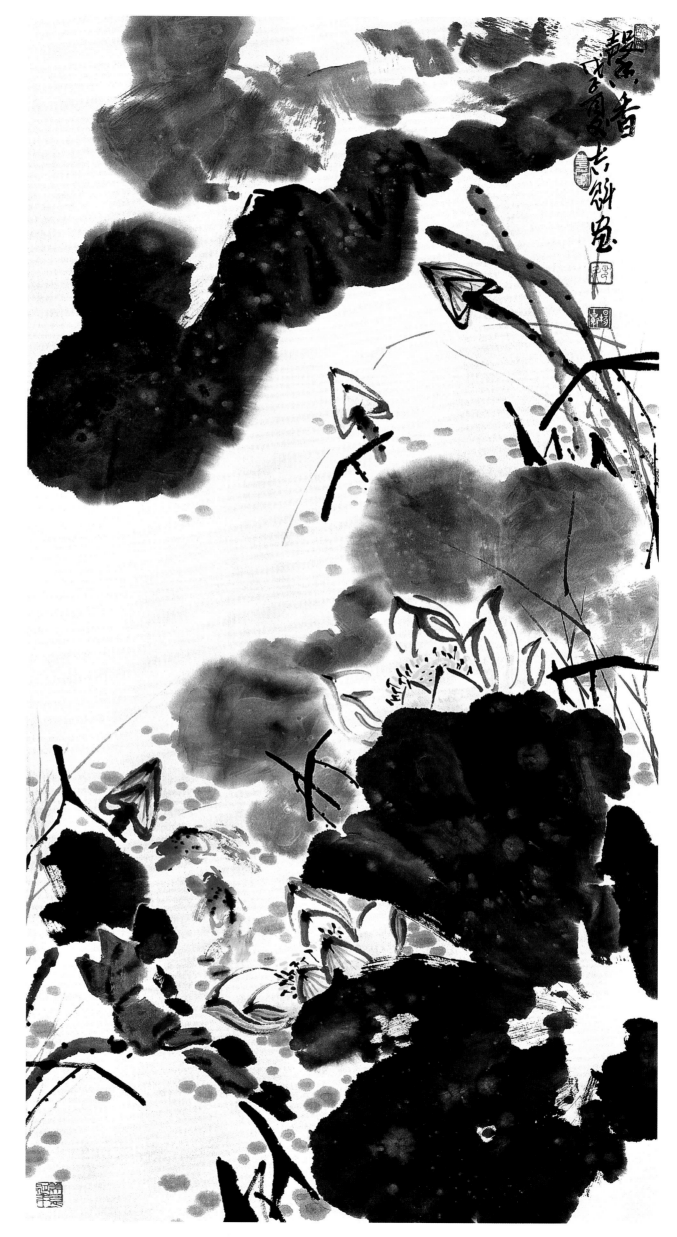

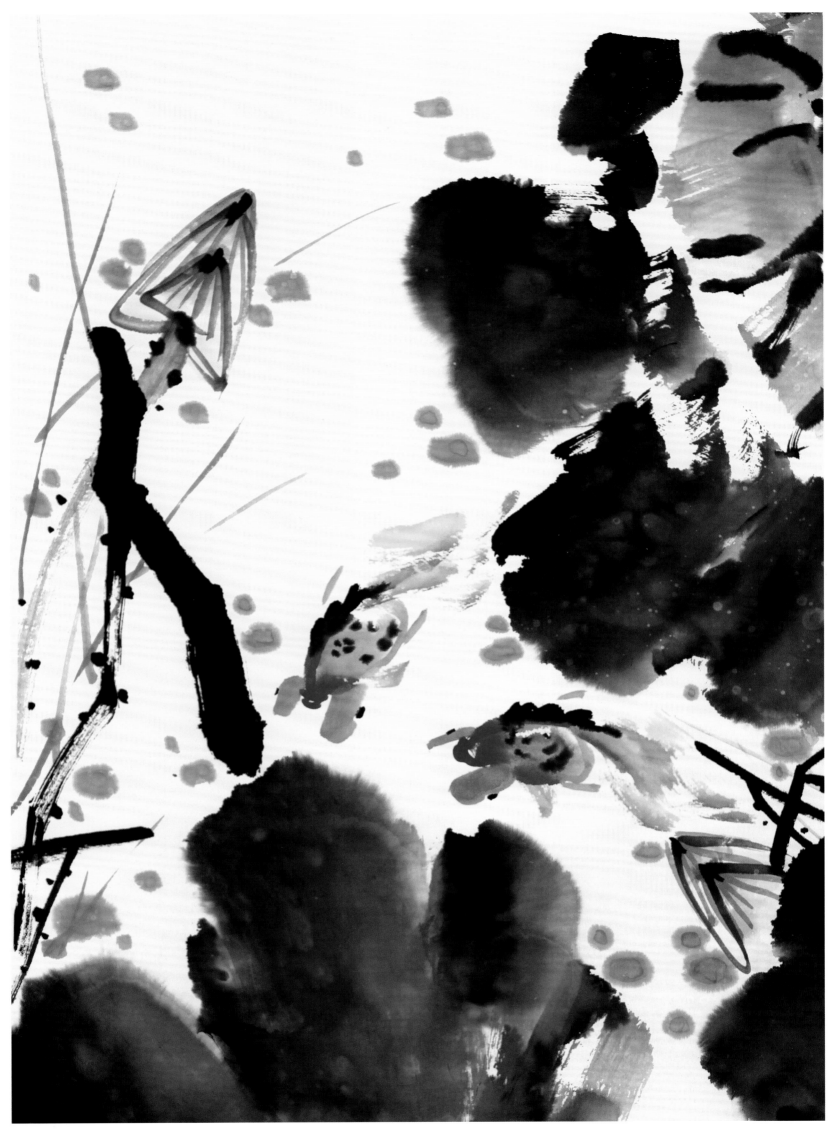

盈　　池（局部）

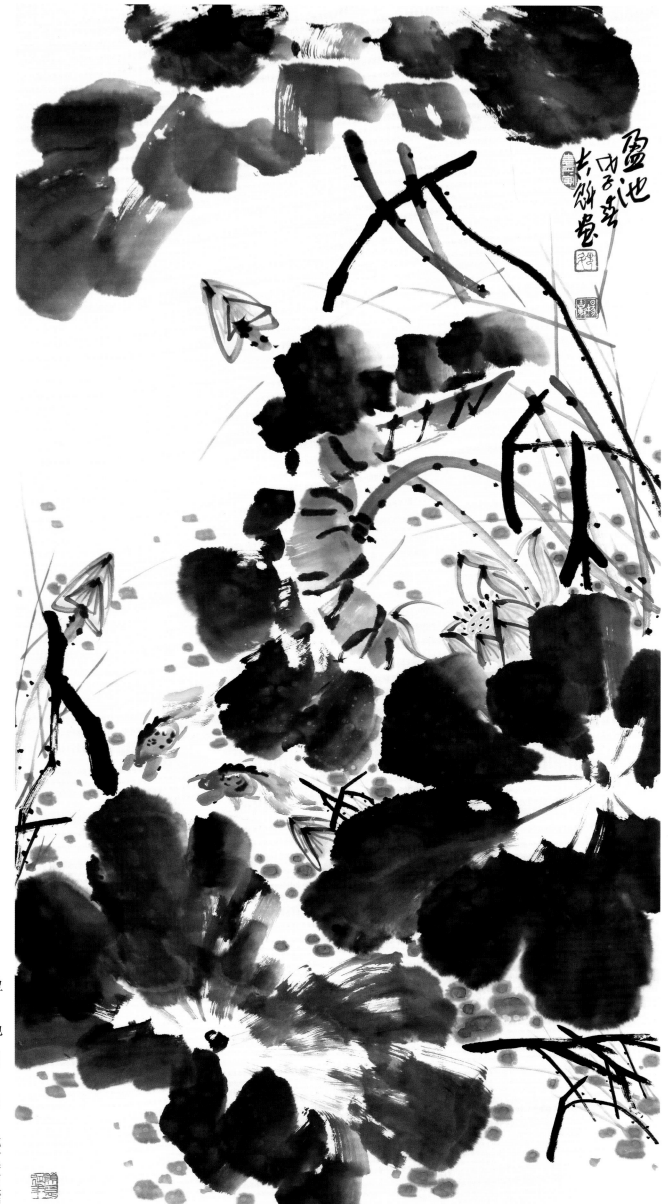

盈　池　137cm×70cm　戊子春吉魁画

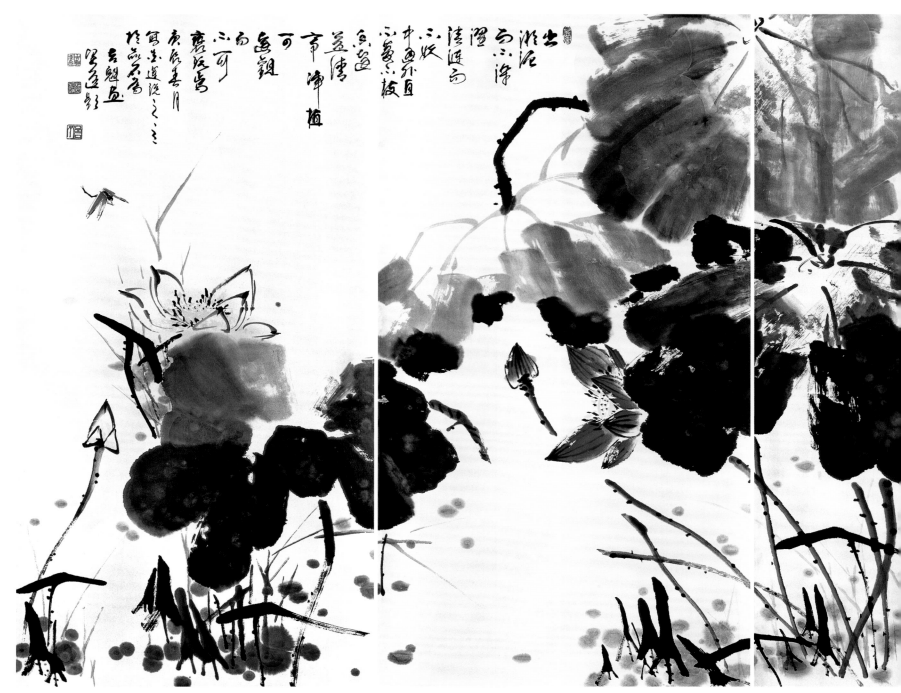

荷花通景

137cm × 70cm × 5

出淤泥而不染，濯清涟而不妖，中通外直，不蔓不枝，香远益清，亭亭净植，可远观而不可亵玩焉。

庚辰春月写《爱莲说》之意于品石斋　吉魁画望进题

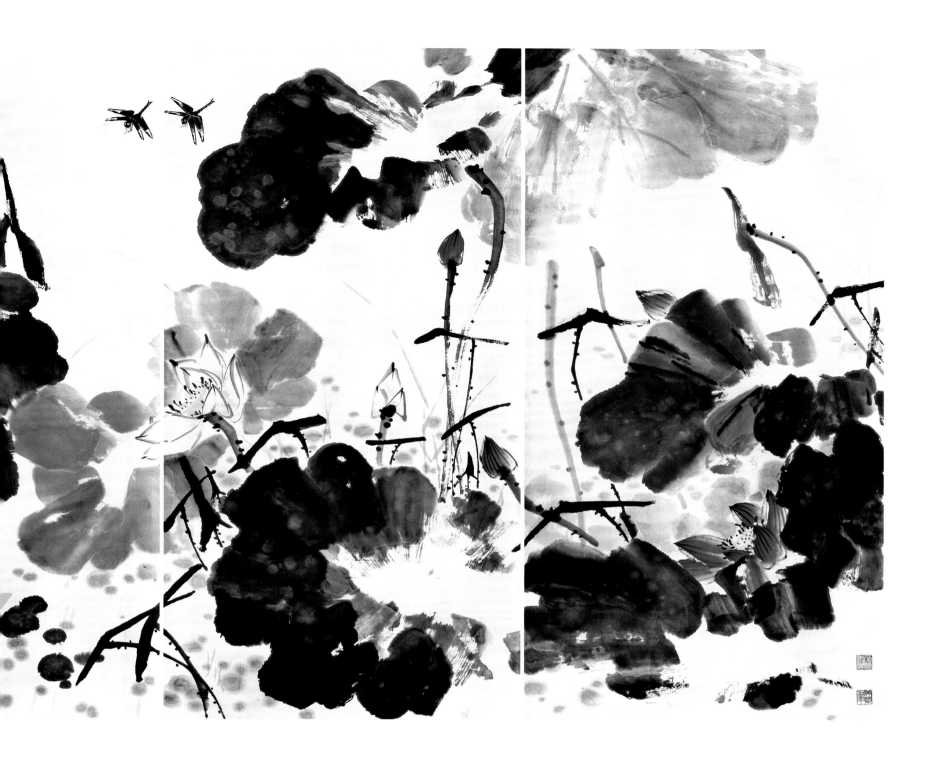

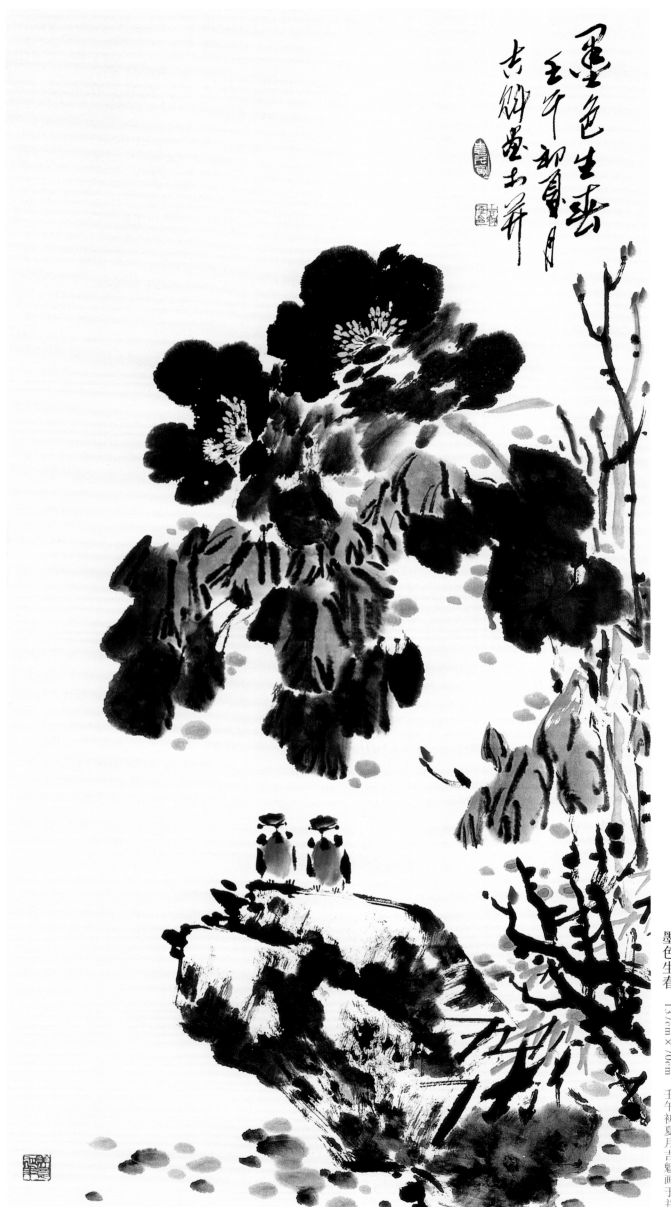

墨色生春　137cm×70cm　壬午初夏月吉魁画于并

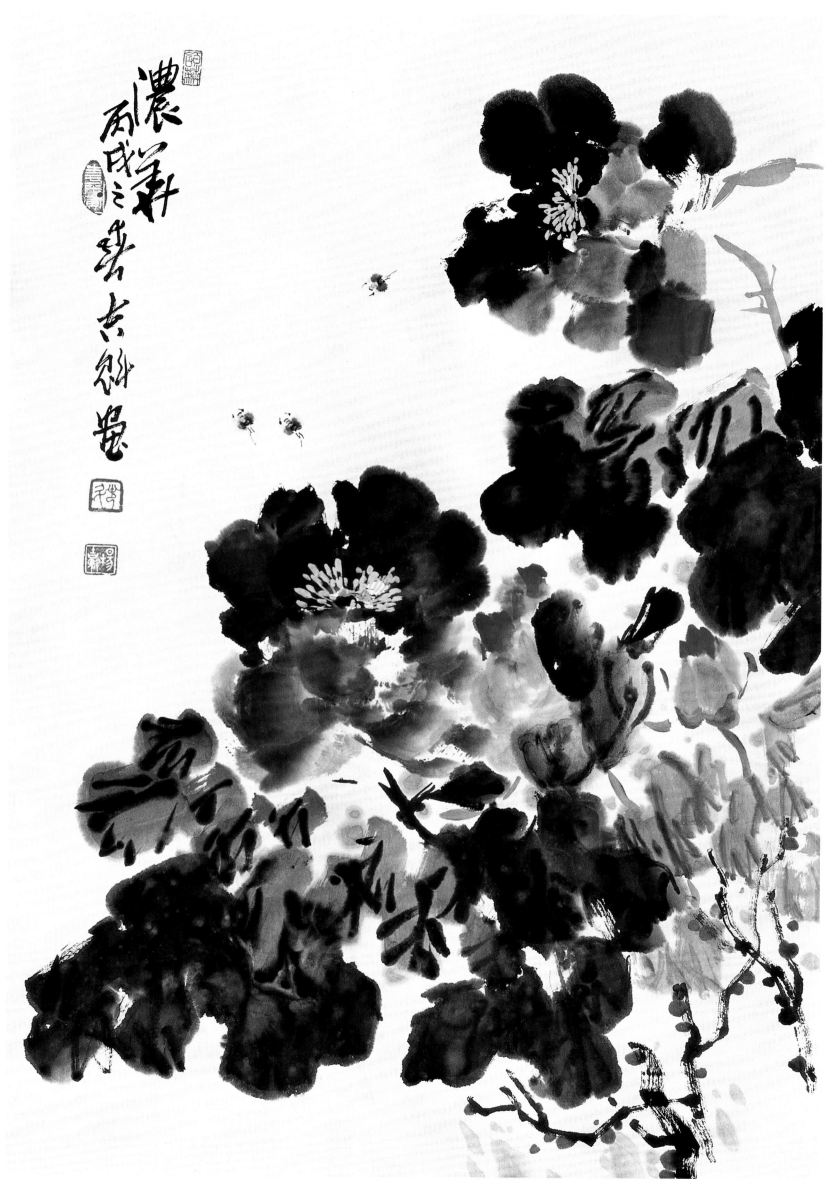

浓　华　90cm×70cm　丙戌之春吉魁画

咏牡丹

佳名唤作百花王，

姹紫嫣红遍洛阳。

笑料权谋空自绐，

逢春照旧吐芬芳。

——杨吉魁

昭阳明艳醉春容　意态天生无上红

137cm×70cm

庚寅春三月吉魁画于并

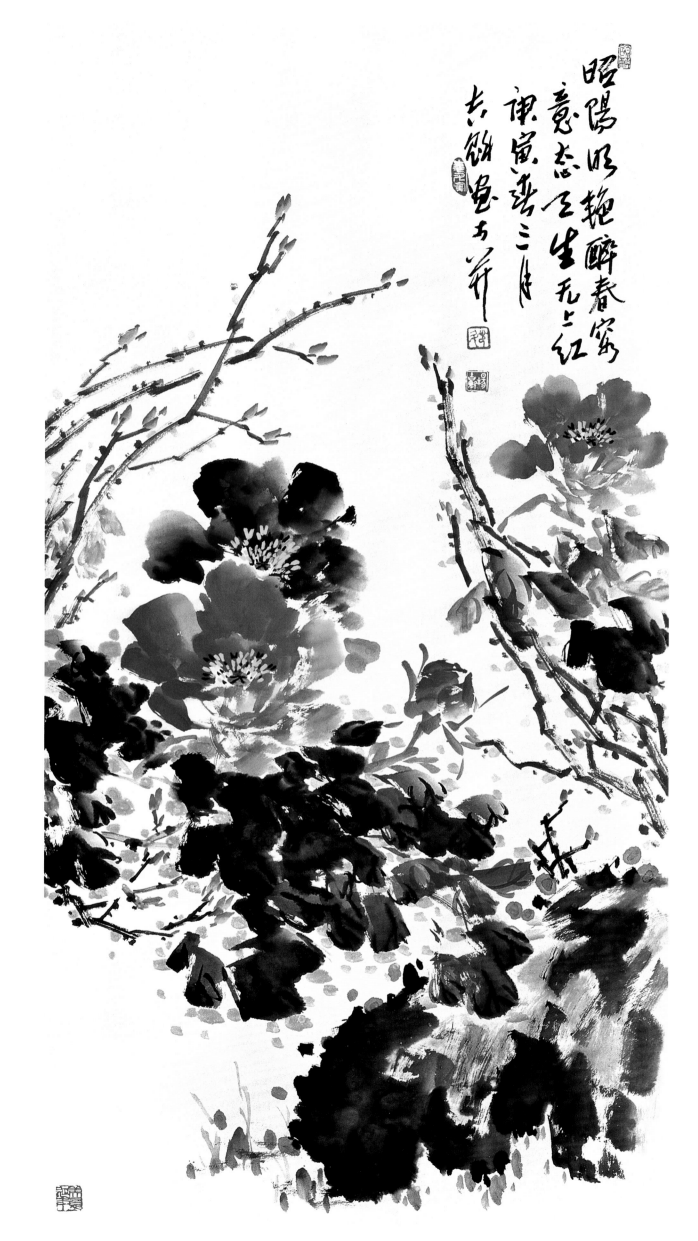

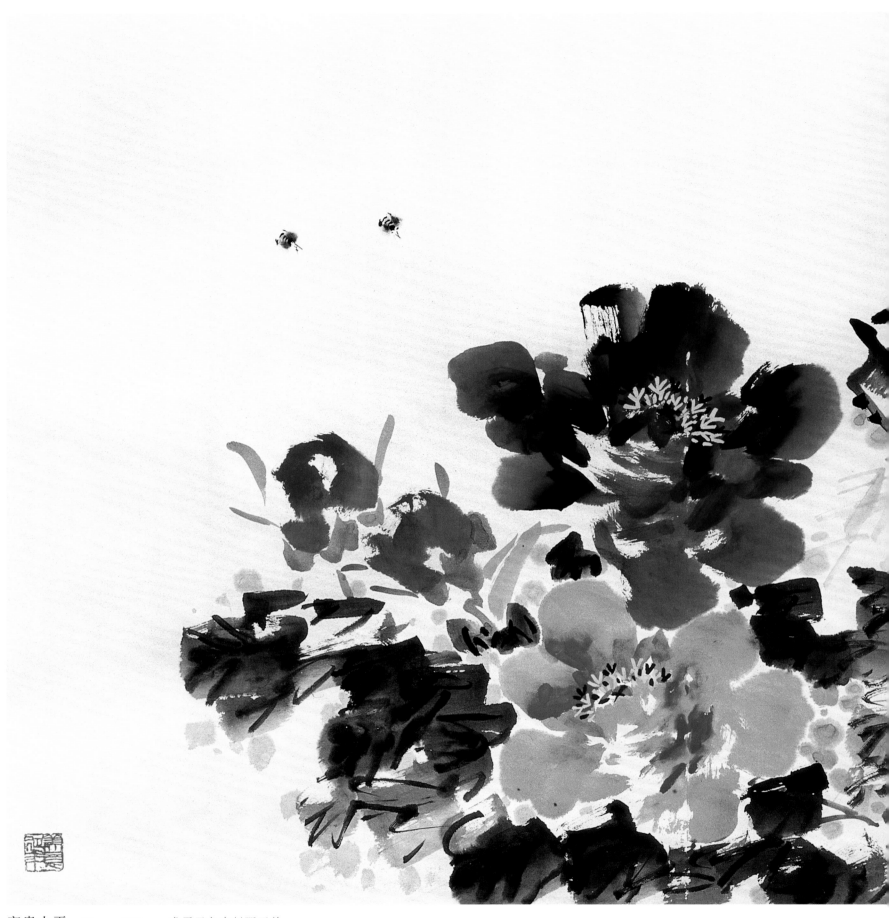

富贵太平　97cm×180cm　戊子孟冬吉魁画于并

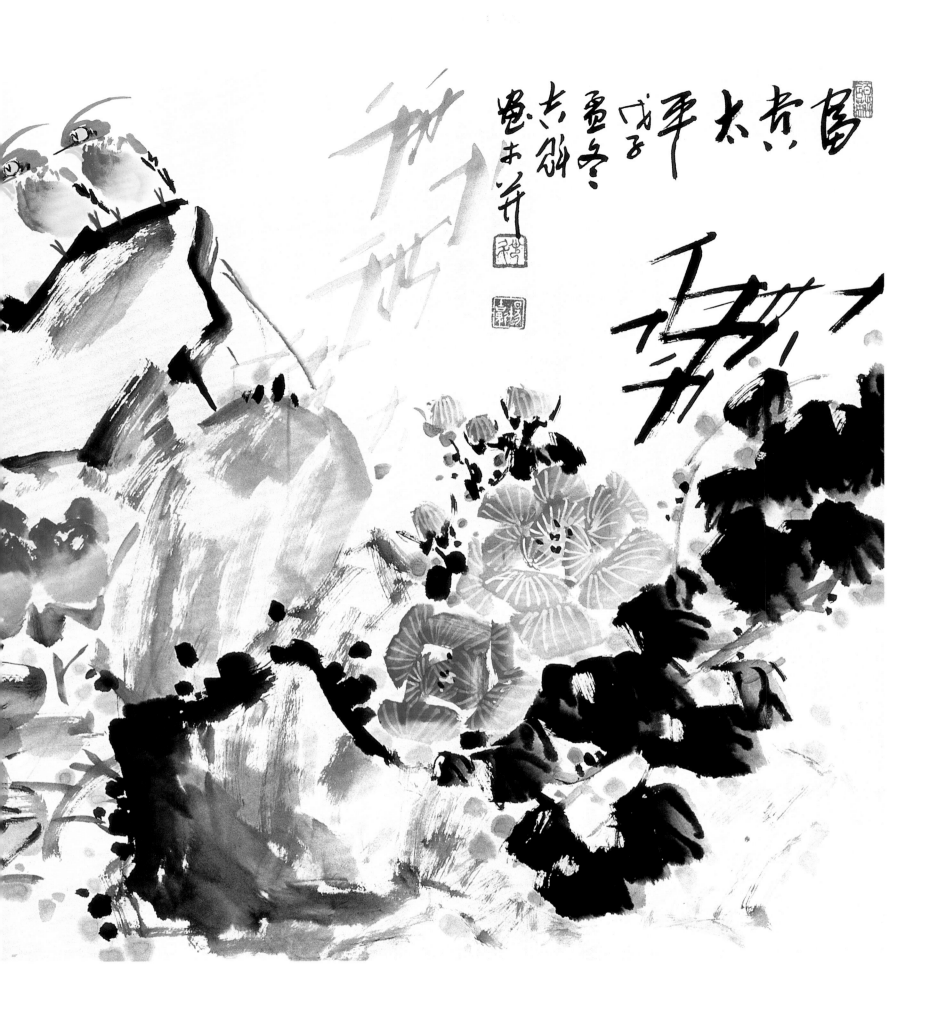

题画牡丹

富贵花开动洛城，

群芳岂敢与其争！

缘何女帝红颜怒，

倒使英贤抱不平。

——杨吉魁

富贵长寿

137cm×70cm

庚寅春吉魁画

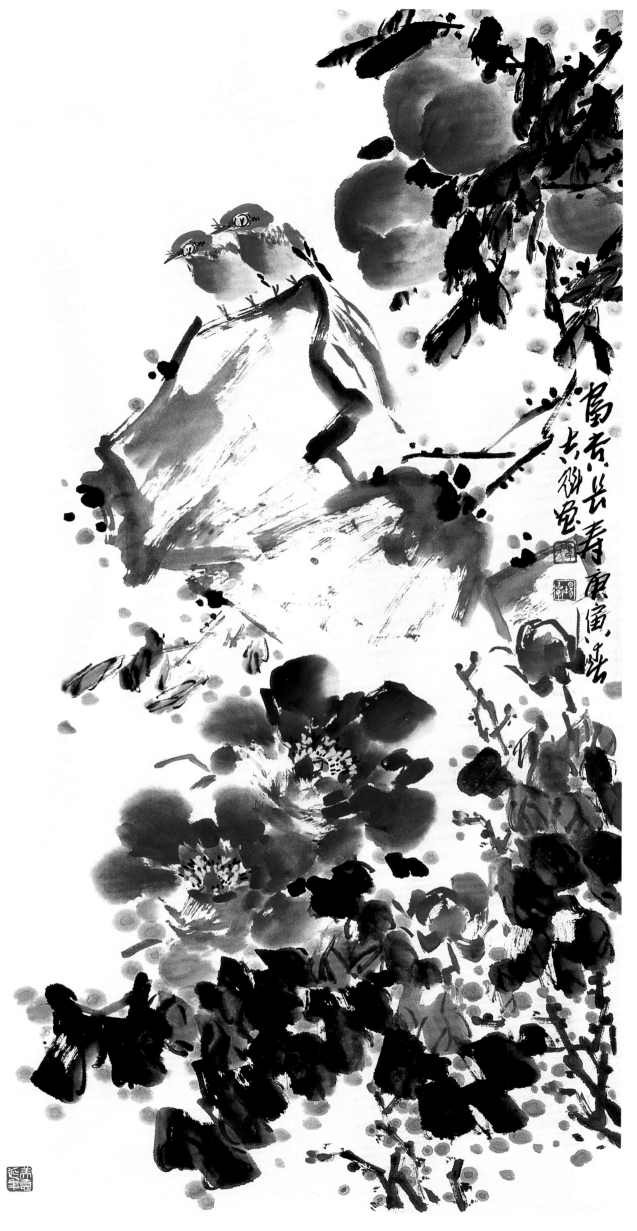

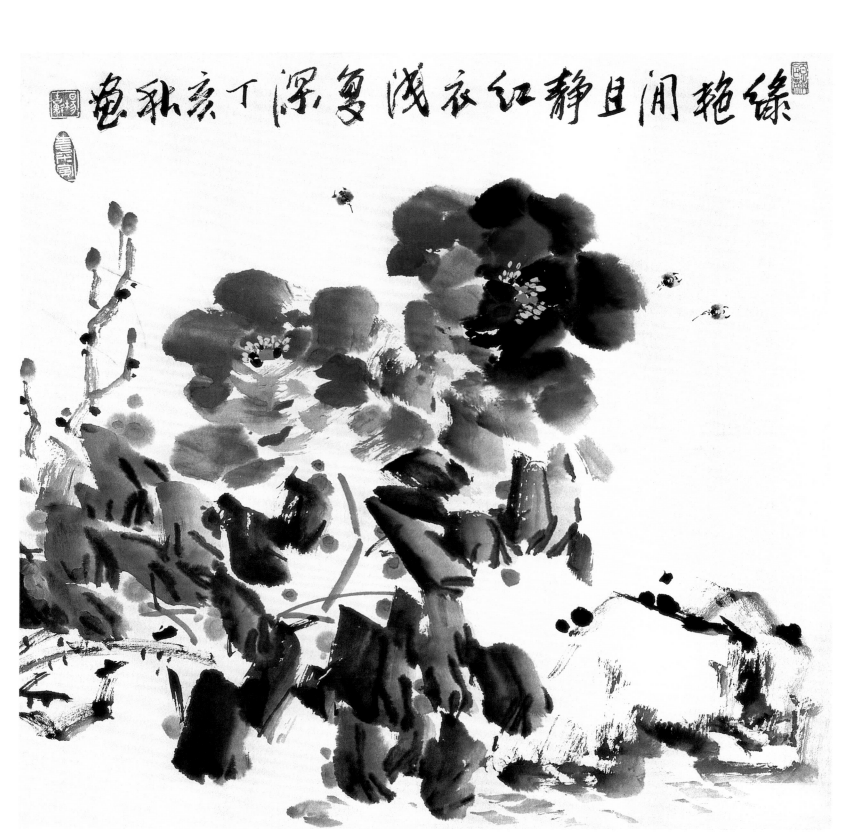

绿艳闲且静　红衣浅复深　68cm×68cm　丁亥秋画

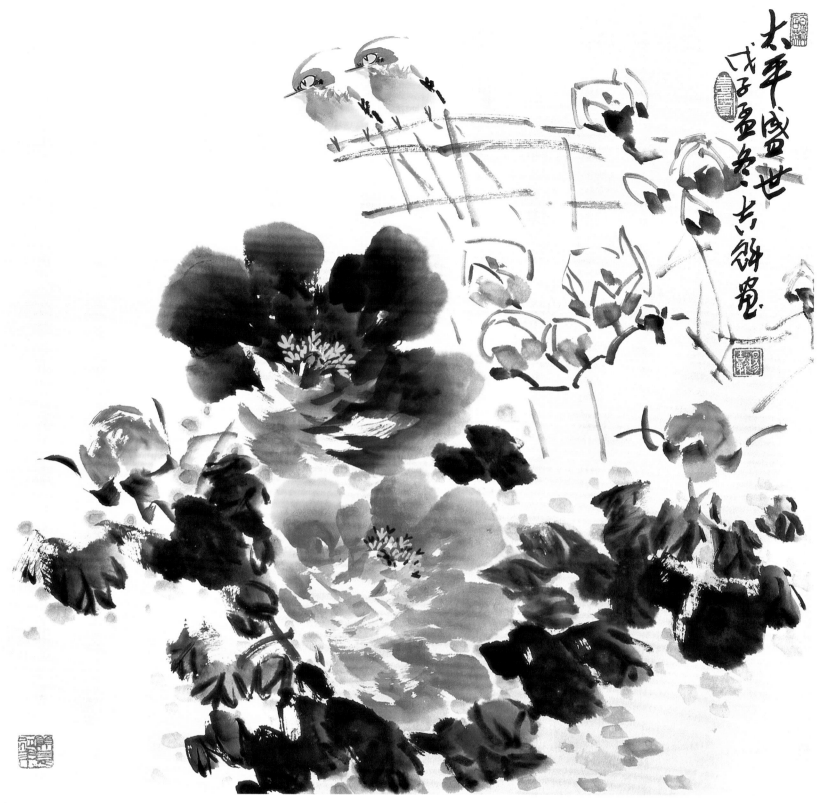

太平盛世　68cm×68cm　戊子孟冬吉魁画

题白牡丹

胭脂不买省银钱，
只好双勾画牡丹。
面世休夸姿态俏，
奇花自有色得天。

——杨吉魁

春 意 浓

137cm × 70cm

辛卯吉魁画

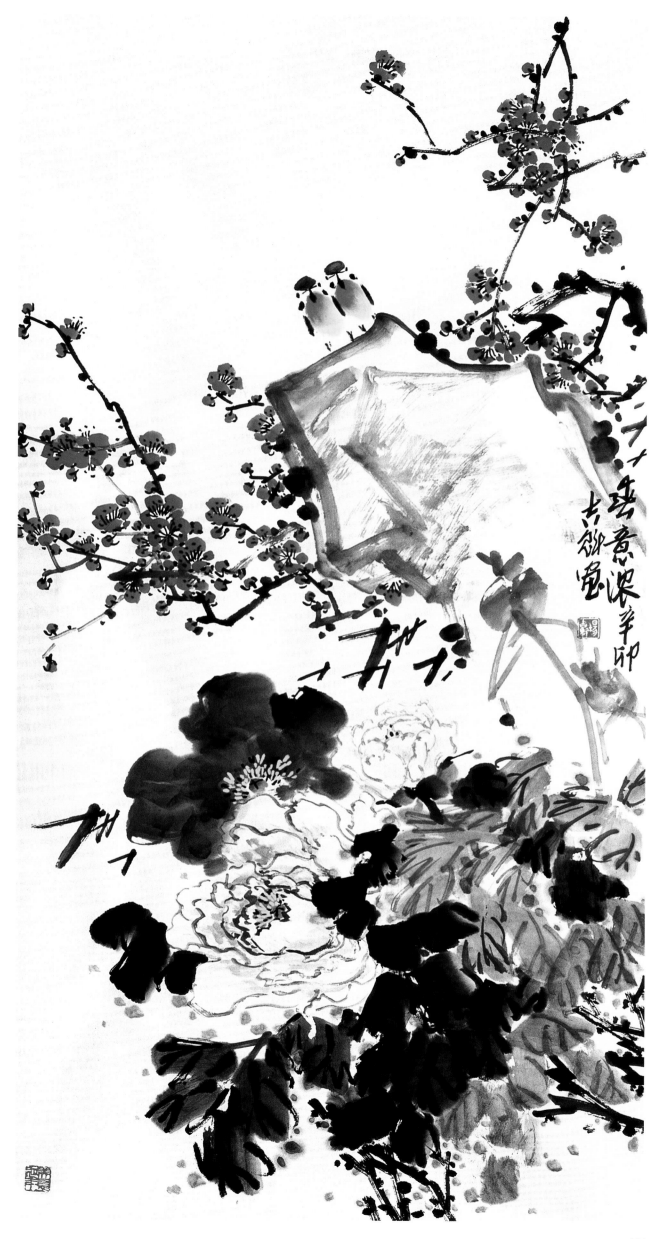

题画

神魂出画卷，
境界满诗篇。
抒尽心中意，
功夫在后天。

——杨吉魁

长 春 图

137cm×35cm

一九九三年冬月吉魁画

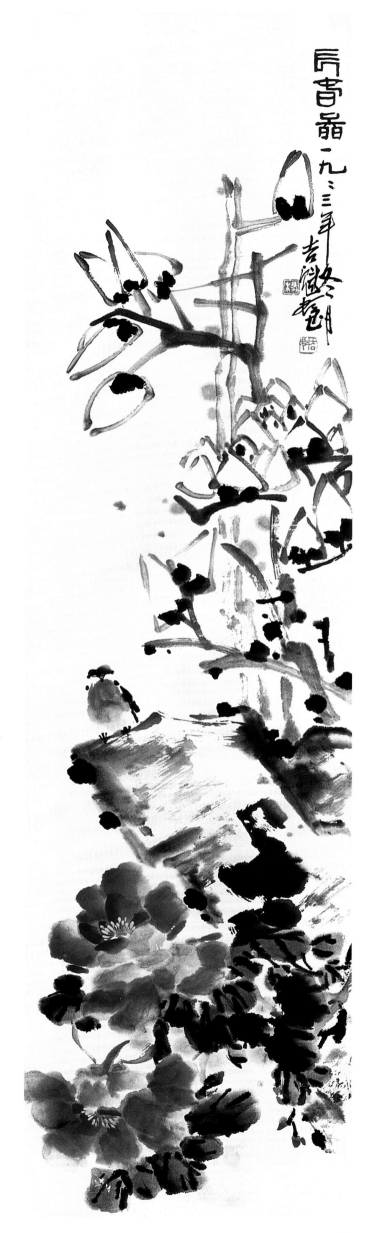

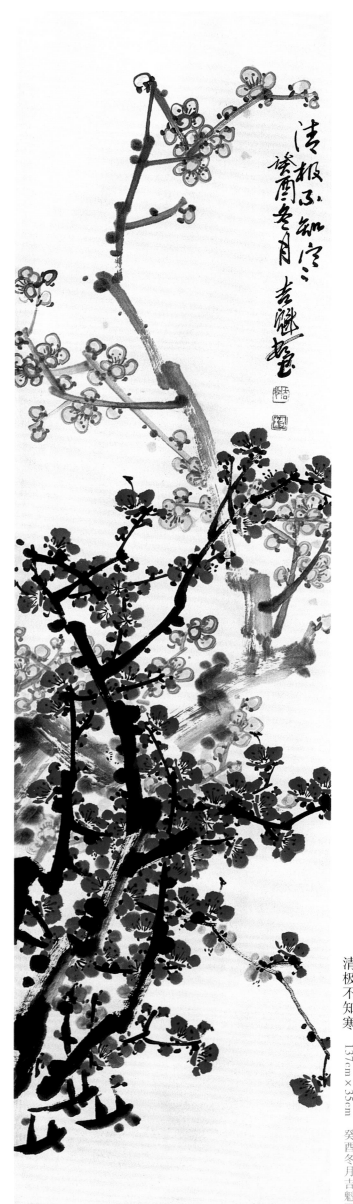

清极不知寒

137cm×35cm 癸酉冬月吉魁画

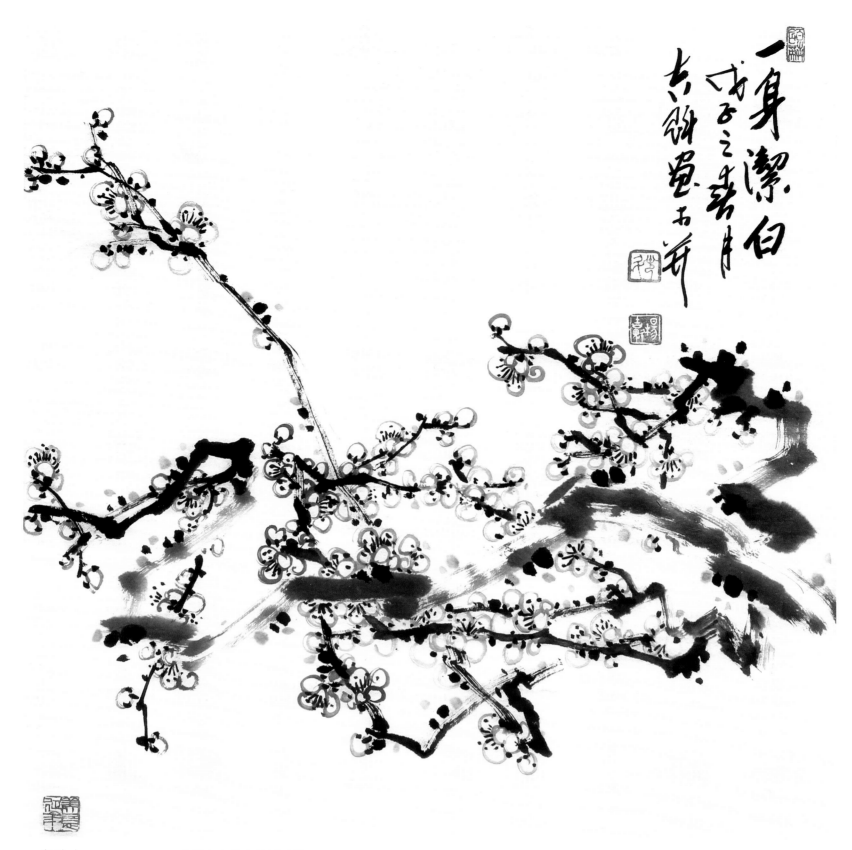

一身洁白　68cm×68cm　戊子之春月吉魁画于并

画梅

淡墨皴擦老树身，

嫣红点瓣报新春。

高洁自古名家颂，

爱画梅花步后尘。

——杨吉魁

暗香疏影

137cm×70cm

己丑年夏吉魁画

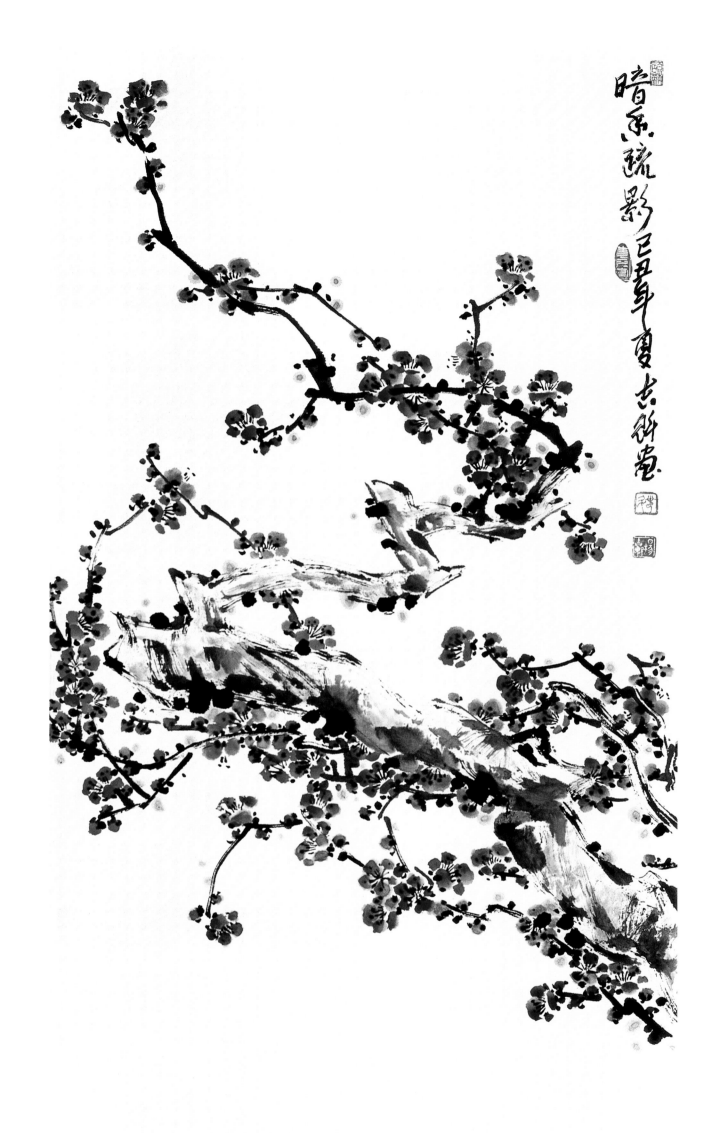

暗香疏影 己丑年夏志群畫

题画梅

高标逸韵避尘埃，
腕底风流任选裁。
铁骨琼枝能傲雪，
馨香远布苦寒来。

——杨吉魁

华中气节最高坚

137cm × 70cm

戊子孟冬吉魁画于品石斋

萬氣中節最高堅壁守全歲寒冬志慮無邪品石

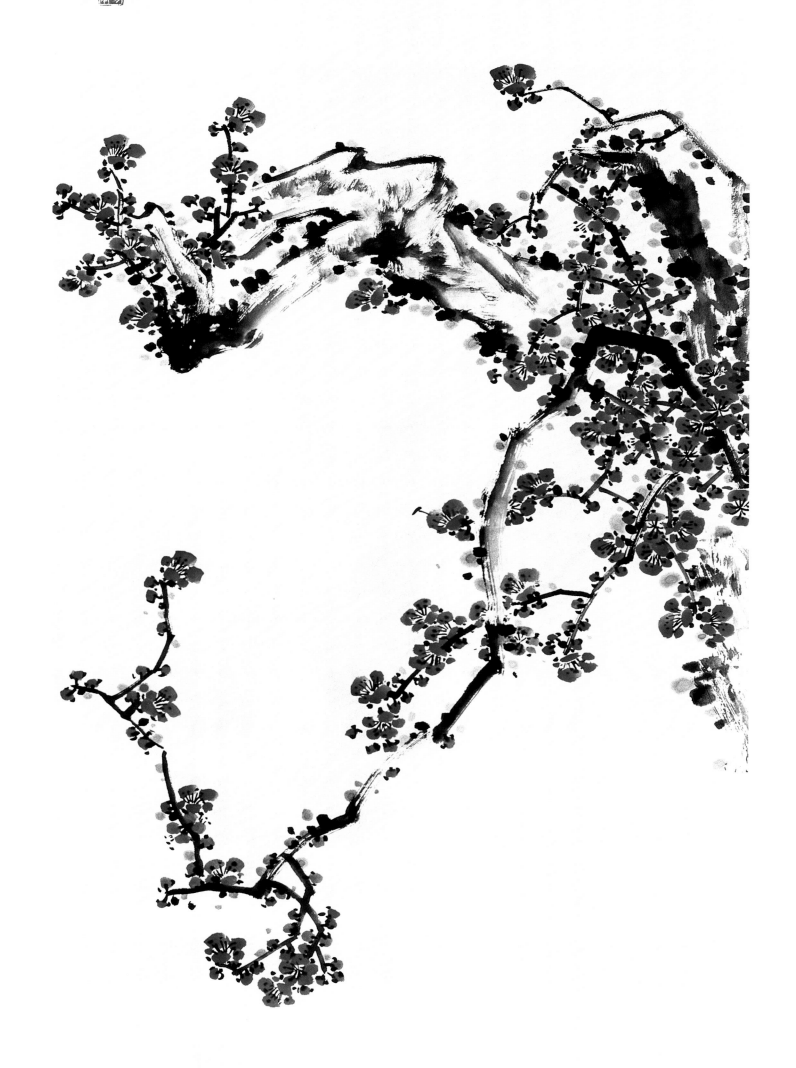

贞姿灿烂（局部）

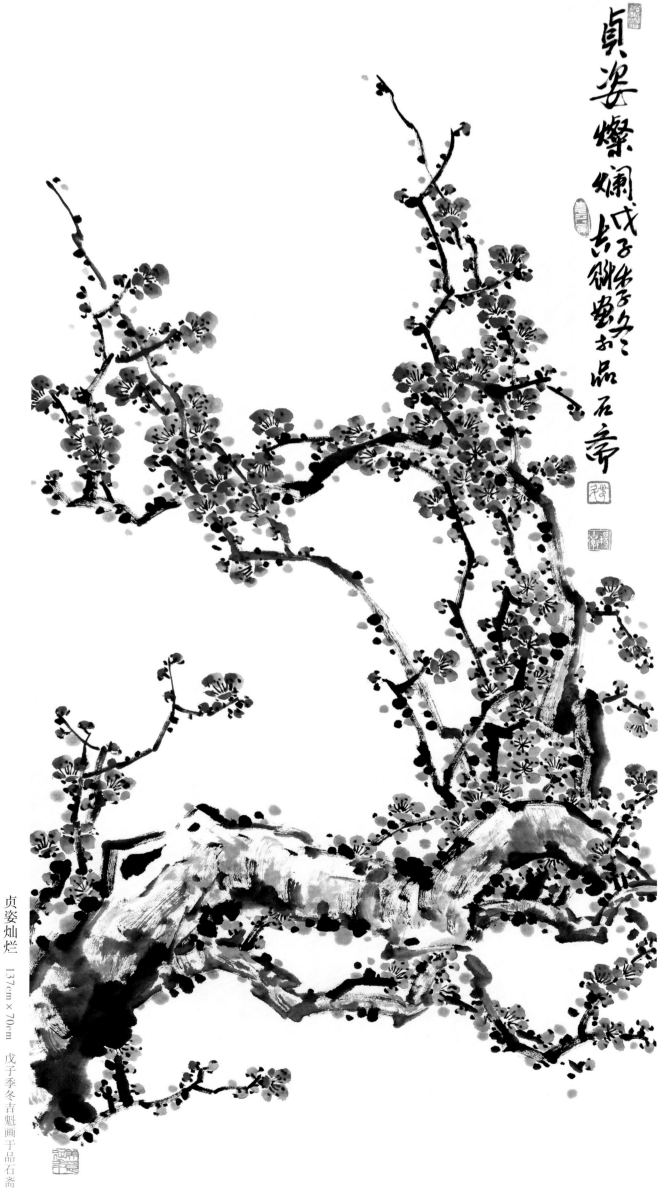

貞姿燦爛 戊子吉魁數之品石齋

貞姿燦爛　137cm×70cm　戊子季冬吉魁画于品石齋

画鸡冠花

冠冕堂皇绿羽齐，
天明起舞不闻啼。
谁知草木学欺世，
惯会乔装落架鸡。

——杨吉魁

秋　艳

137cm×70cm

己卯初冬吉魁画于并

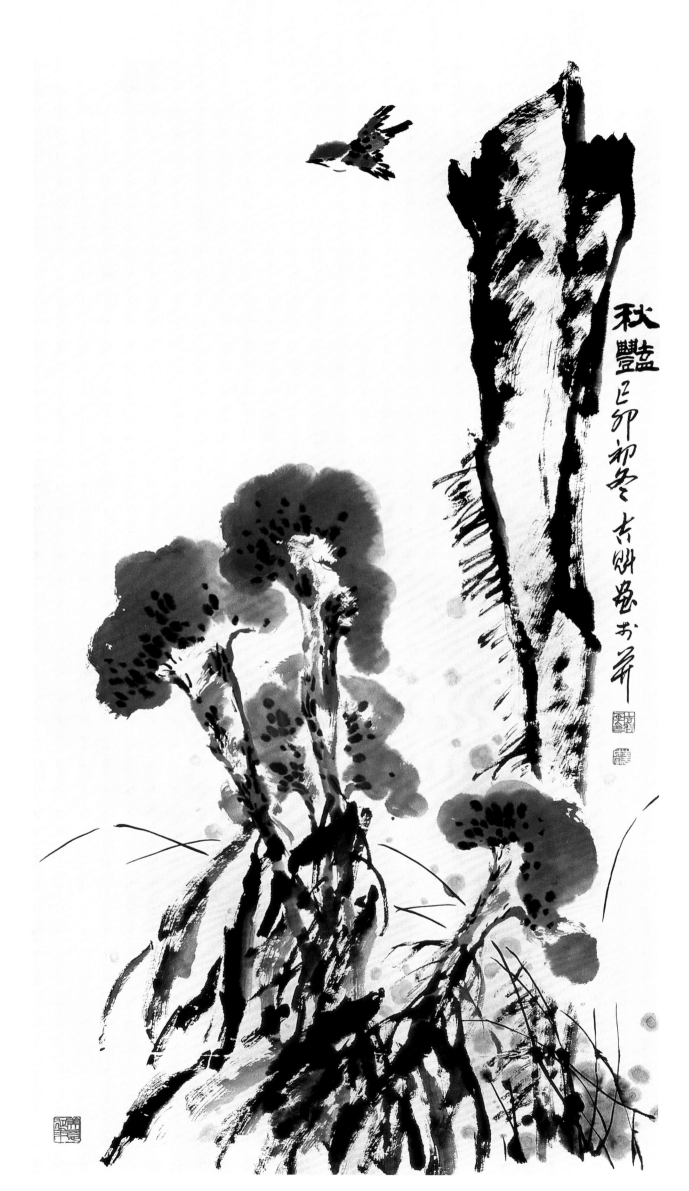

秋豔

己卯初冬
古黟墨君書于昇

青松赞

傲骨一身是此公，

风饕雪虐上苍穹。

雄姿浩气山中见，

叶茂枝繁自郁葱。

——杨吉魁

三 友 图

137cm×35cm

己巳冬月吉魁画

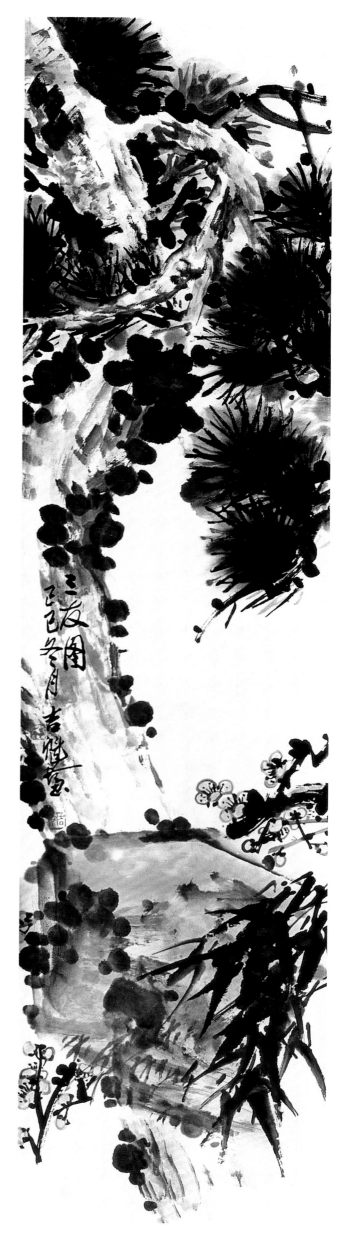

画菊

篱下一枝带露斜，

金英翠叶若人夸。

蕊寒不与蝶为伍，

铁骨霜姿笑物华。

——杨吉魁

君子之风

68cm×68cm

丁丑夏吉魁画于太原

兰馨菊秀

一九九八年秋奠中题

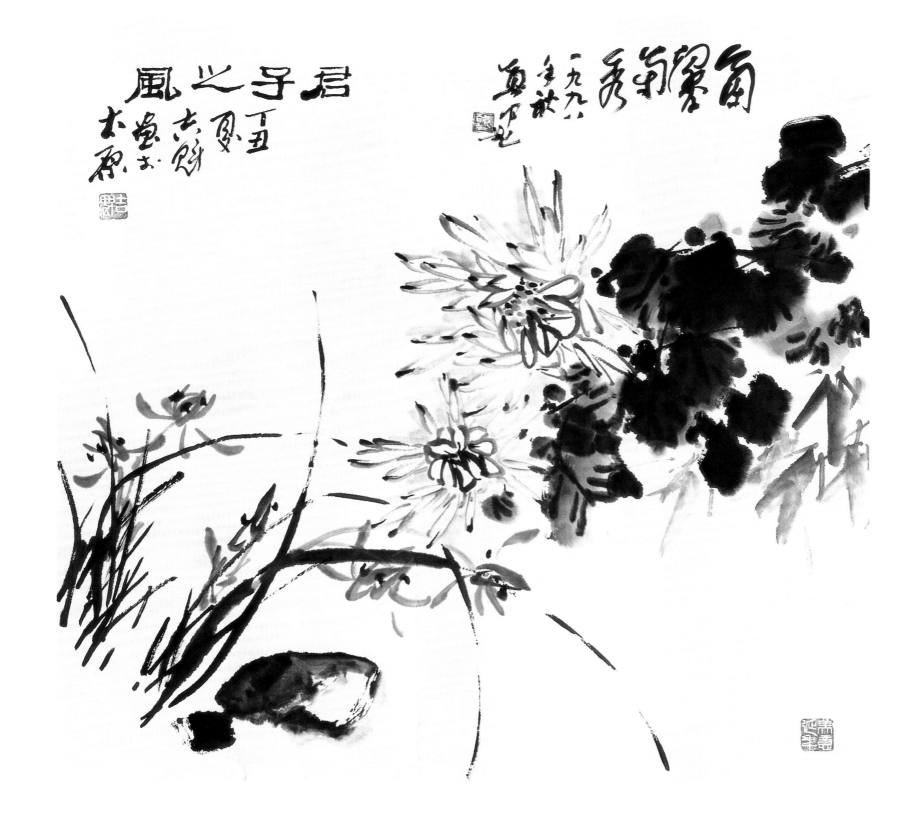

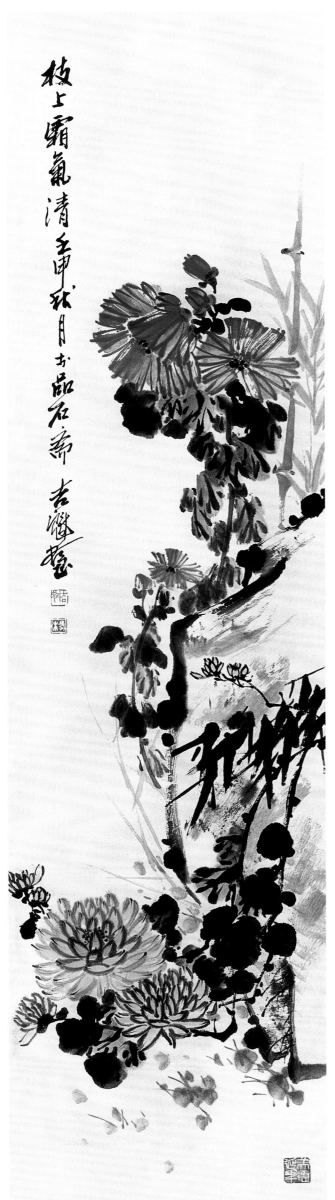

枝上霜气清　137cm×35cm　壬申秋月于品石斋吉魁画

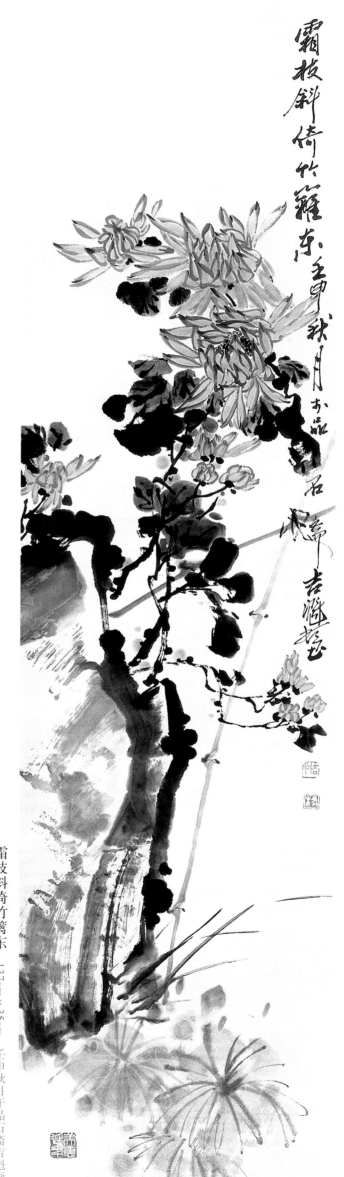

霜枝斜倚竹篱东　137cm×35cm　壬申秋月于品石斋吉魁画

95

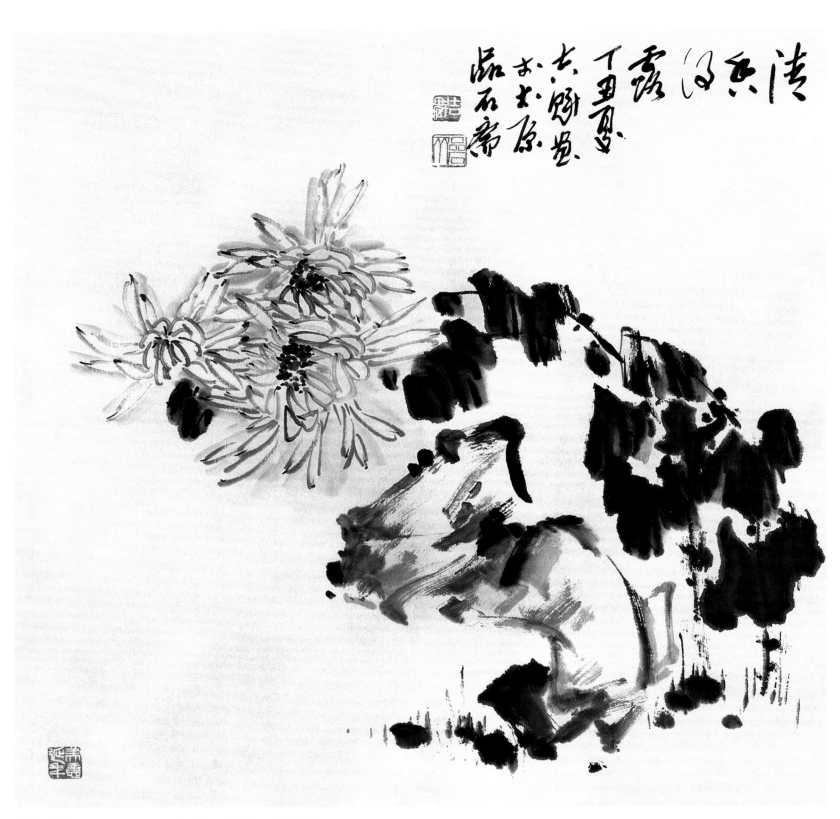

清香得露　68cm×68cm　丁丑夏吉魁画于太原品石斋

己卯金秋十月大庆之季吉魁画于太原

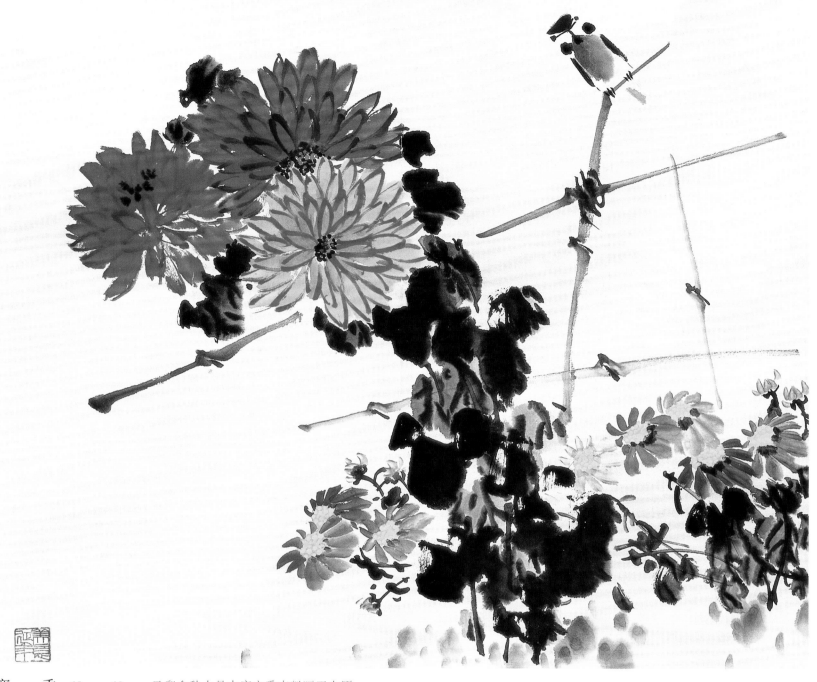

寒　　香　68cm×68cm　己卯金秋十月大庆之季吉魁画于太原

画痴

光阴荏苒见时钟，

绘画痴心兴趣浓。

欲立新风求墨韵，

情激砚岸写苍松。

——杨吉魁

富贵长春

137cm×70cm

庚寅十月二十四日吉魁画

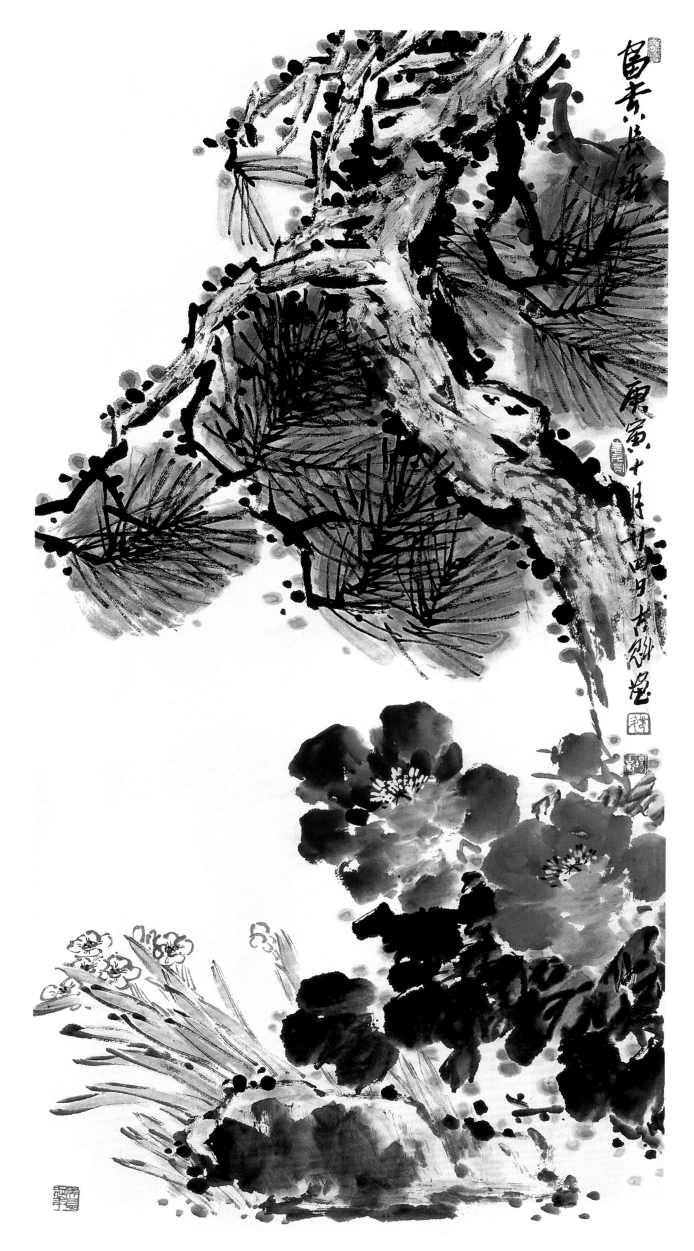

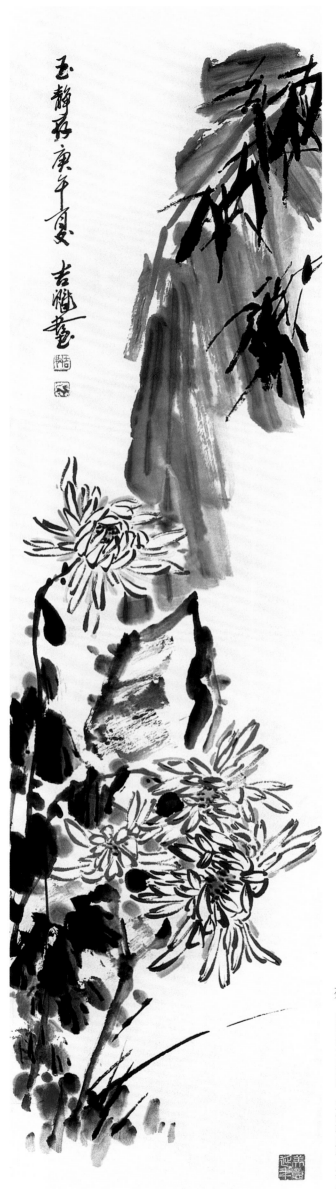

菊　137cm×35cm　玉静存庚午夏吉魁画

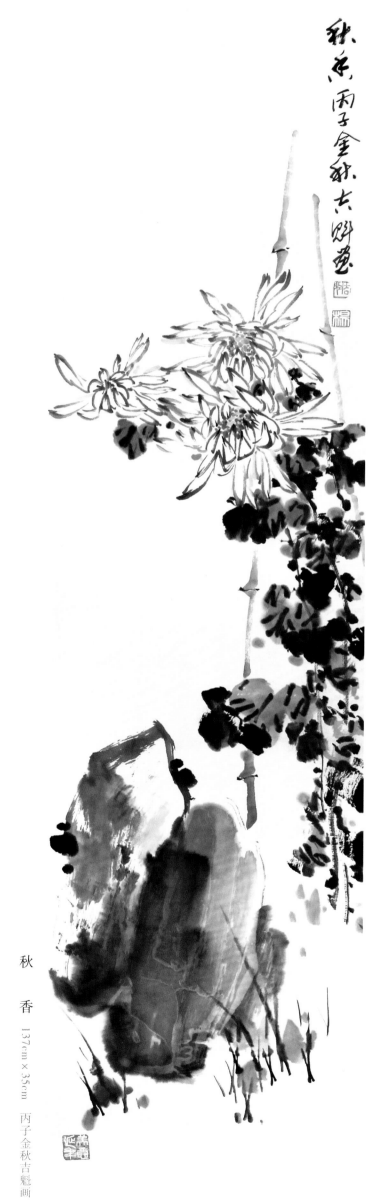

秋水 丙子金秋 吉魁画

秋　香　137cm×35cm　丙子金秋吉魁画

101

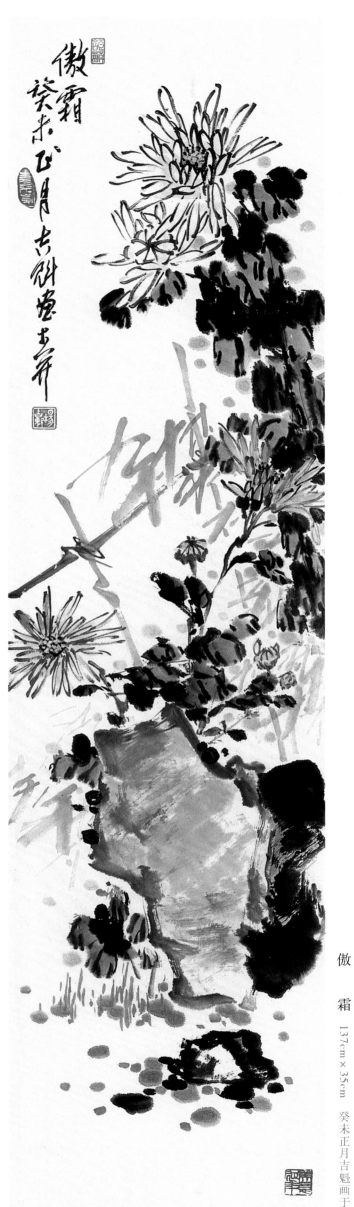

傲

霜　137cm×35cm　癸未正月吉魁画于并

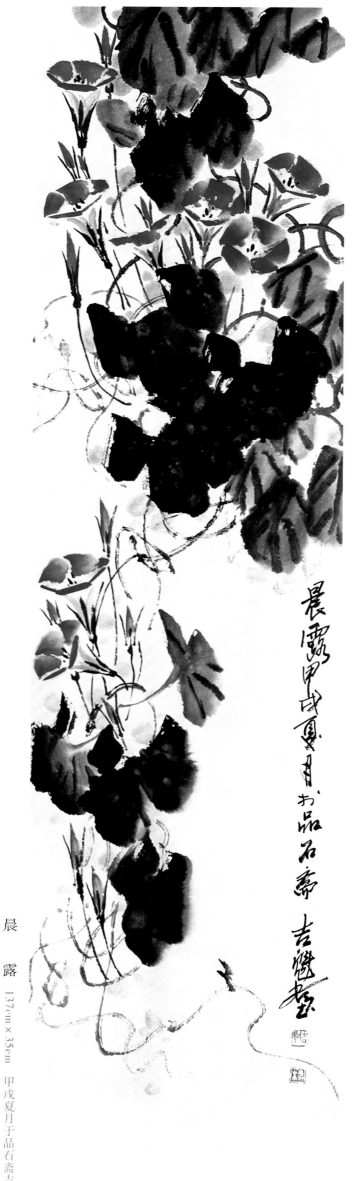

晨　露　137cm×35cm　甲戌夏月于品石斋吉魁画

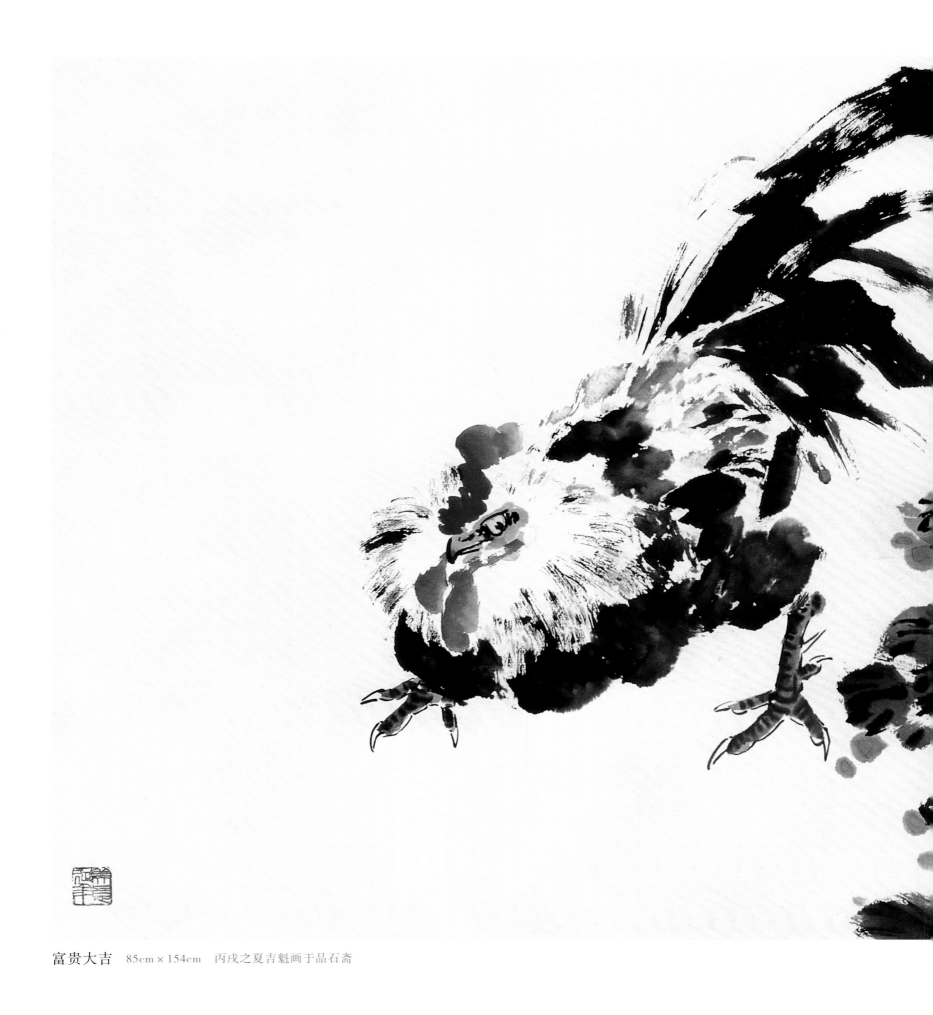

富贵大吉　85cm×154cm　丙戌之夏吉魁画于品石斋

富貴大吉者 丙戌之夏吉齋書 品石齋

画鸡

红冠锦羽见精神，

风侣鸾俦作化身。

不必天明闻汝唱，

吉祥献瑞胜司晨。

——杨吉魁

春鸡唱晓

137cm×70cm

辛卯正月吉魁画于并

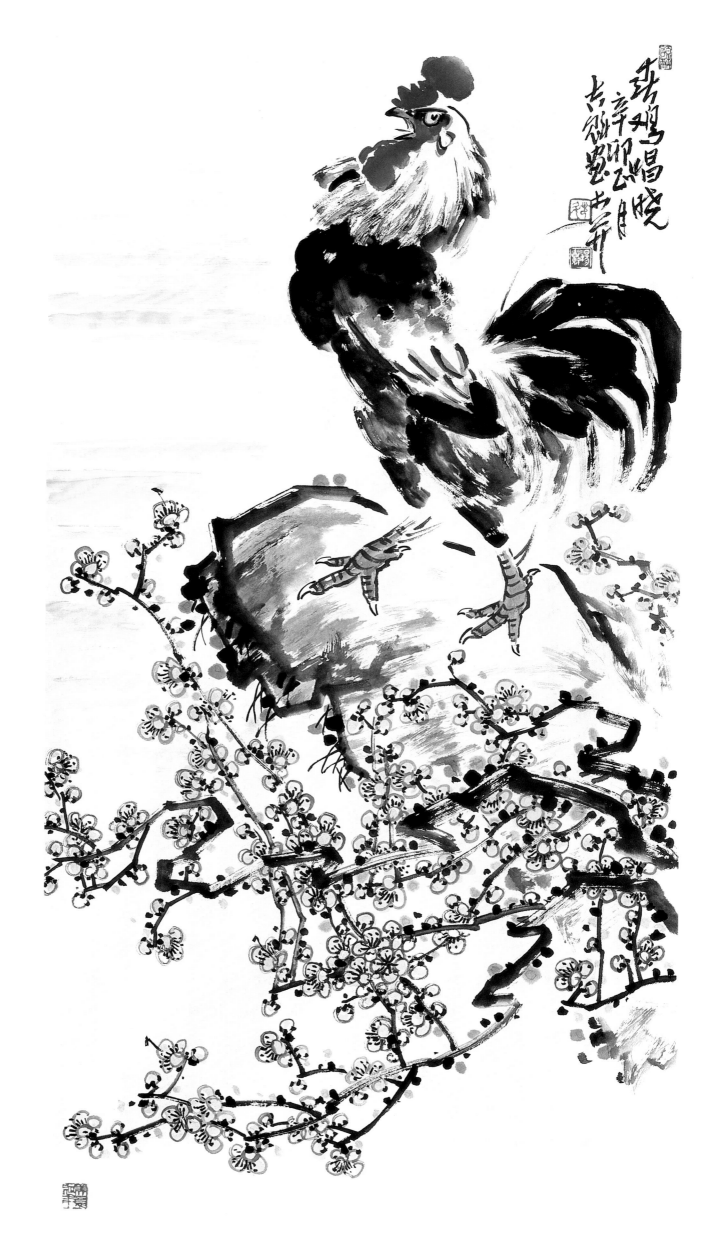

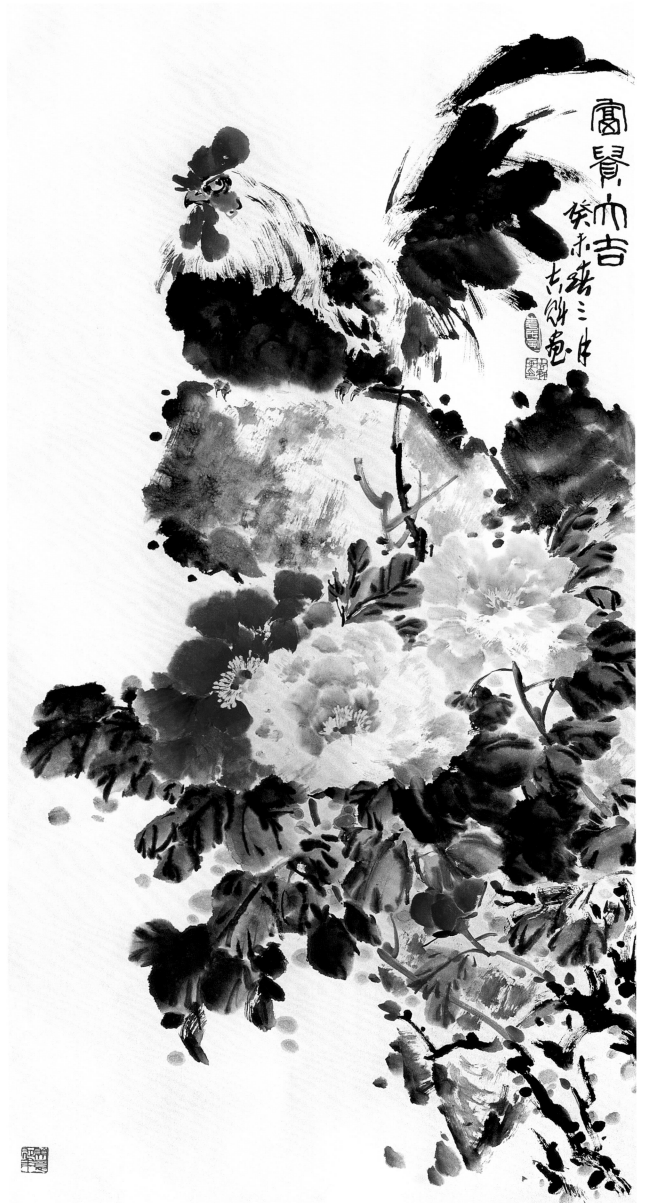

富贵大吉　137cm×70cm　癸未春三月吉魁画

催人奋进是清晨

催人奋进是清晨　137cm×70cm　庚寅夏月吉魁画

画大公鸡

峨冠锦羽气轩昂，

阔步追逐态势狂。

可贵通身集五德，

赢得妙手绘吉祥。

——杨吉魁

丁丑大吉

137cm×70cm

吉魁画于品石斋

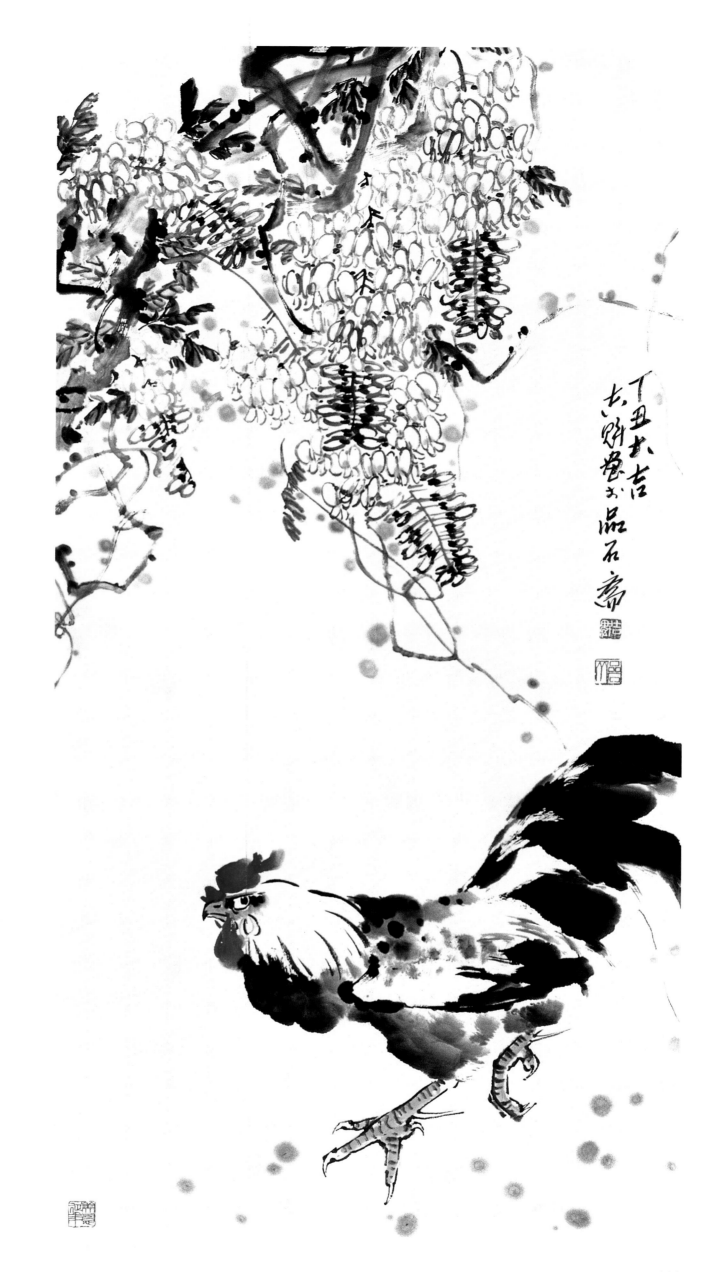

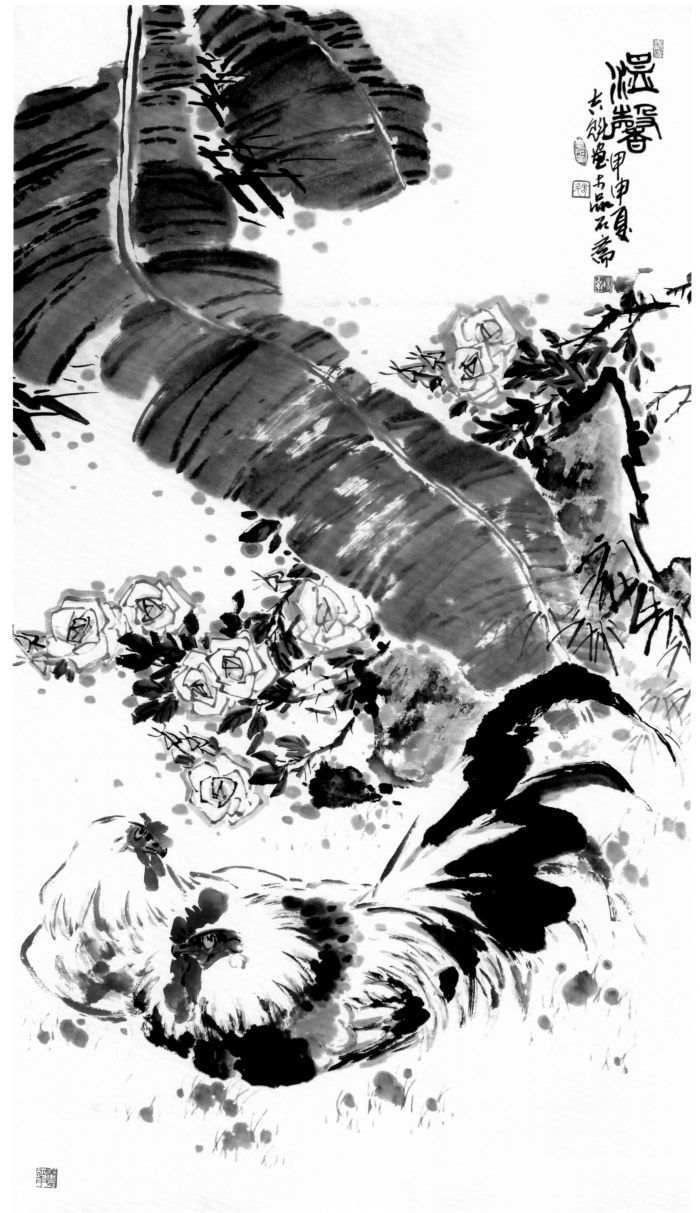

温　馨　180cm×97cm　甲申夏吉魁画于品石斋

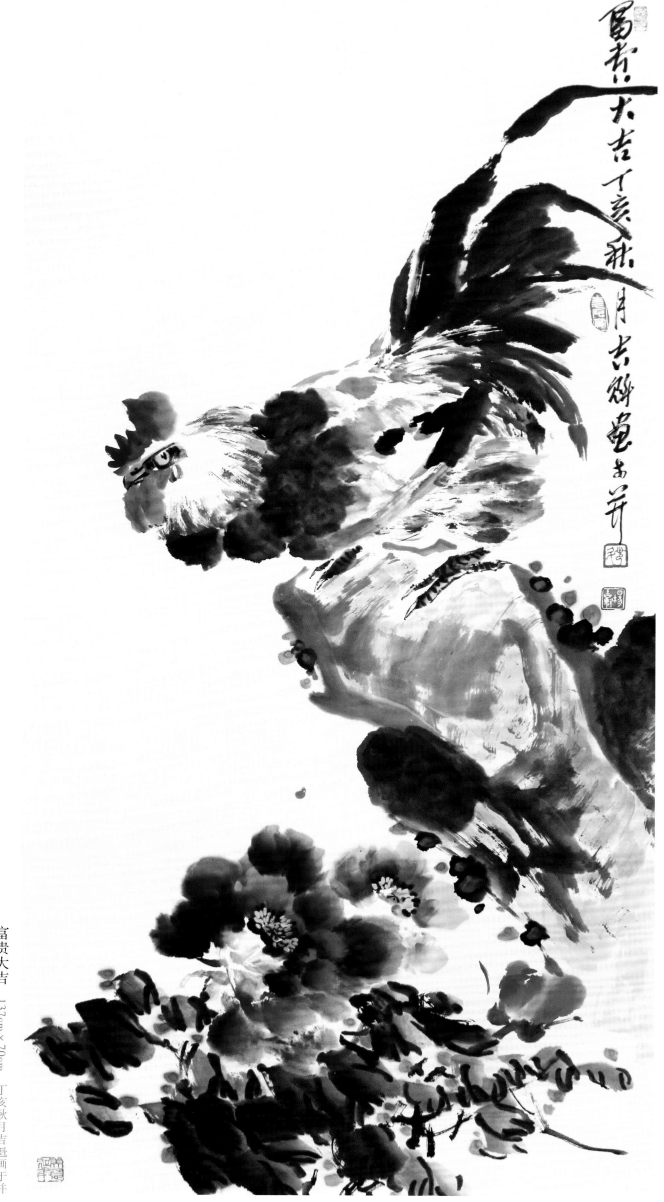

富贵大吉　137cm×70cm　丁亥秋月吉魁画于并

画菊

黄花傲世不招摇，
惯傍东篱处处娇。
写就英姿瞧仔细，
平生顿悟未折腰。

——杨吉魁

清景芳菊　吉祥如意

137cm×70cm

庚寅夏吉魁画

114

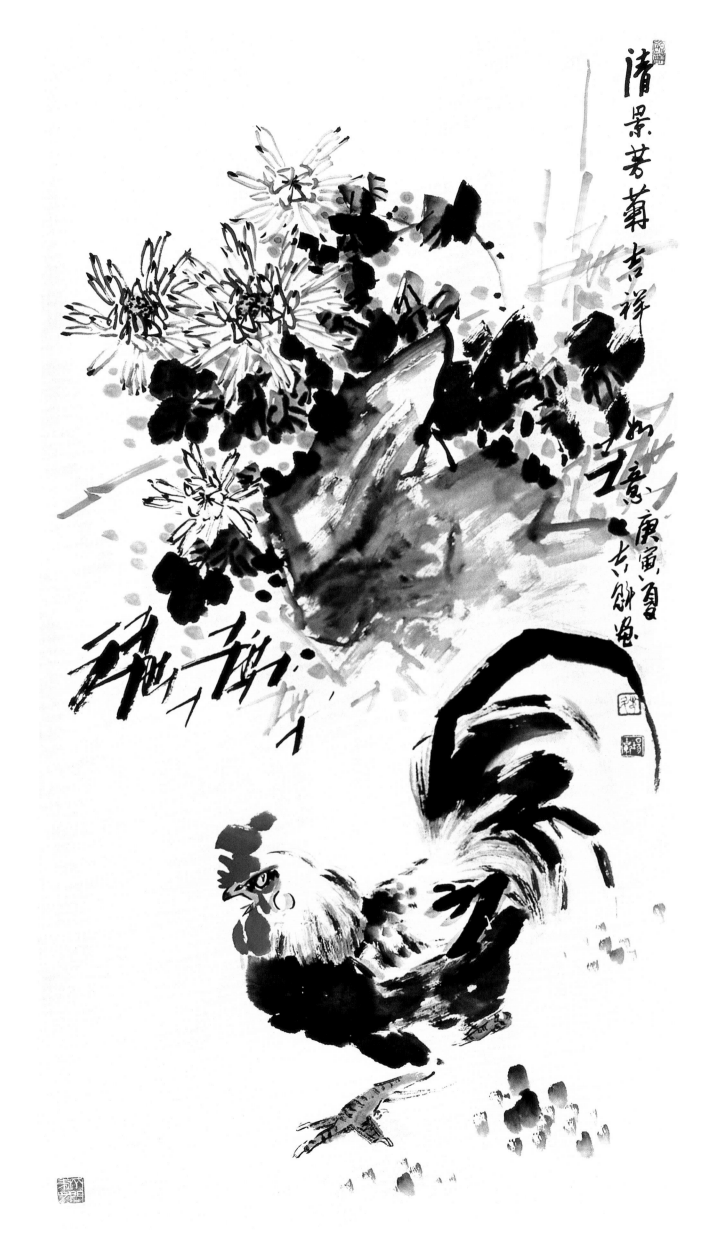

清景芳菊吉祥如意 庚寅夏 志鹏画

115

画褐马鸡

索稿庞泉远有时，
珍禽妙造伴松枝。
今朝笔下留稀世，
礼赞还应自作诗。

——杨吉魁

富贵珍禽天下惜

137cm × 69cm

庚寅春吉魁画于并

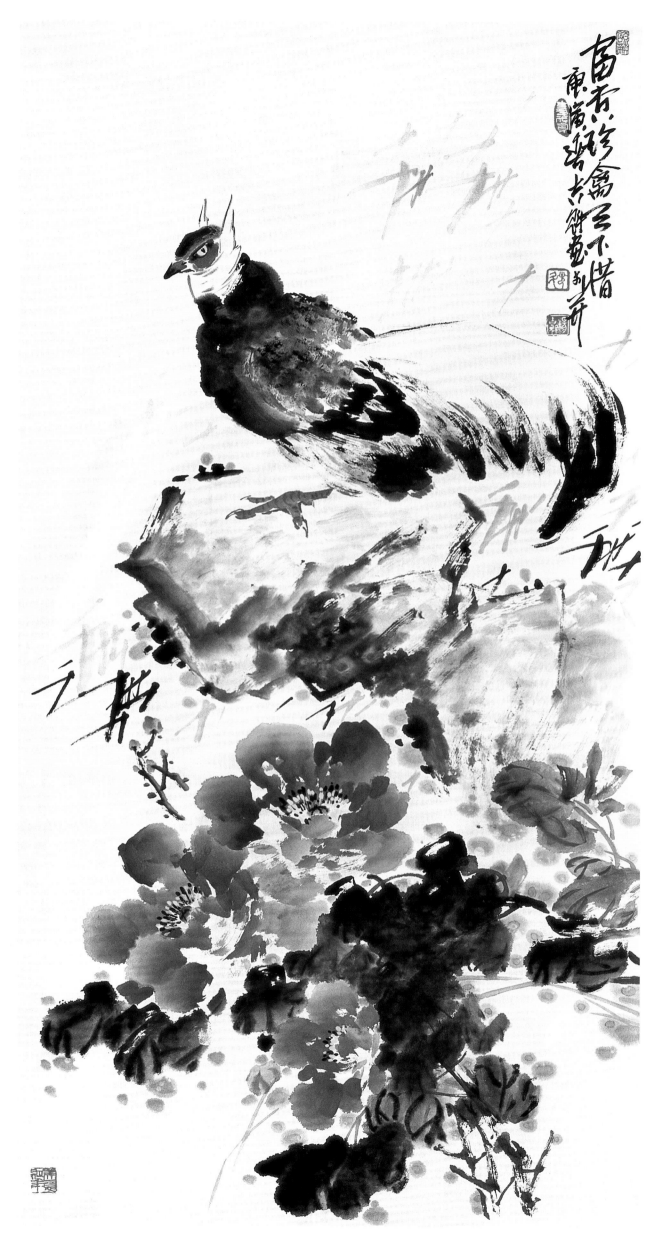

117

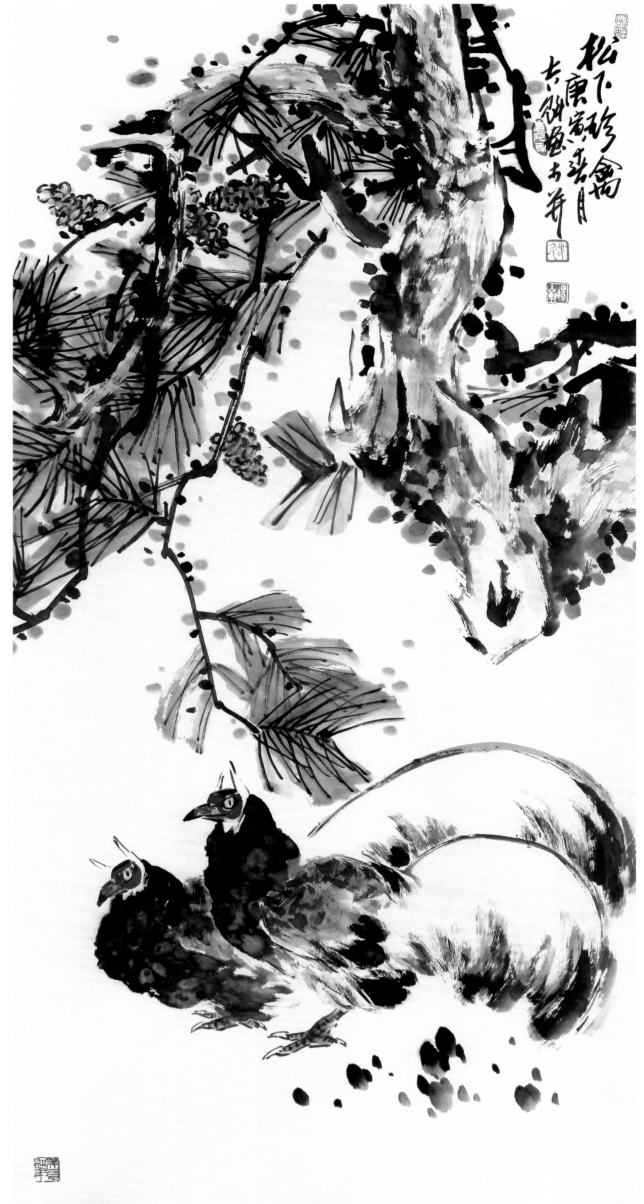

松下珍禽　137cm×70cm　庚寅春月吉魁画于并

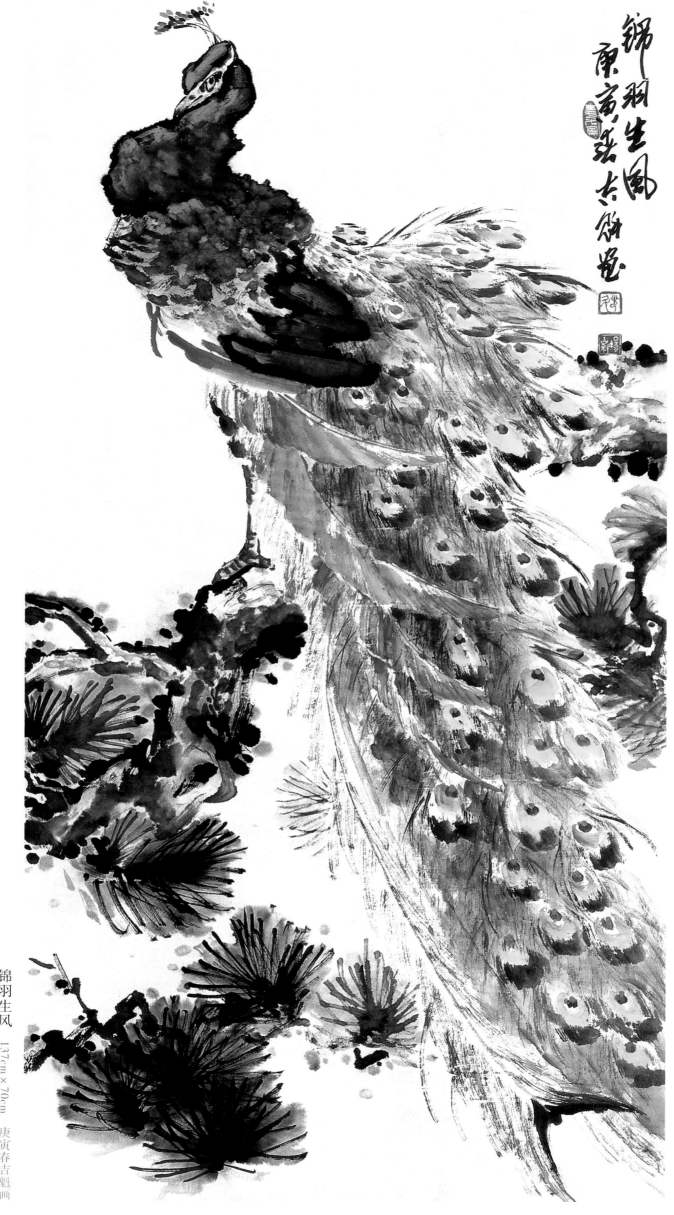

锦羽生风　137cm×70cm　庚寅春吉魁画

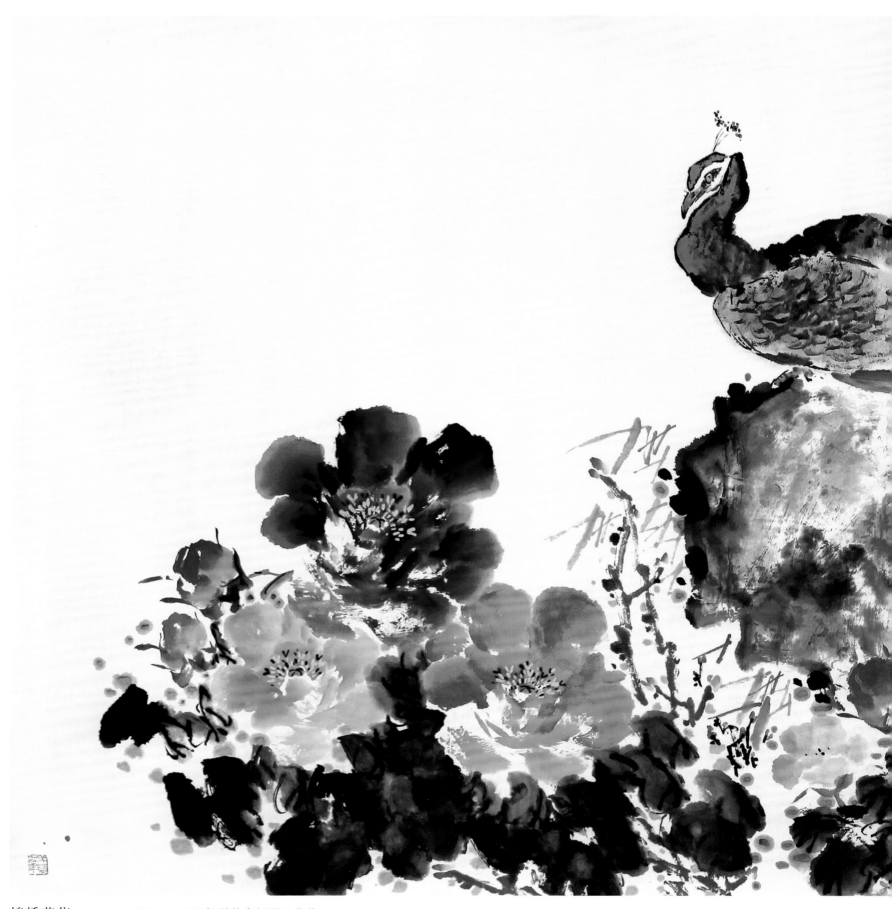

锦绣荣华 124cm×280cm 乙丑年夏月吉魁画于北美

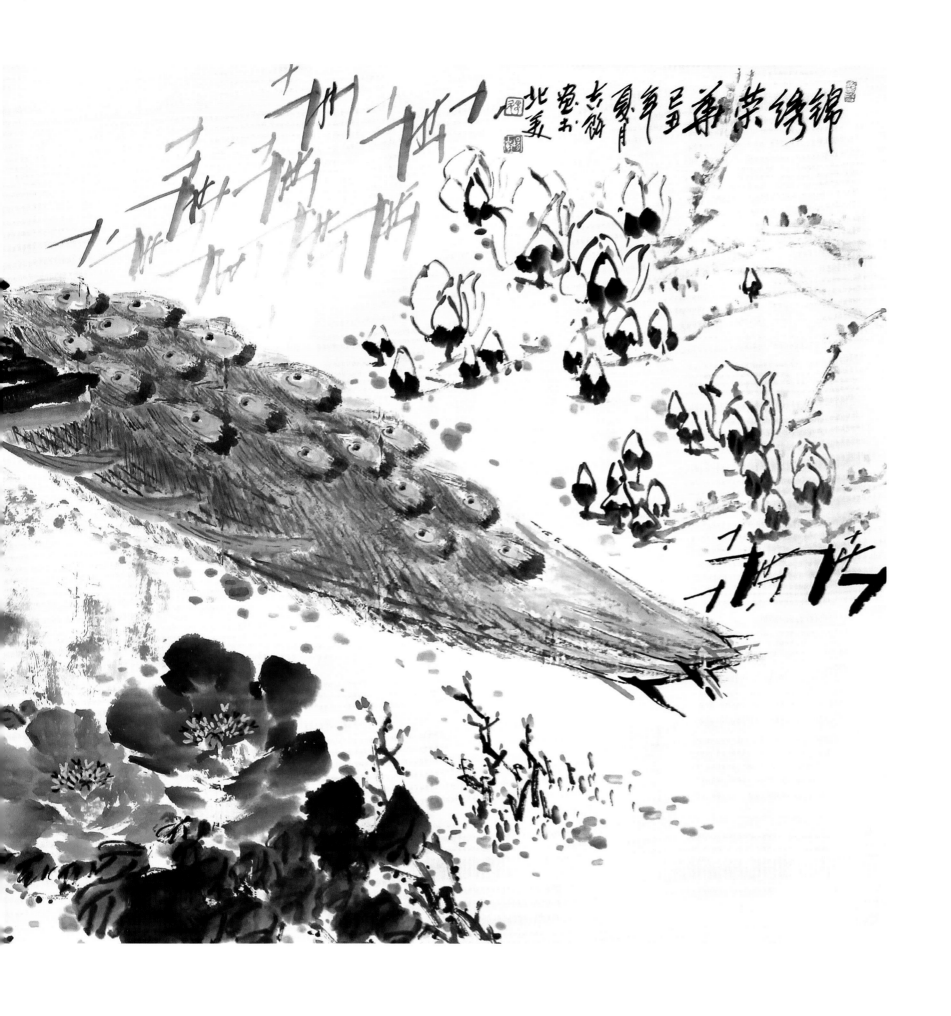

自寿

苦尽甘来自有期，

流香翰墨见神奇。

稀龄已过天心胜，

艺不惊人到老时。

——杨吉魁

九秋风露鹤精神

137cm×70cm

庚寅秋月小雨日近寒露吉魁画于并

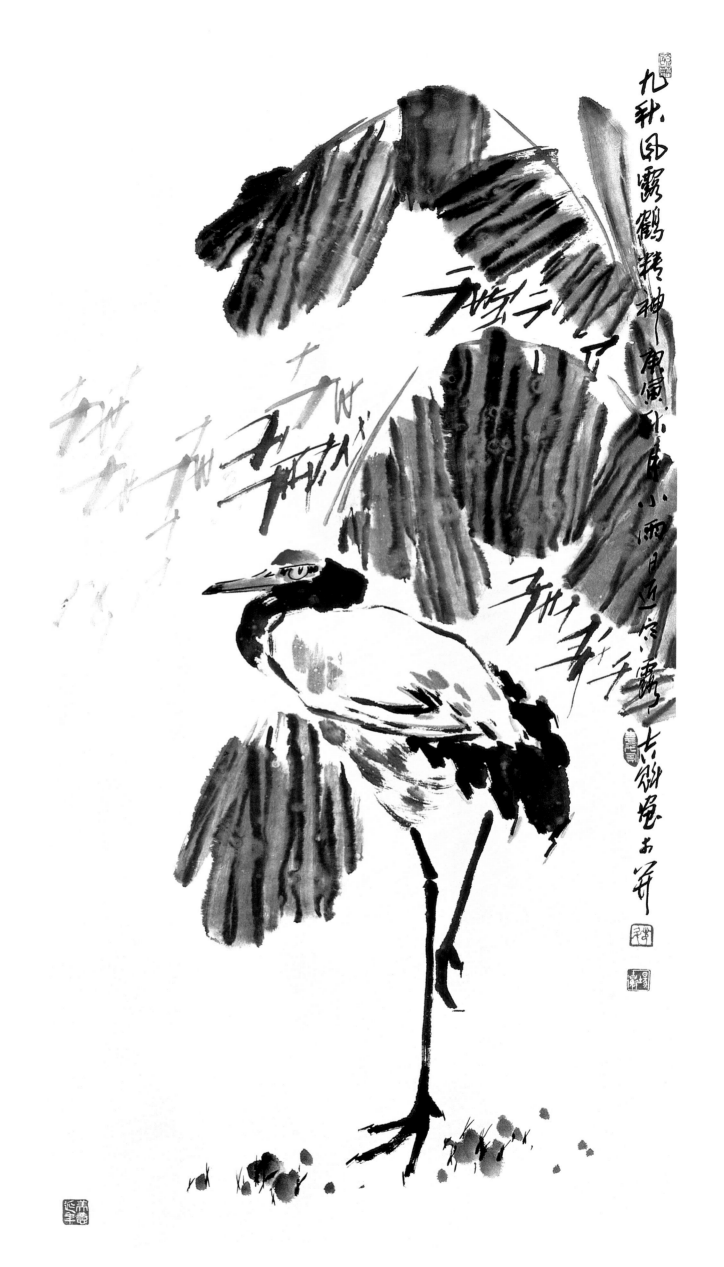

九秋風露鶴精神 庚寅小春 小雨初过一室露 大鹏凡于画

123

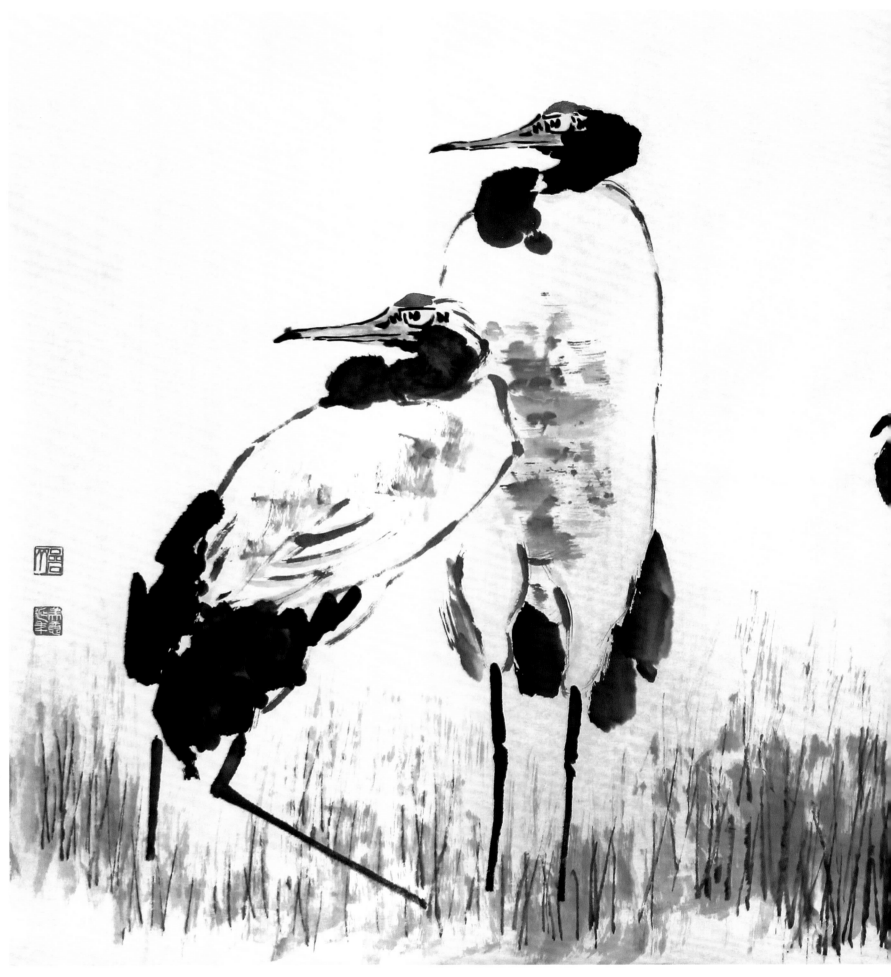

仙鹤多寿　97cm×180cm　己卯春吉魁画

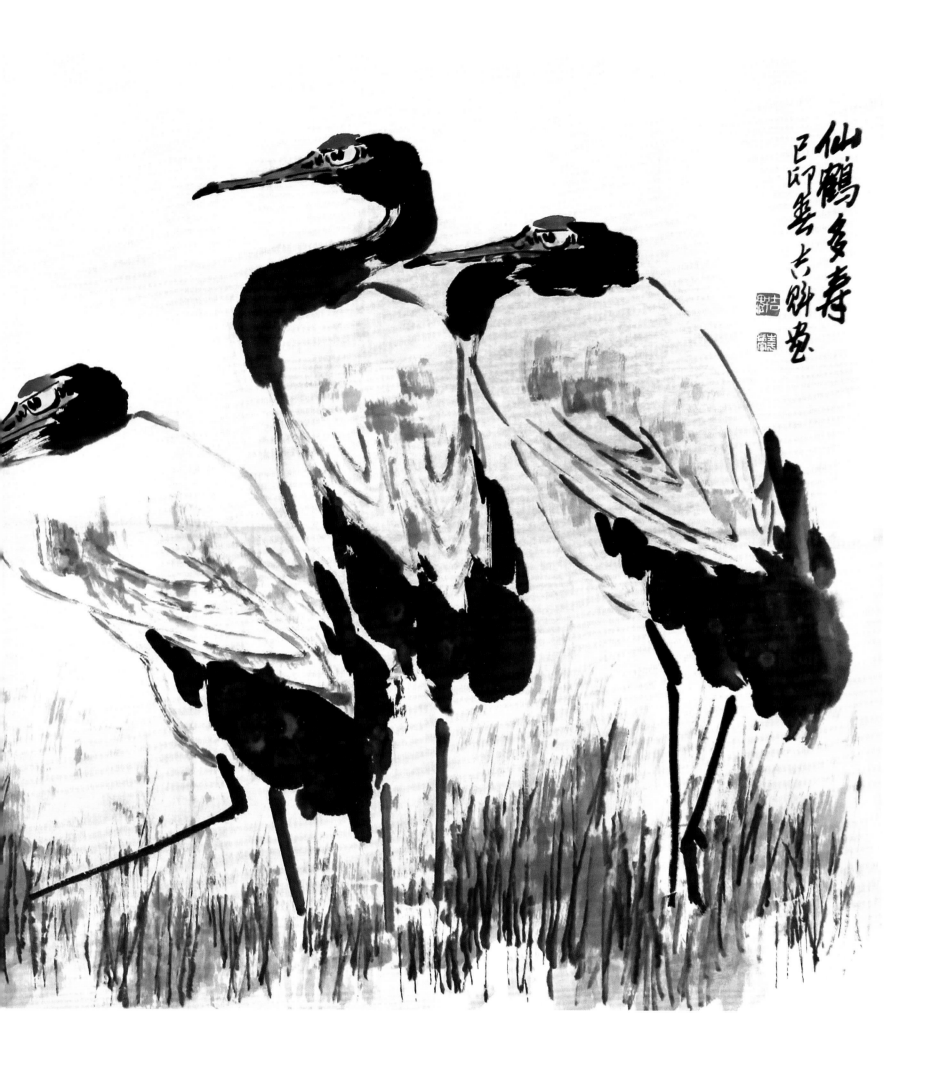

仙鶴多壽
己卯年 大雄畫

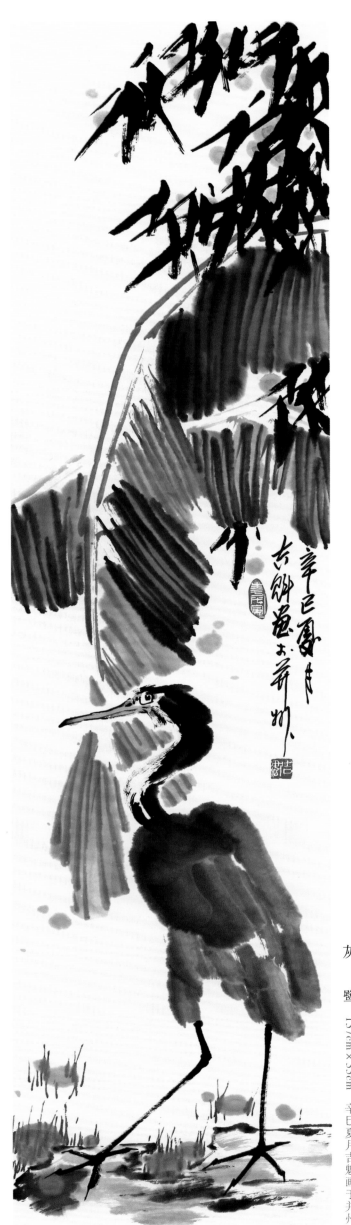

灰　鹭　137cm×35cm　辛巳夏月吉魁画于并州

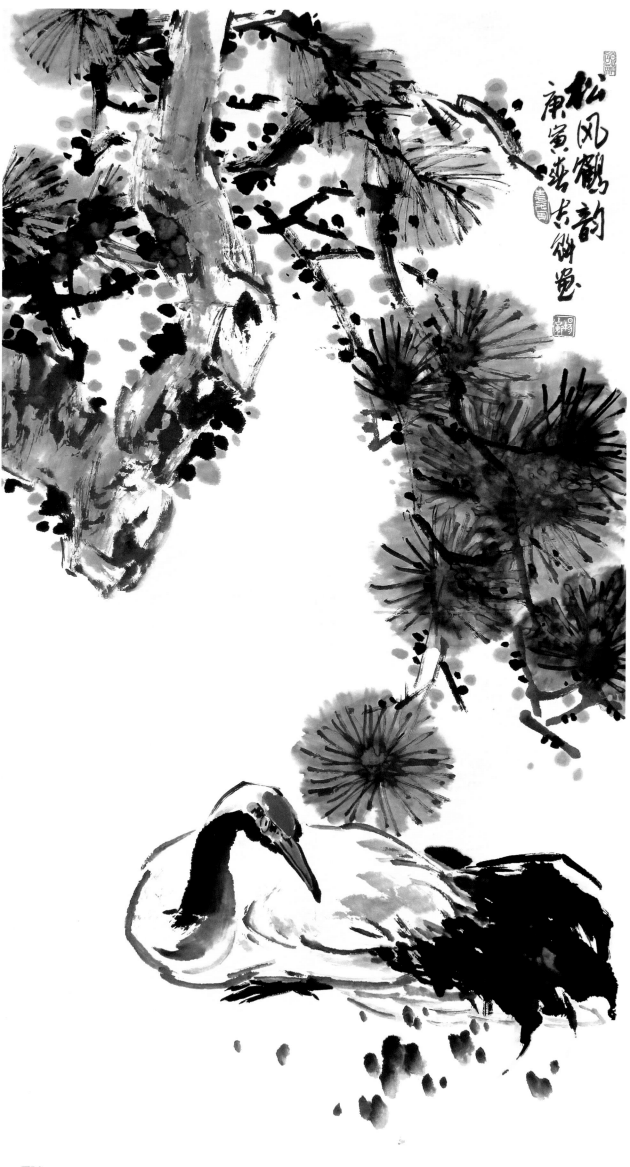

松风鹤韵

137cm×70cm 庚寅春吉魁画

双鸭

照影双鸭笔下生，

轻拨碧水每环行。

缘何戏闹随新草，

引颈争呼大姓名。

——杨吉魁

春　晴

137cm×70cm

辛巳冬月吉魁画于品石斋

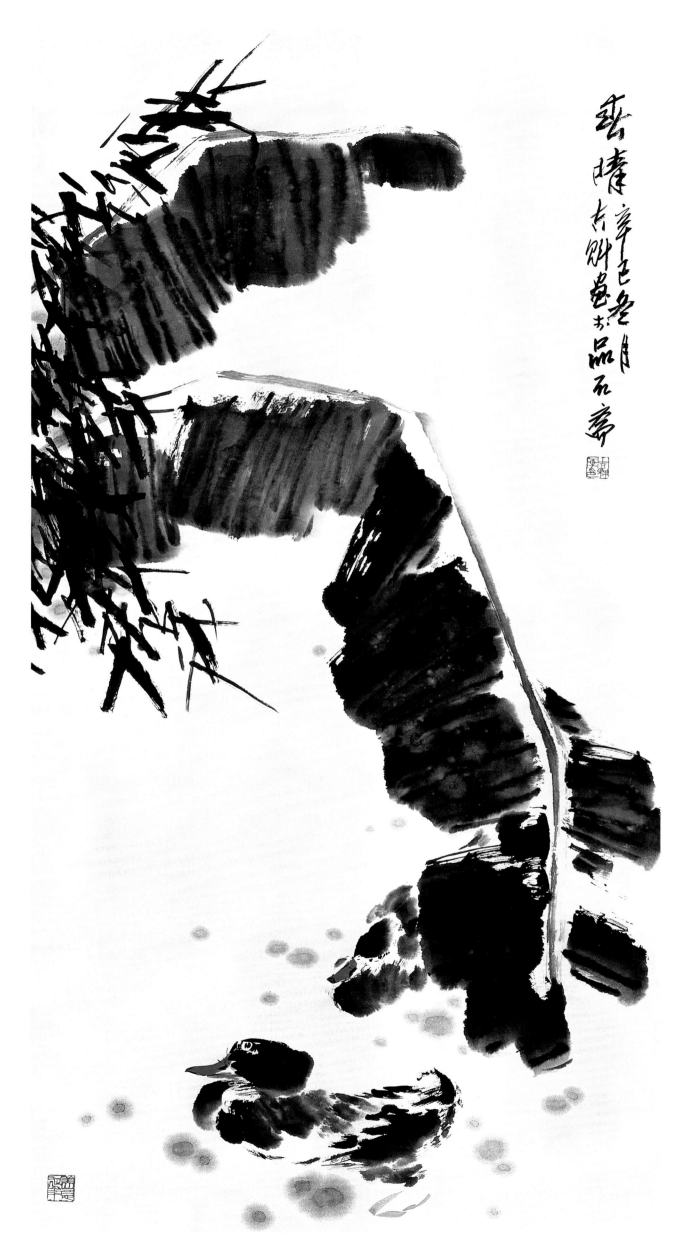

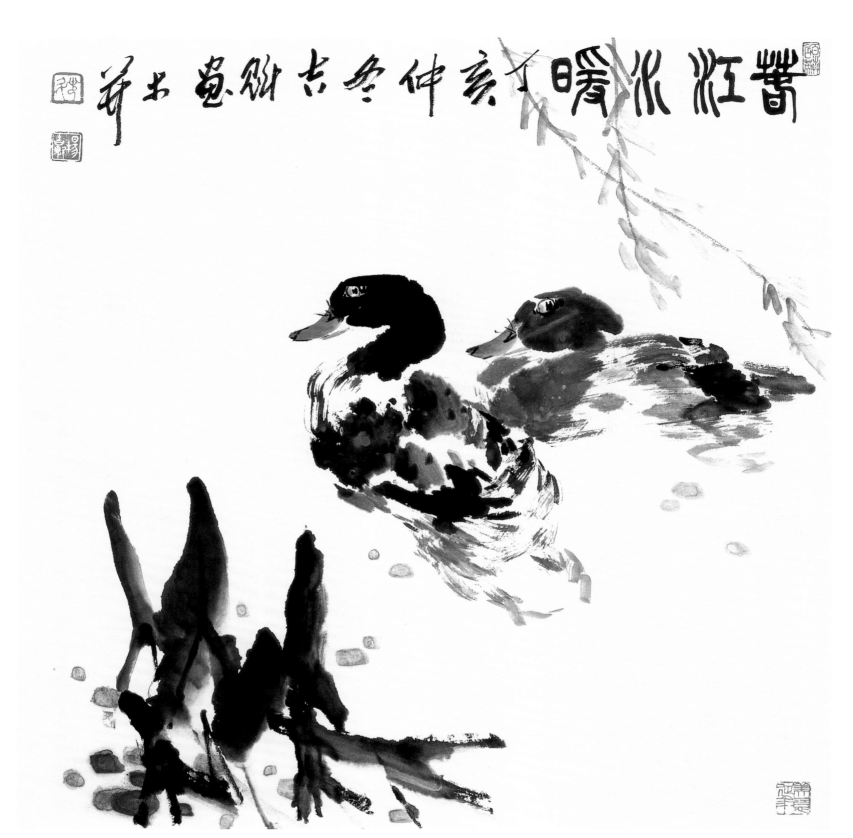

春江水暖　68cm×68cm　丁亥仲冬吉魁画于并

春禽处处起新声　137cm×70cm　庚寅三月吉魁画于并

131

作画偶得

惨淡经营总相宜，

自然笔运墨淋漓。

如今腕底生奇妙，

苦尽甘来赏画时。

——杨吉魁

三春处处有新声

137cm×70cm

庚寅春月吉魁画于并

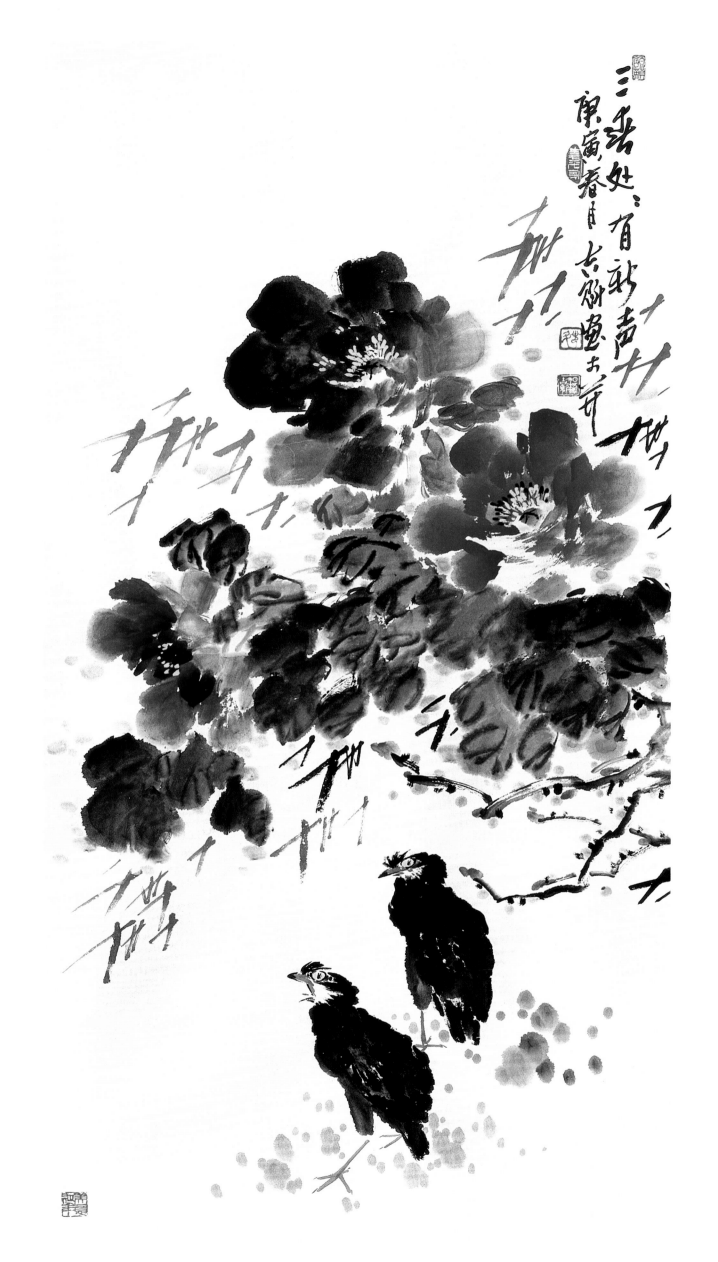

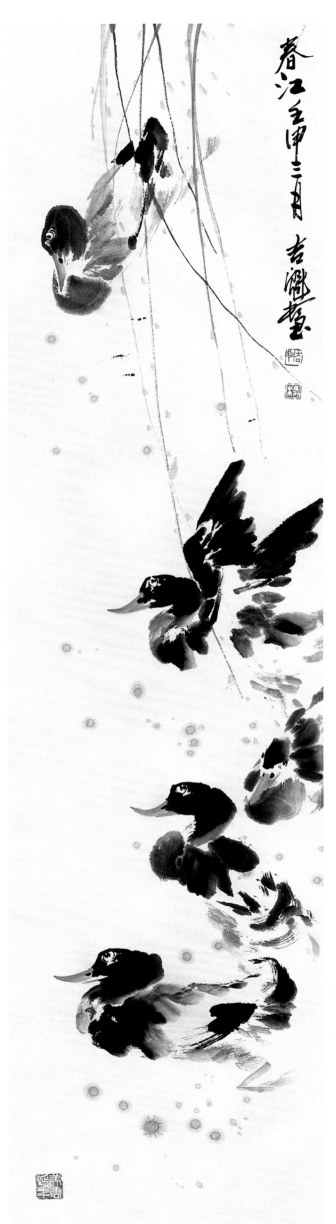

春江　壬申三月吉魁画

春

江

137cm×35cm

北国江南　暖气浮春　137cm×70cm　庚寅三月吉魁画于井

北国江南暖气浮春 庚寅之二吉魁画于井

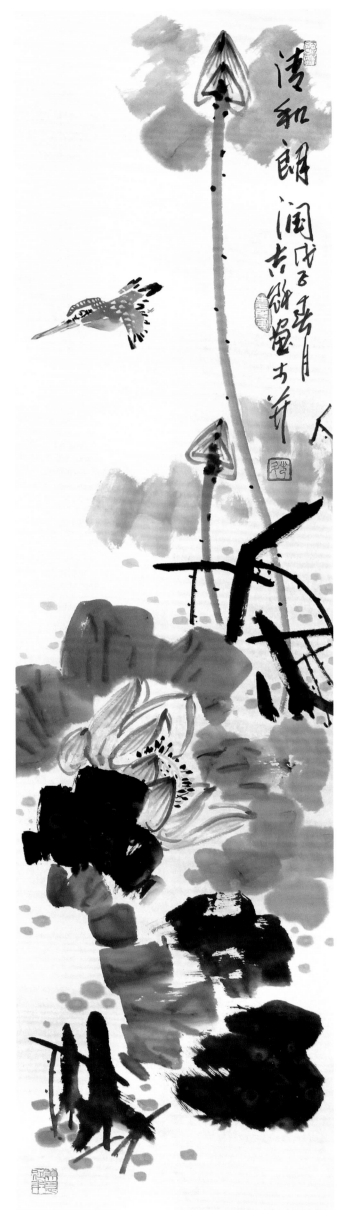

清和朗润·夏（四条屏之二） 137cm×34cm 戊子春月吉魁画于并

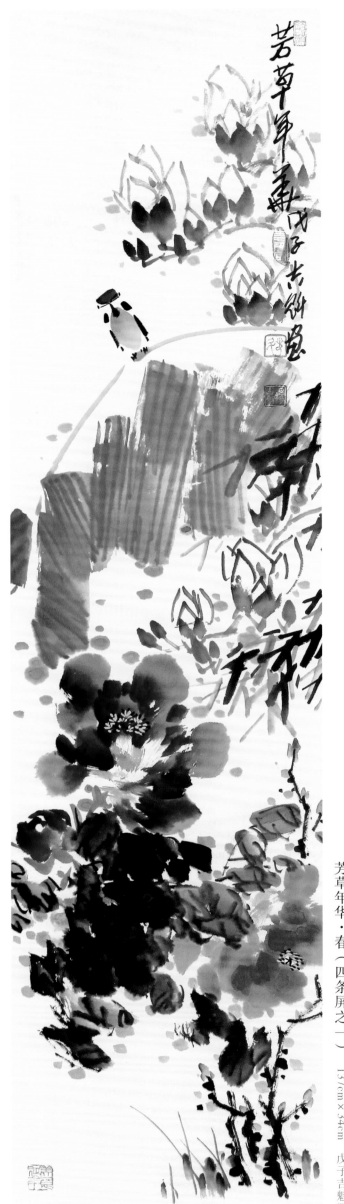

芳草年华·春（四条屏之一） 137cm×34cm 戊子吉魁画

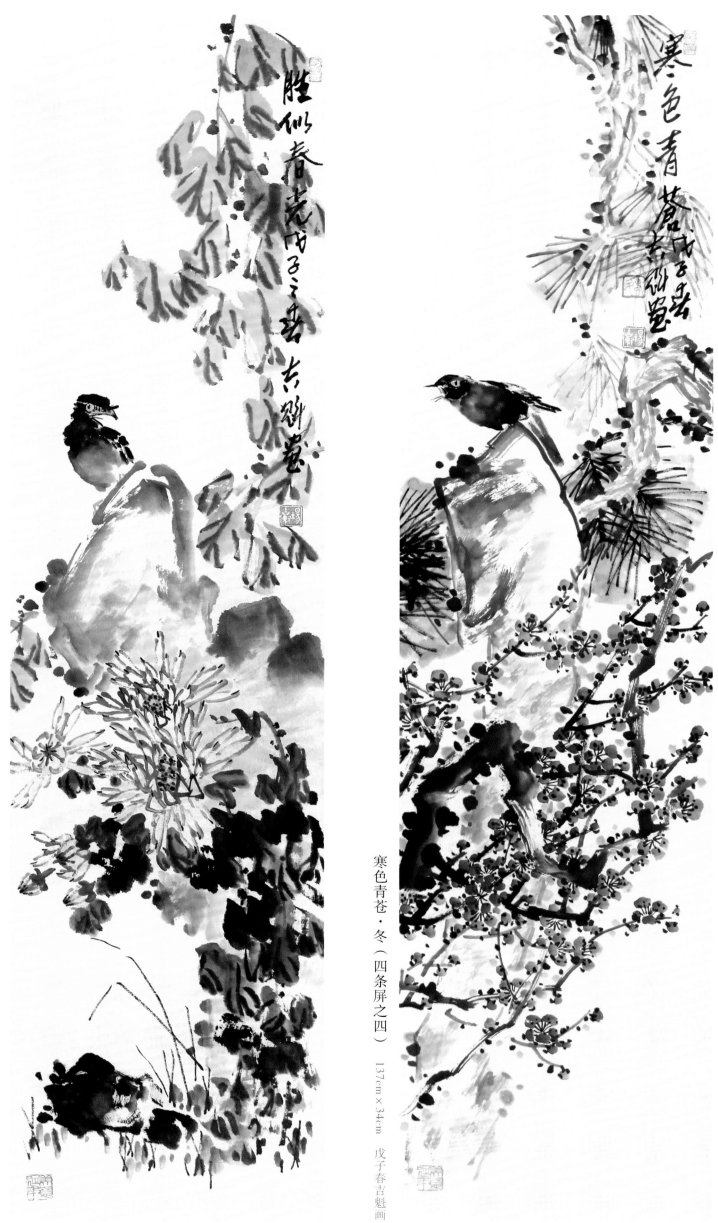

胜似春光·秋（四条屏之三）　137cm×34cm　戊子之春吉魁画

寒色青苍·冬（四条屏之四）　137cm×34cm　戊子春吉魁画

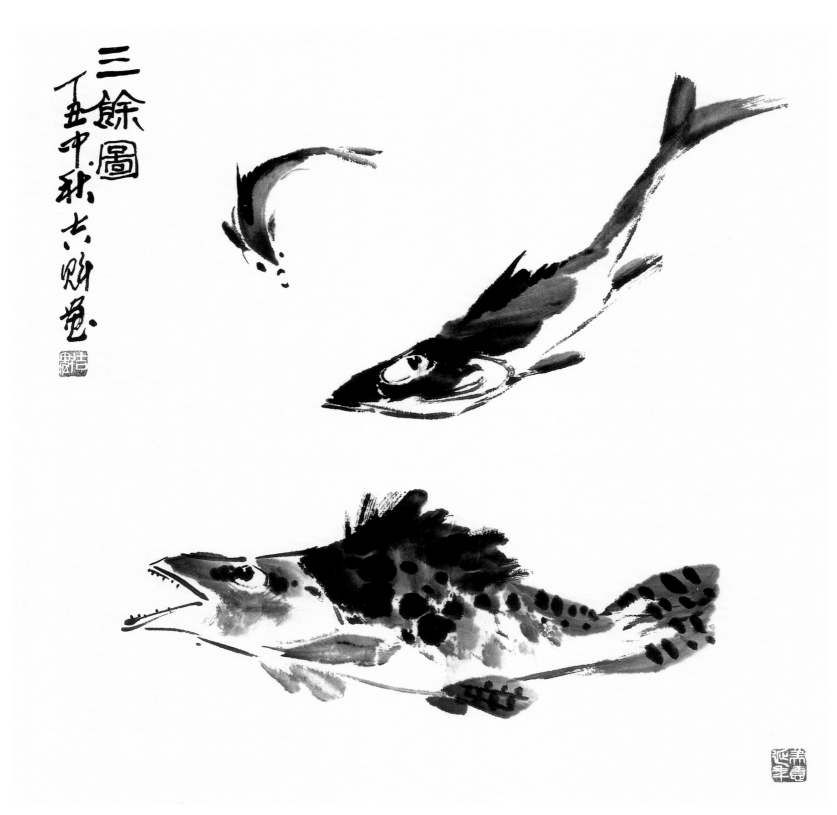

三余图　68cm×68cm　丁丑中秋吉魁画

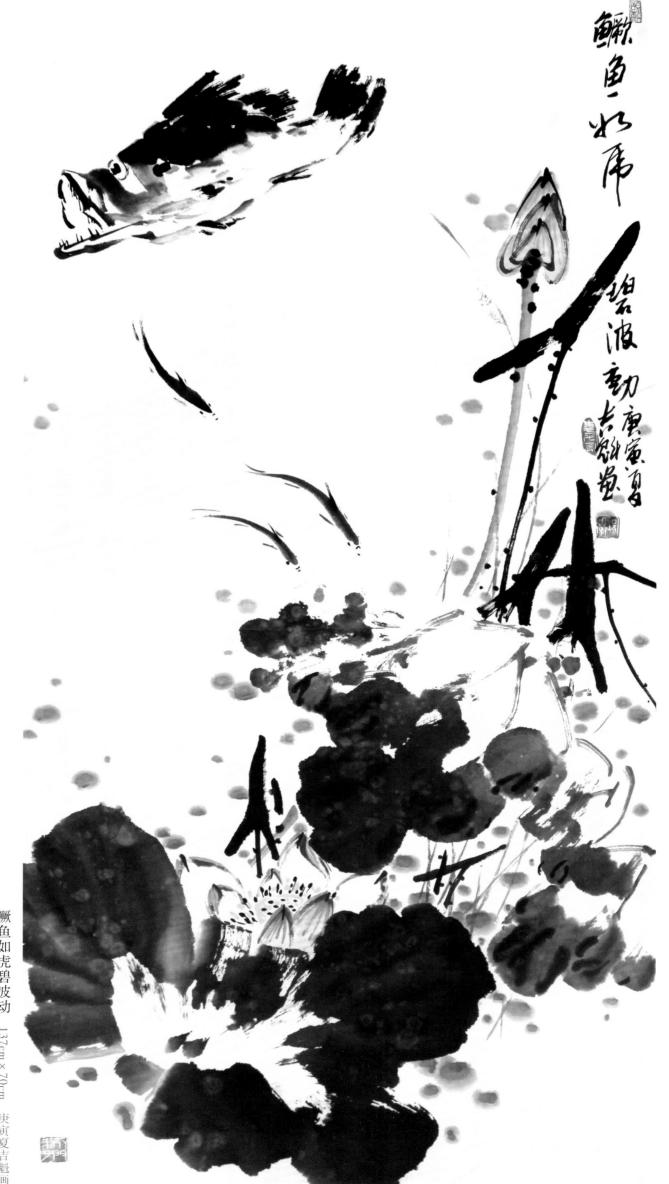

鳜鱼如虎碧波动　137cm×70cm　庚寅夏吉魁画

题画

—虾蟹鱼蛙

虾群列队享风流，

蟹大须得等过秋。

赤锦游行多变幻，

青蛙奏乐不识愁。

——杨吉魁

池上春风动绿萍　池边清浅见金鳞

137cm×70cm

己丑年夏月吉魁画于北美

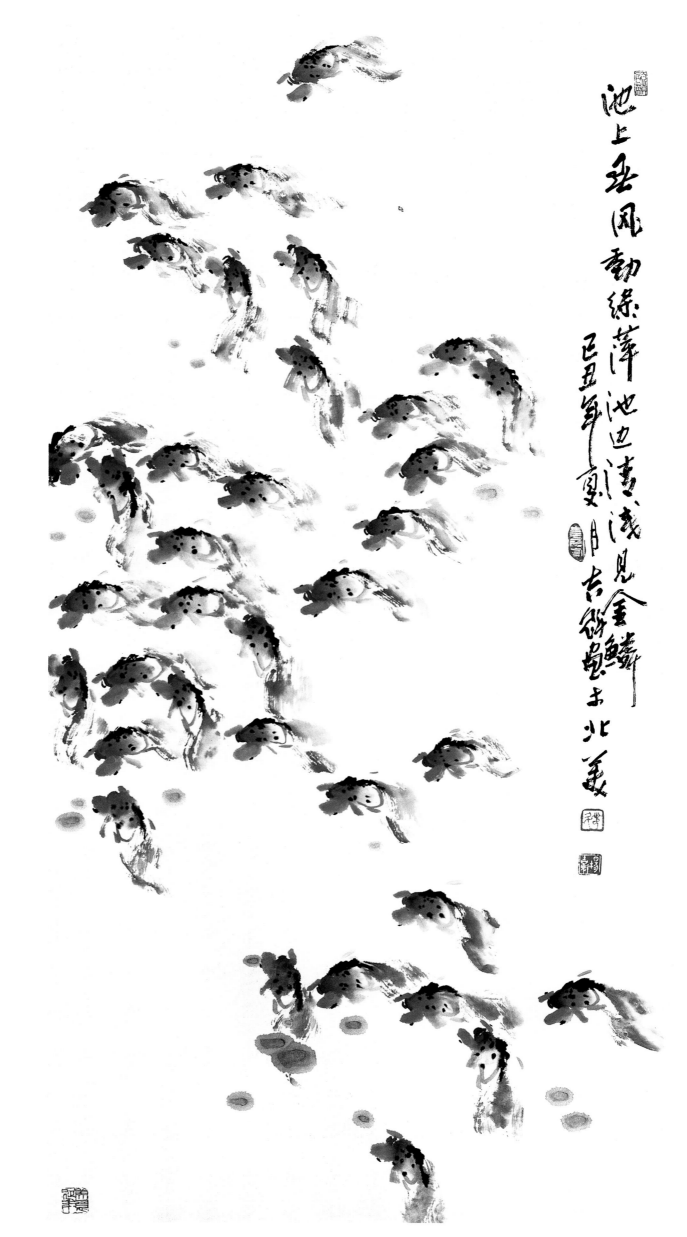

池上东风动绿萍池边清浅见金鳞己丑年夏月古稀翁于北羡

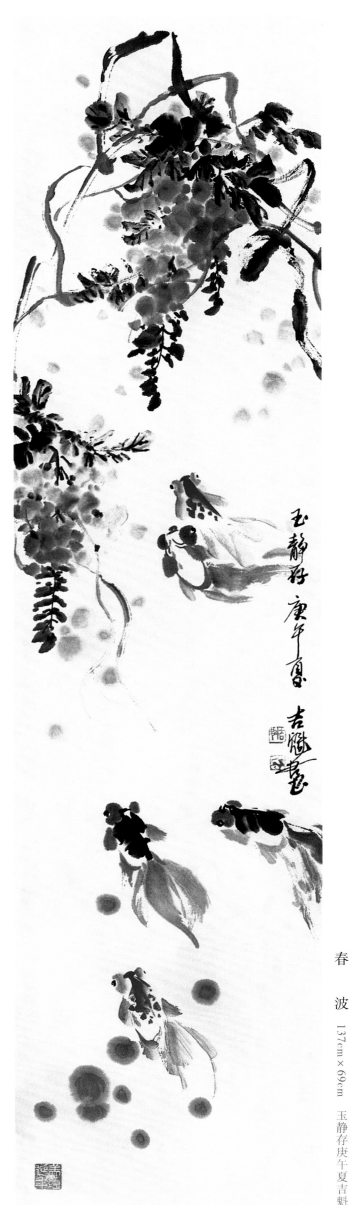

春　波　137cm×69cm　玉静存庚午夏吉魁画

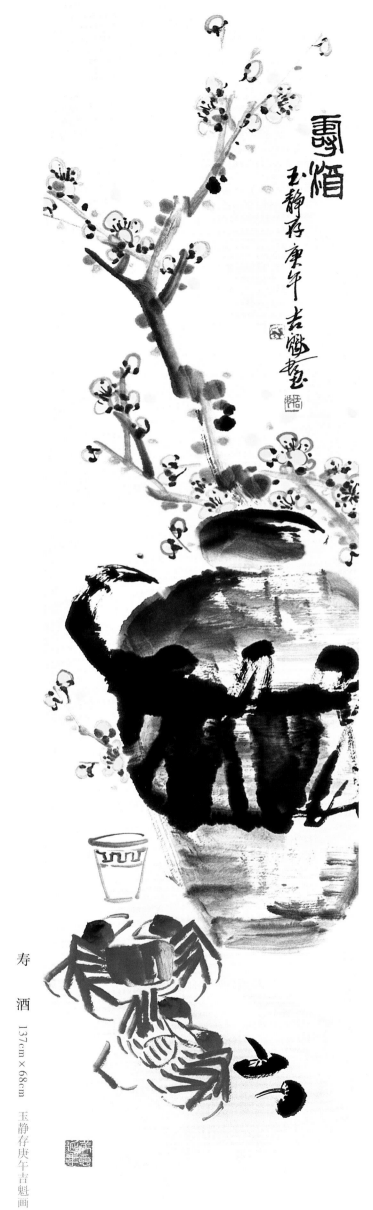

寿　酒　137cm×68cm　玉静存庚午吉魁画

题画

笔墨泼酣气岸心，
丹青与我共胸襟。
齐璜韵致恩师手，
再育知音造诣深。

——杨吉魁

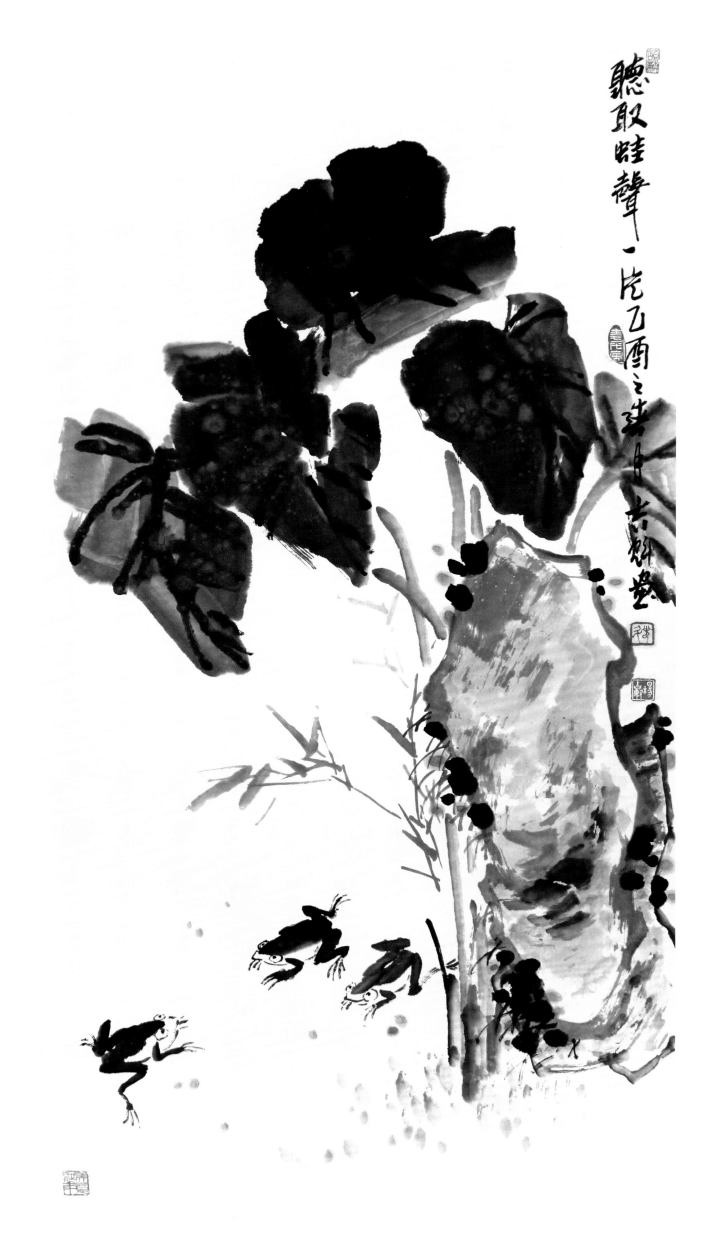

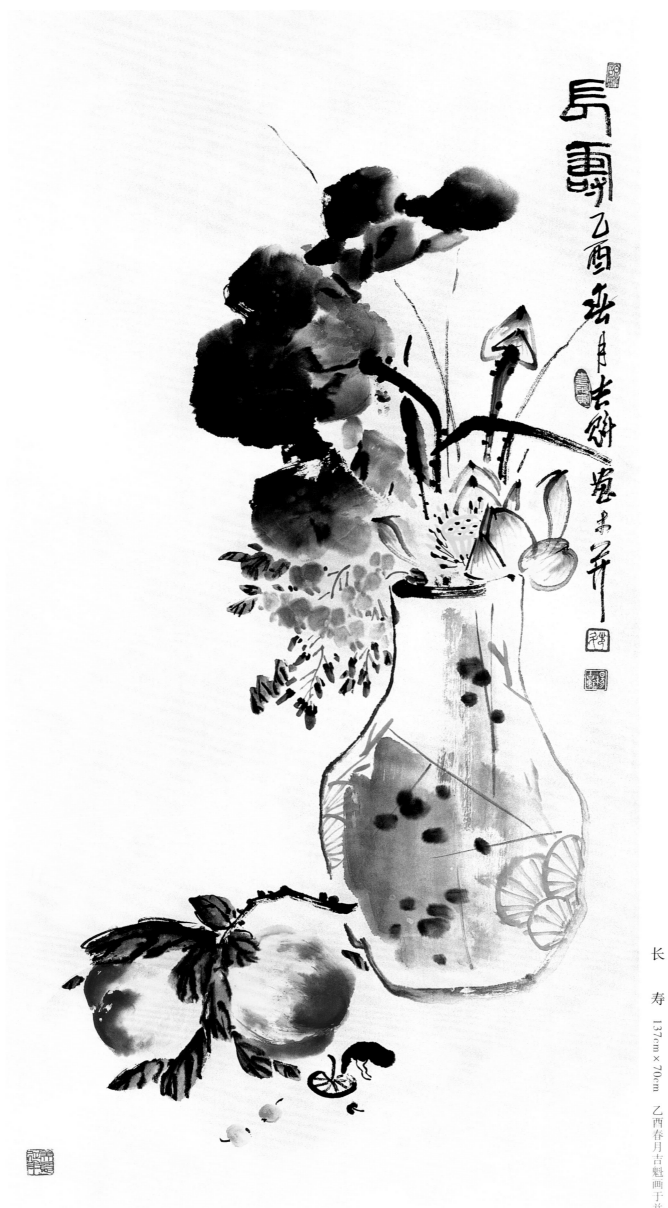

长　寿　137cm×70cm　乙酉春月吉魁画于并

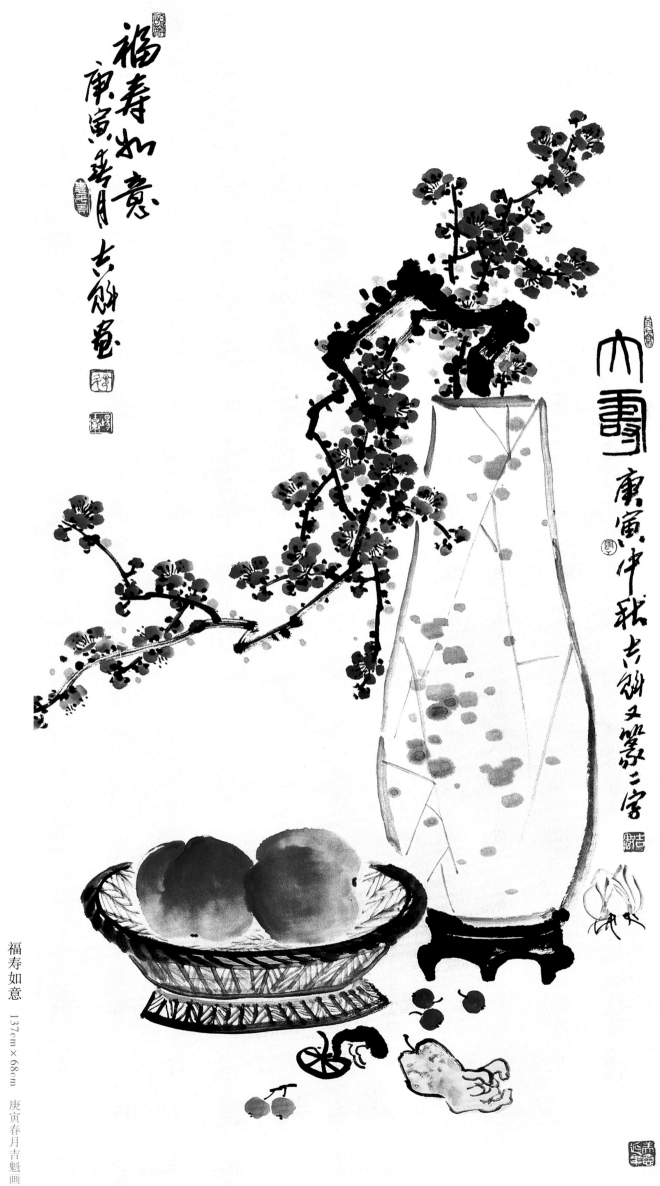

福寿如意　137cm×68cm　庚寅春月吉魁画

生辰感怀

处世无求意志坚，

丹青造就品格贤。

人生百岁难得见，

画苑长年道乐天。

——杨吉魁

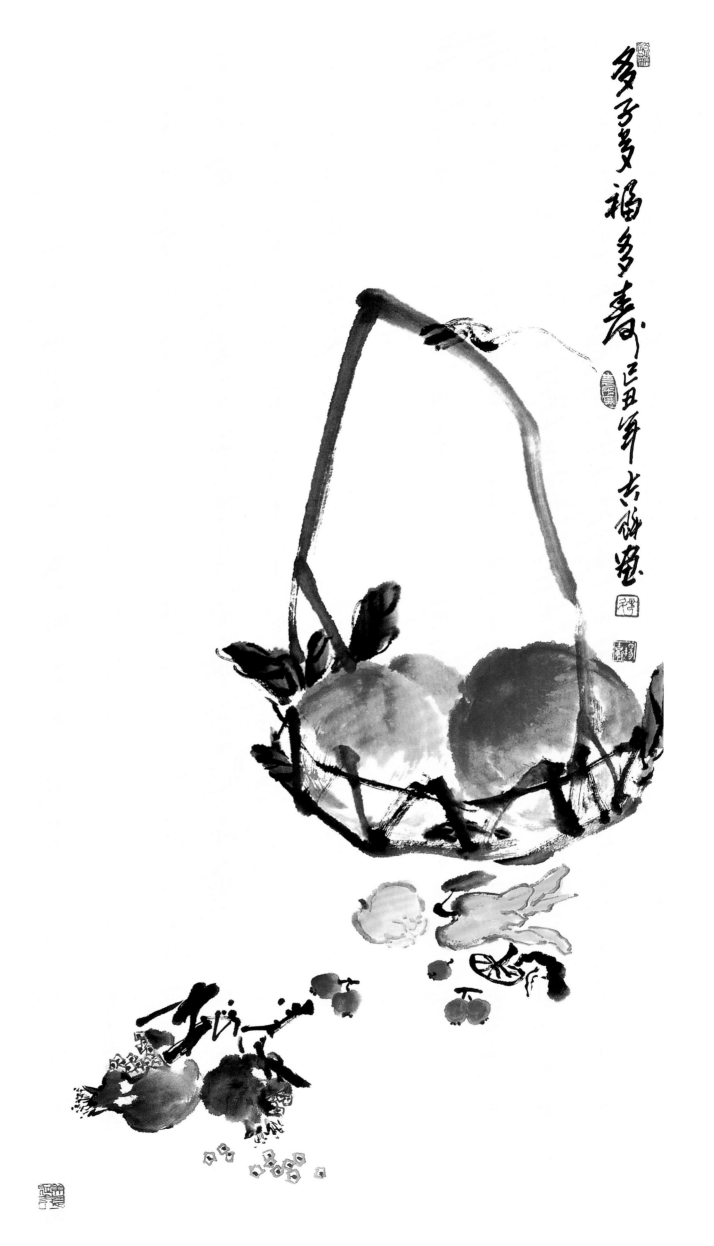

149

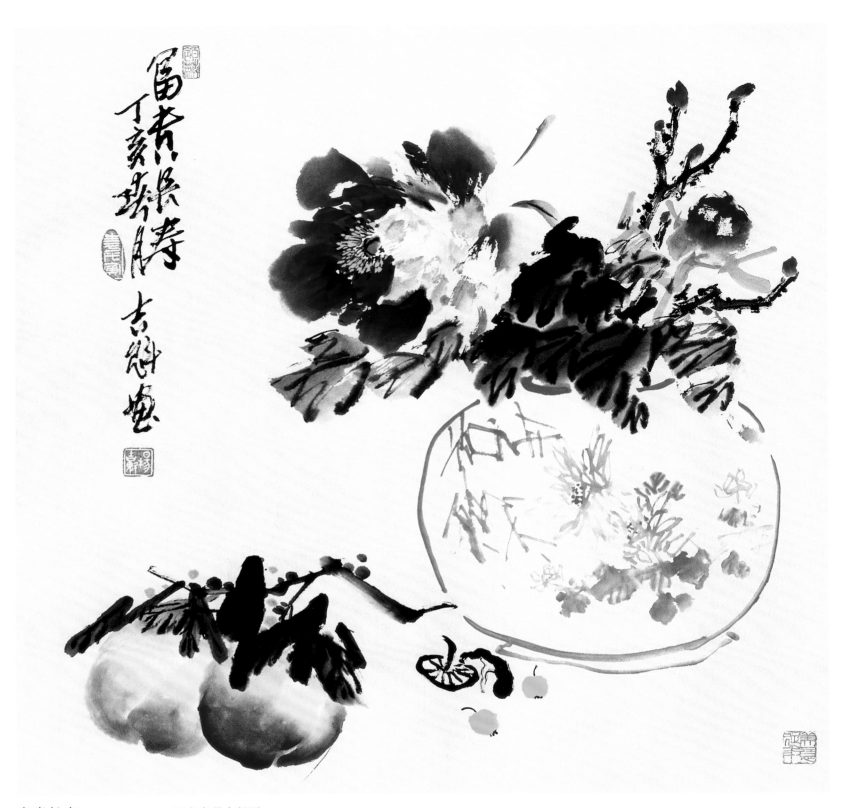

富贵长寿　69cm×69cm　丁亥春月吉魁画

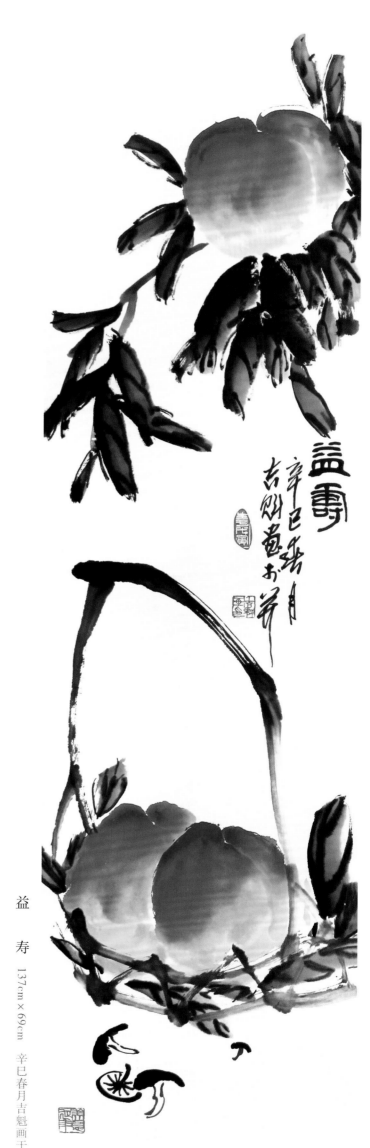

益　寿　137cm×69cm　辛巳春月吉魁画于并

寿宴

岁岁生辰领好春，

七十小度畅心身。

三人寿宴君休笑，

骨肉同欢是至亲。

——杨吉魁

长　寿

137cm×70cm

己丑年夏月吉魁画于北美女儿家

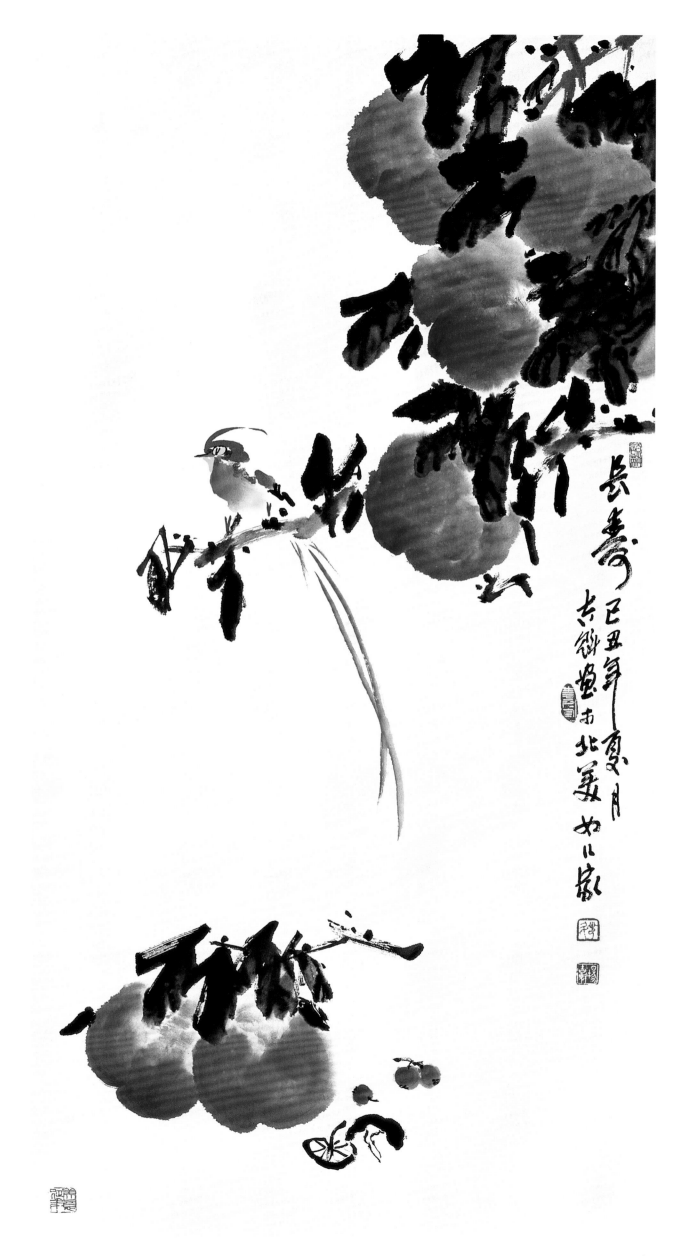

長壽

己丑年夏月
古鄴魚玄
于北美如水居

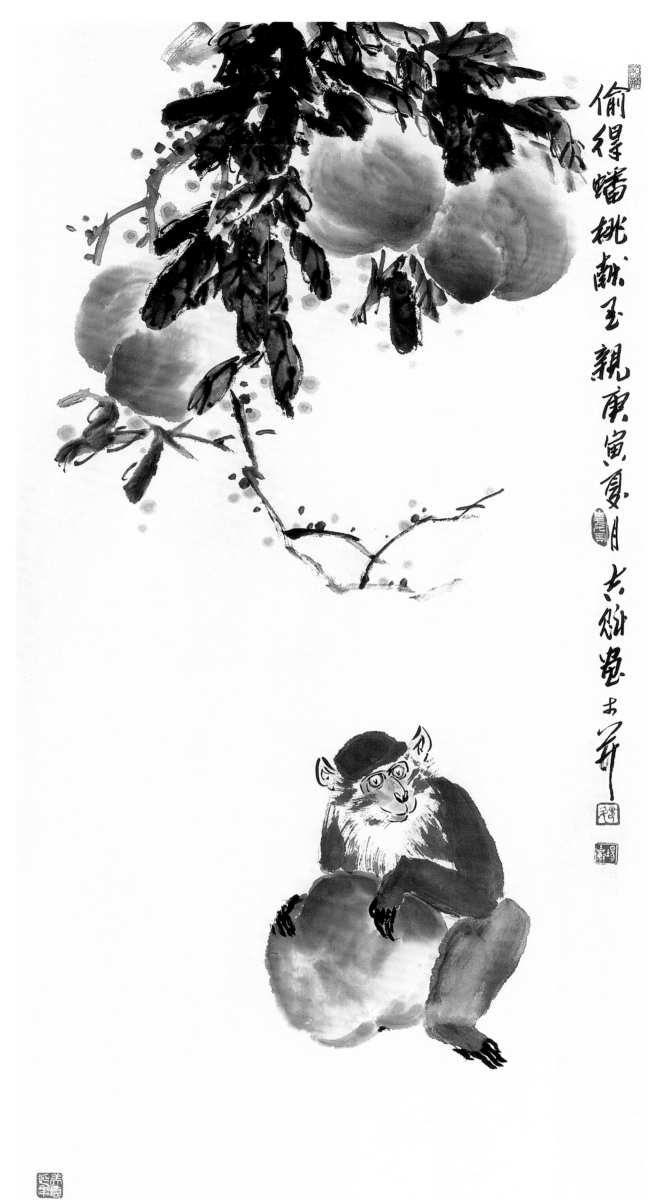

偷得蟠桃献至亲　137cm×69cm　庚寅夏月吉魁画于并

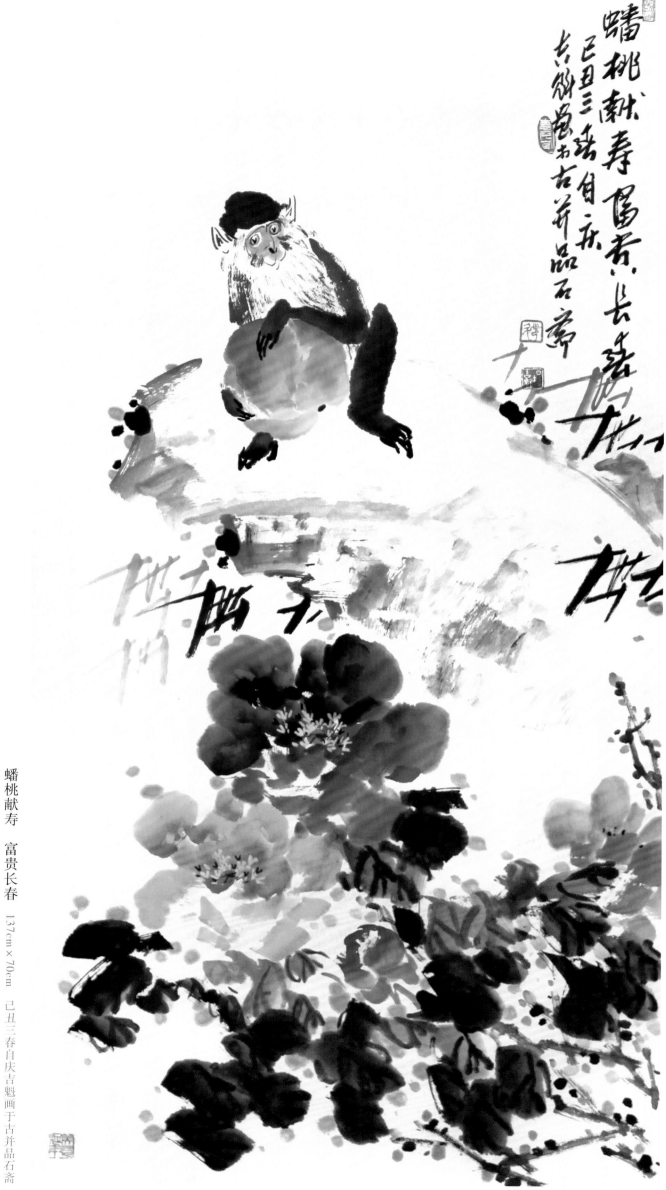

蟠桃献寿　富贵长春　137cm×70cm　己丑三春自庆吉魁画于古并品石斋

155

丹青益寿

丹青能益寿，
境界见高风。
不可求名利，
容颜老亦红。

——杨吉魁

寿
39cm × 39cm
戊子春吉魁画

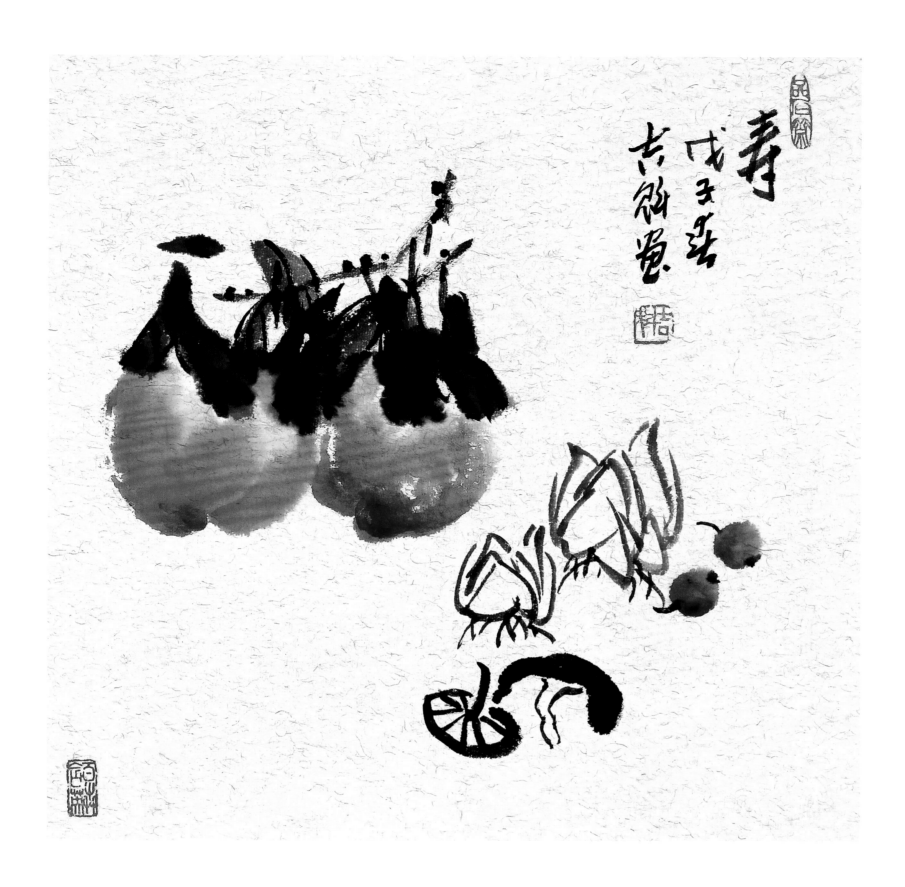

题画

经营位置几经难，

笔底烟生汗满颜。

妙用禅机空处理，

超然物外喜心间。

——杨吉魁

一架葫芦采未稀

68cm×68cm

丁亥秋吉魁画于并

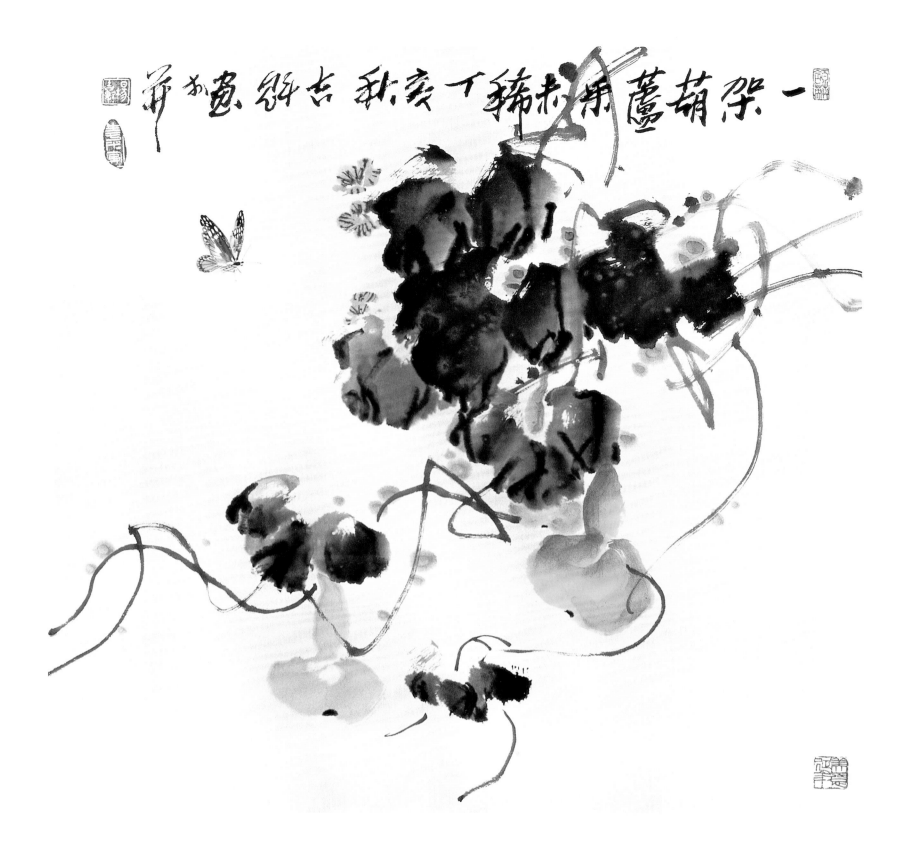

159

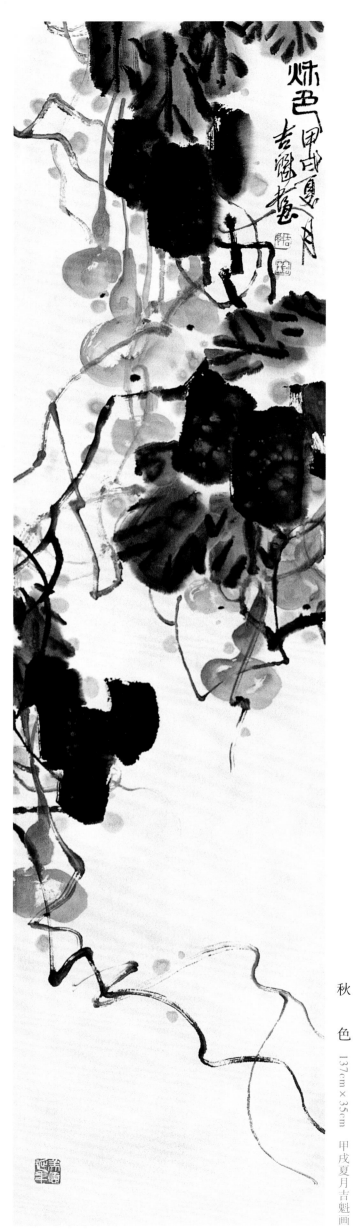

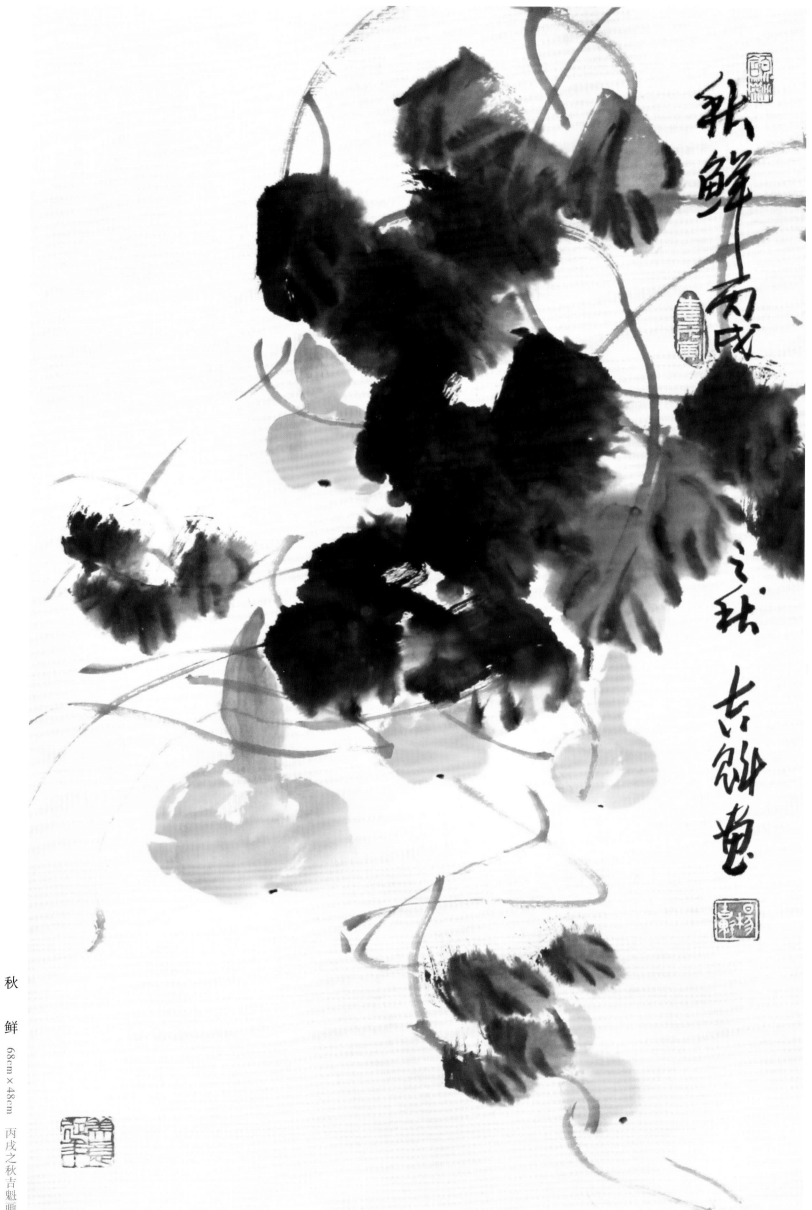

秋　鮮　68cm×48cm　丙戌之秋吉魁画

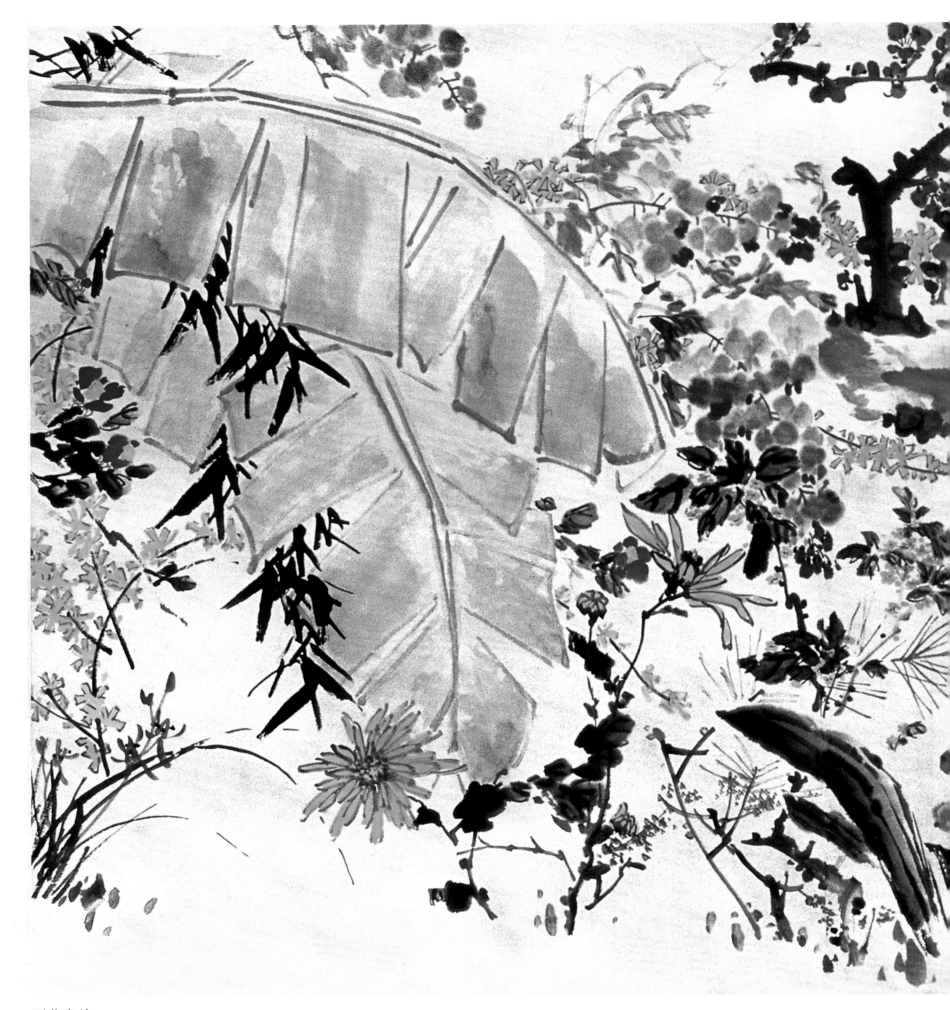

百花齐放

98cm × 360cm

"女帝催花空自绐黄王宏愿付蒿莱而今天命为人制桂菊兰梅一处开" 姚奠中先生诗意图戊寅之春吉魁画于品石斋

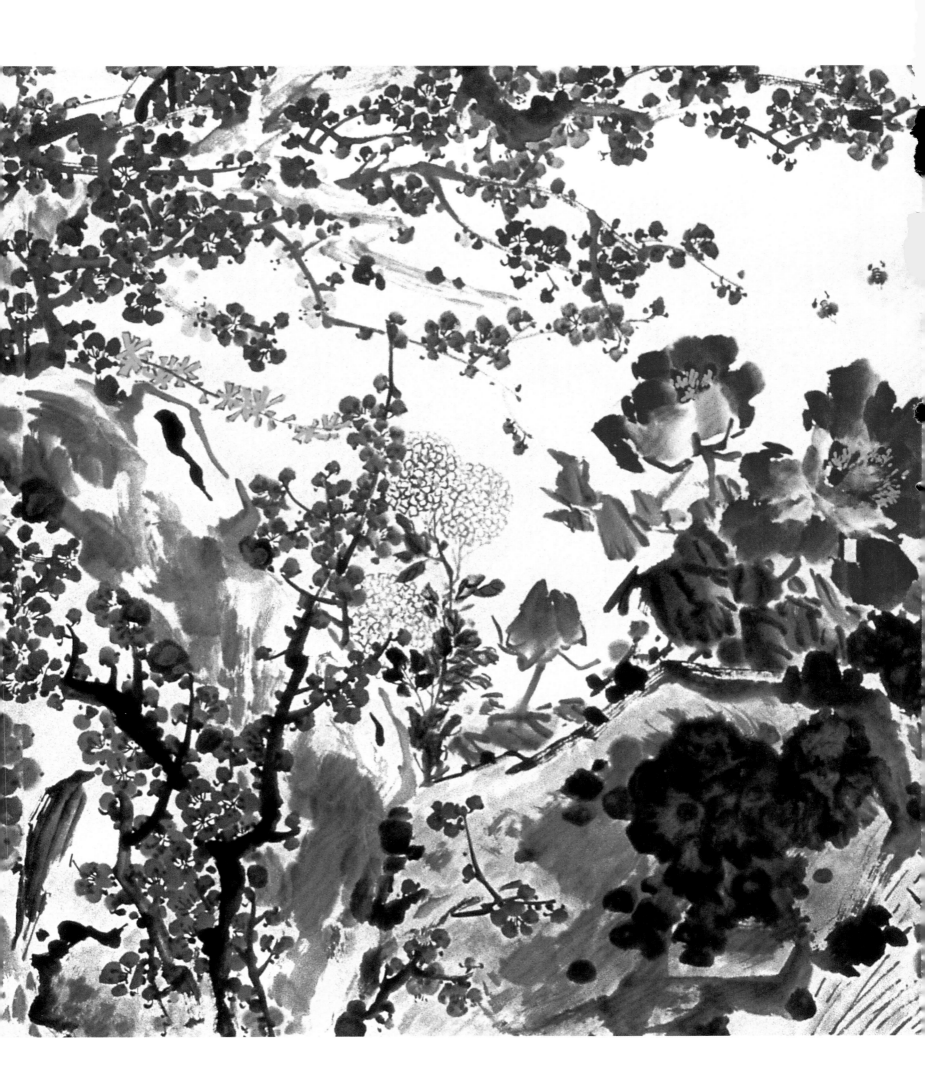

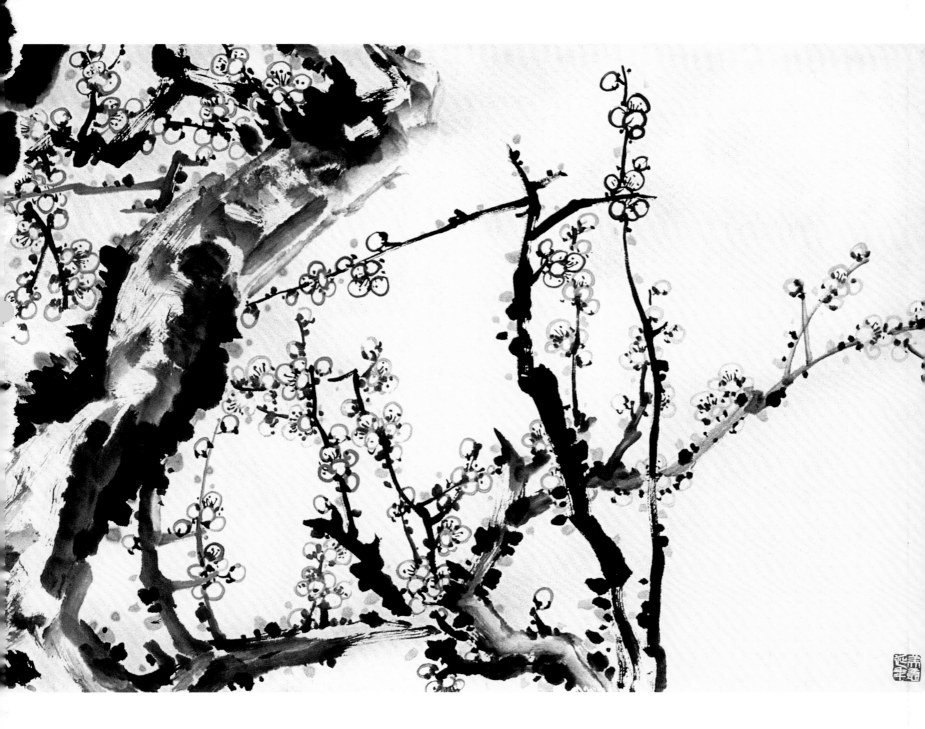

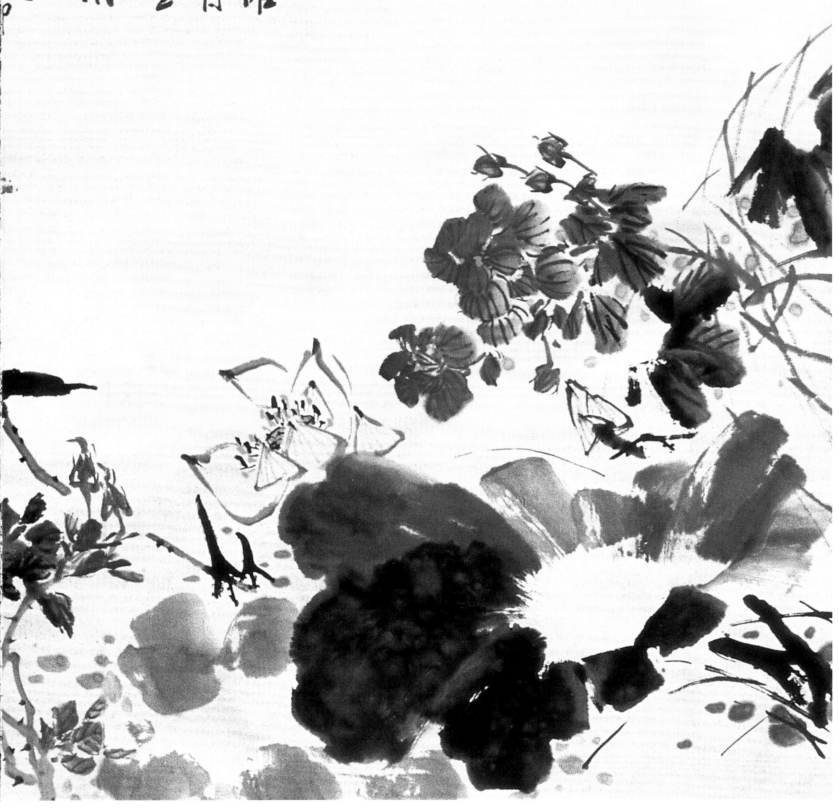

百卉皆放

如帝催
花宣付
绍黄王
宏愿伴
萬葉

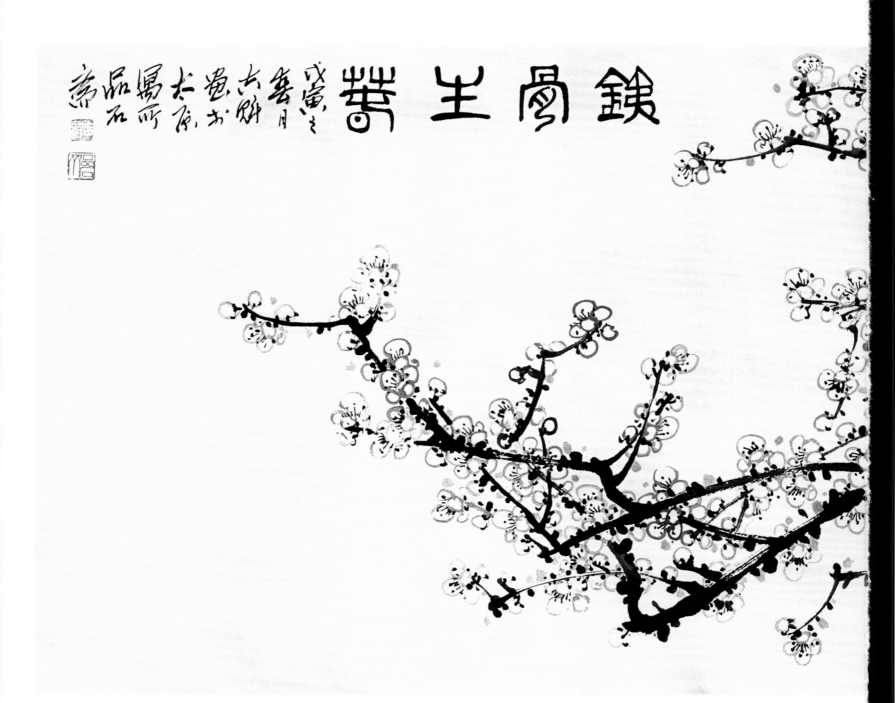

铁骨生春

97cm×360cm

戊寅之春月吉魁画于太原寓所品石斋

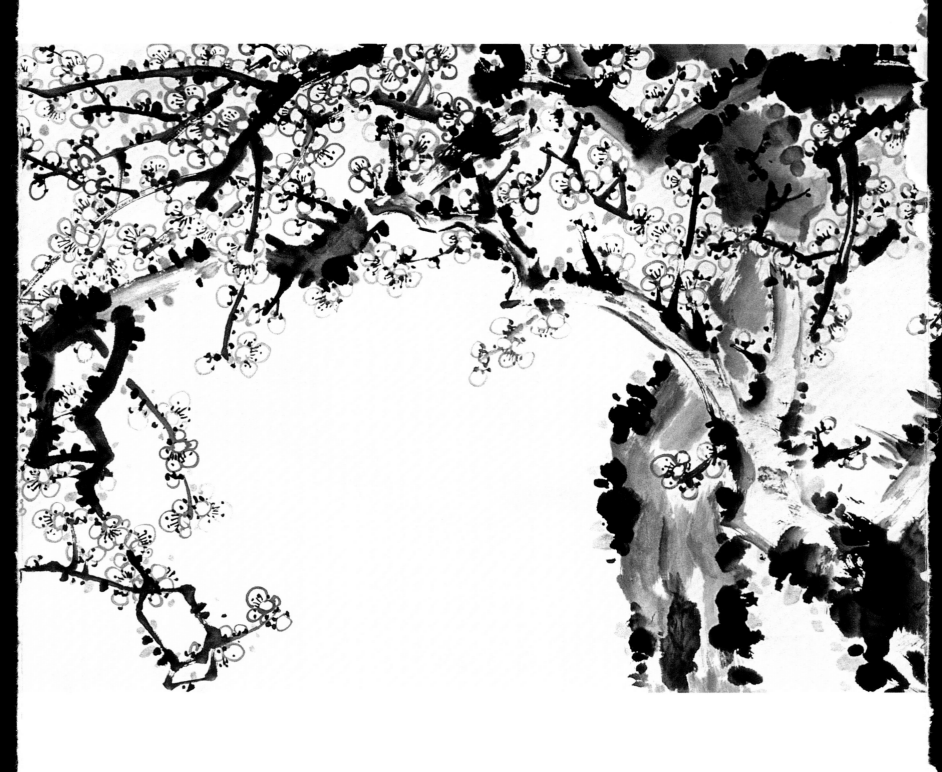

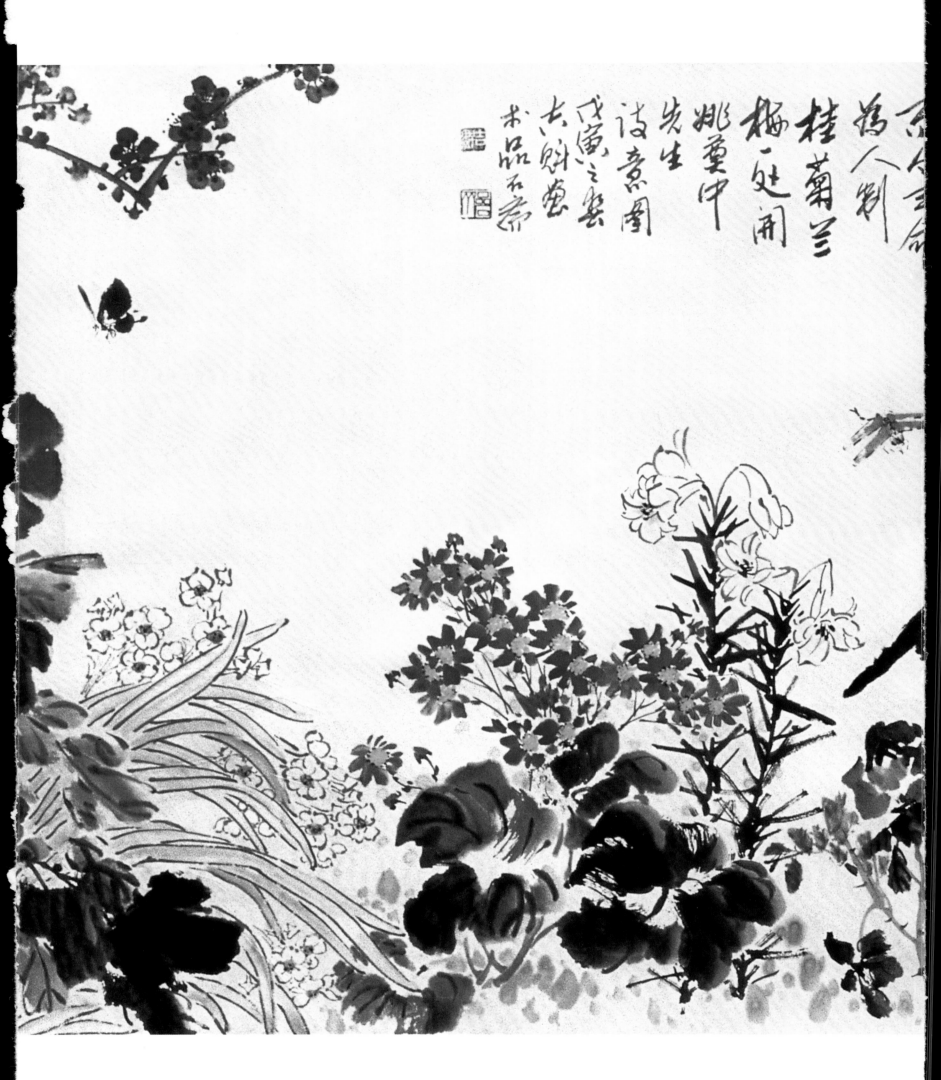

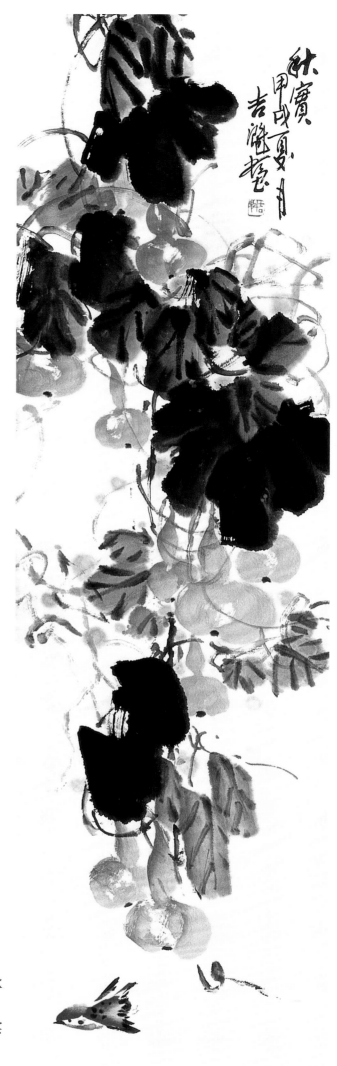

秋

实 137cm×35cm 甲戌夏月吉魁画

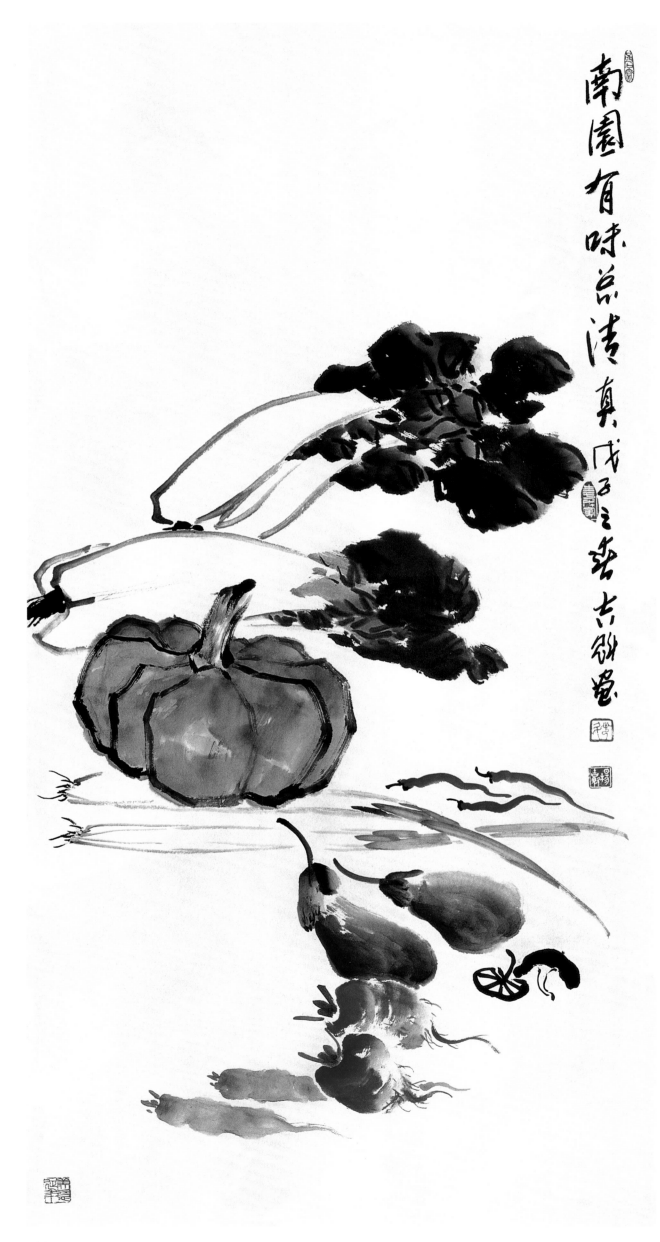

南园有味总清真　137cm×70cm　戊子之春吉魁画

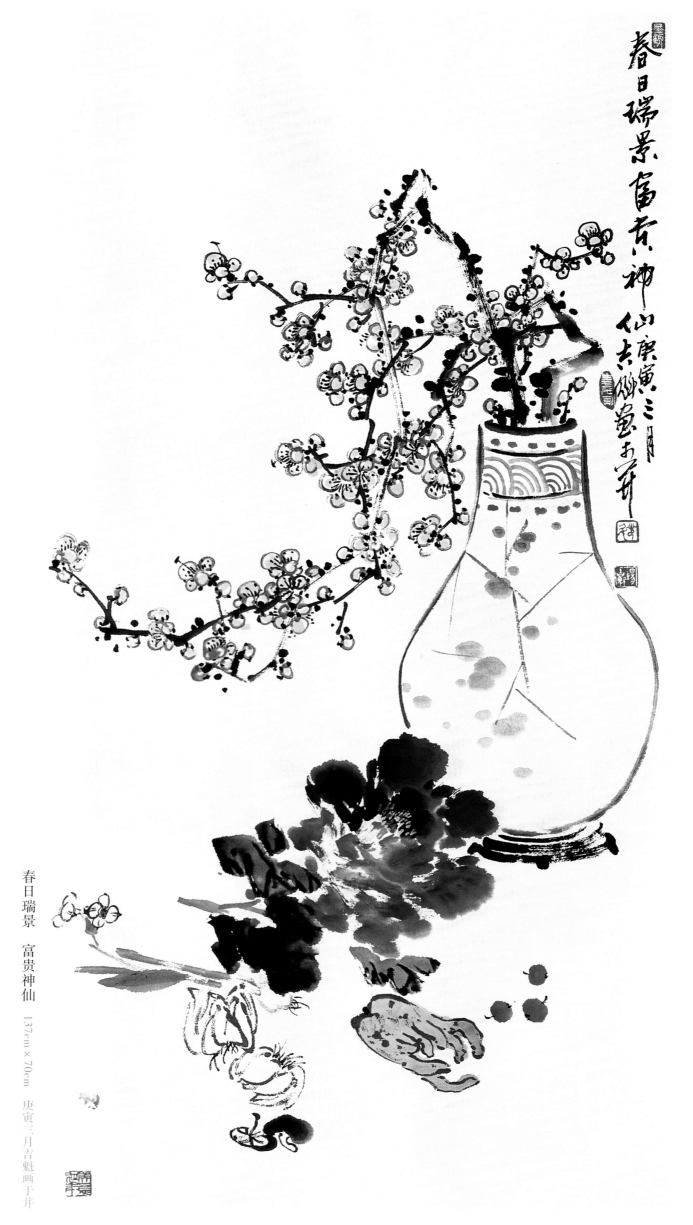

春日瑞景　富贵神仙　137cm×70cm　庚寅三月吉甡画于齐

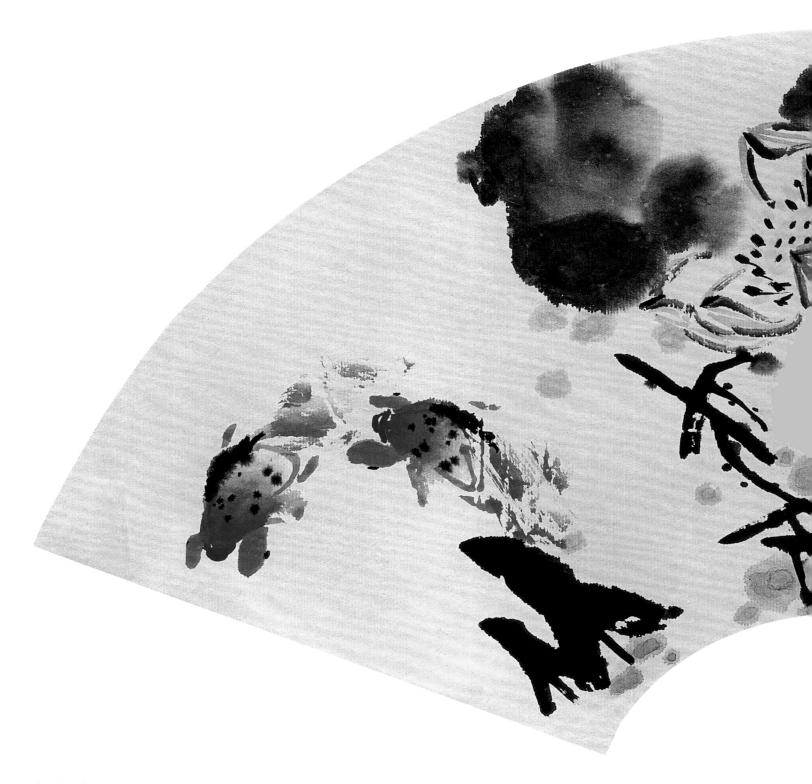

荷香（扇面） 戊子秋吉魁画于并

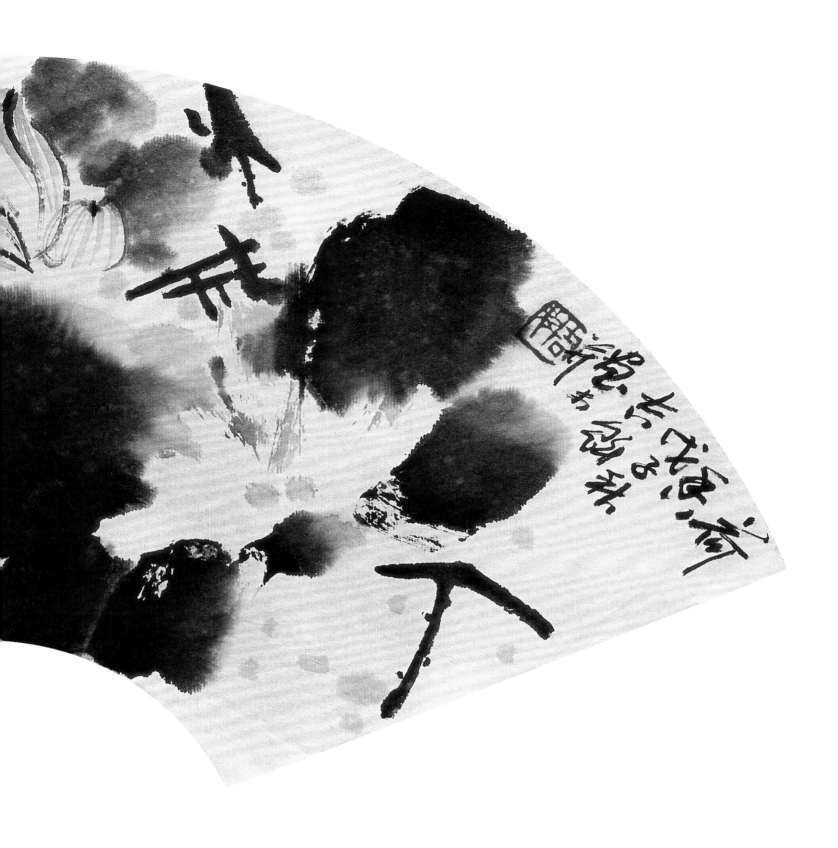

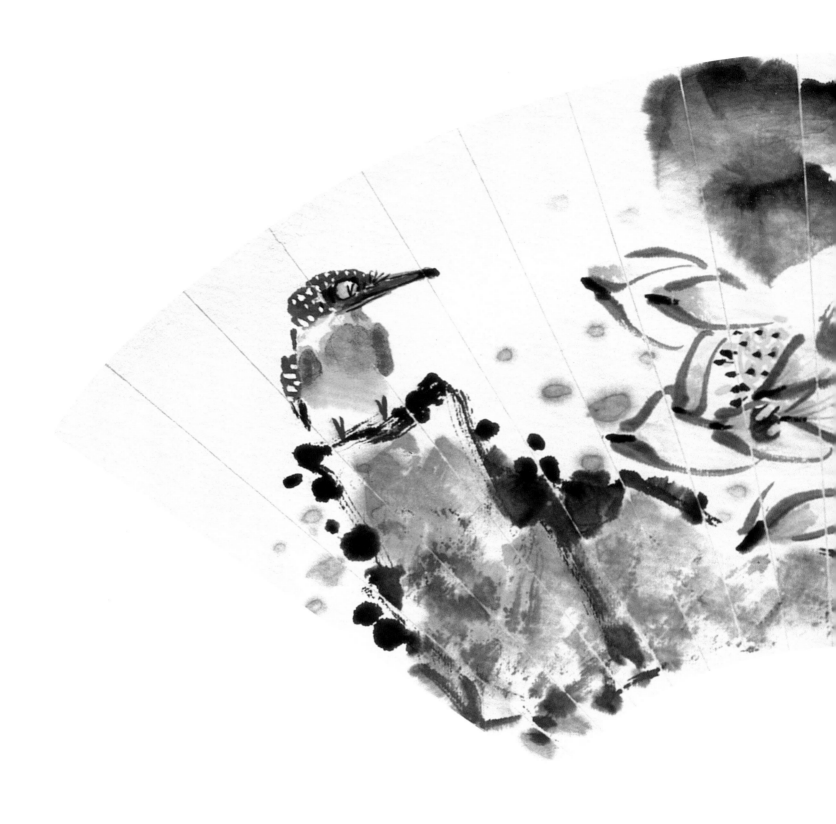

翠影（扇面）　戊子春吉魁画

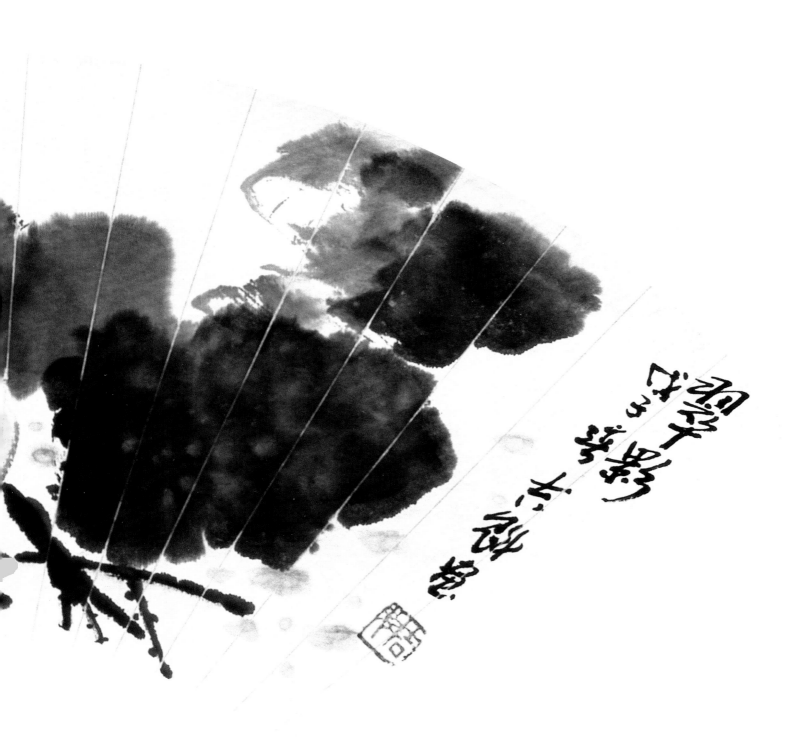

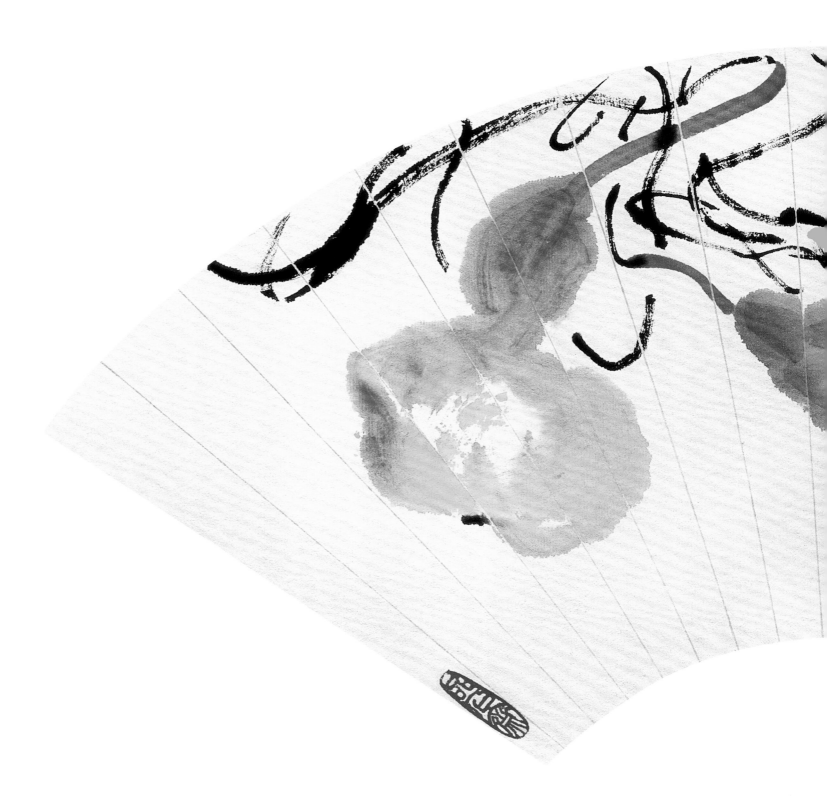

金辉（扇面） 戊子之春吉魁画于并

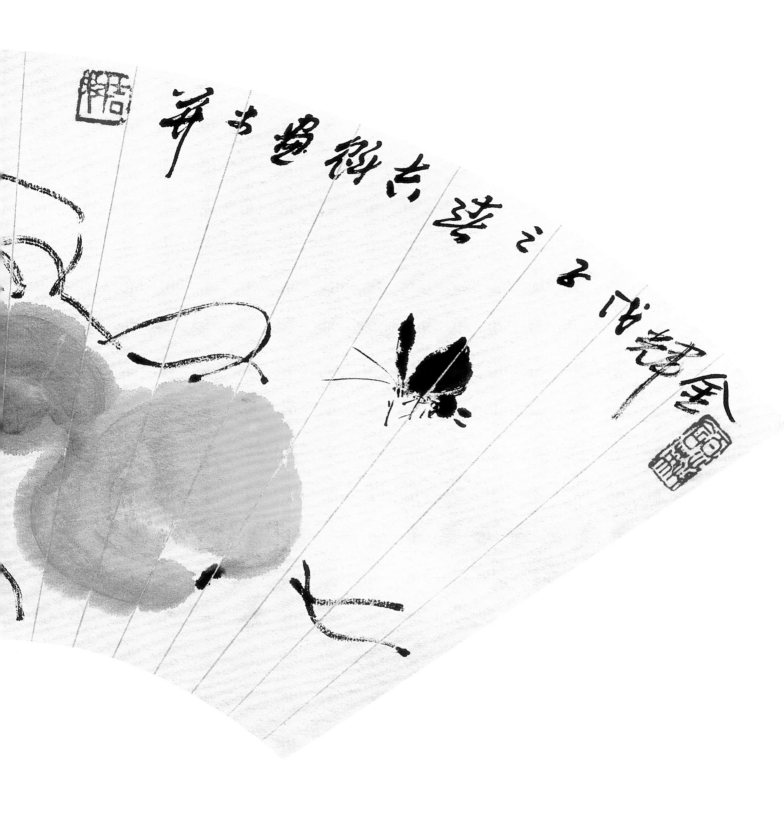

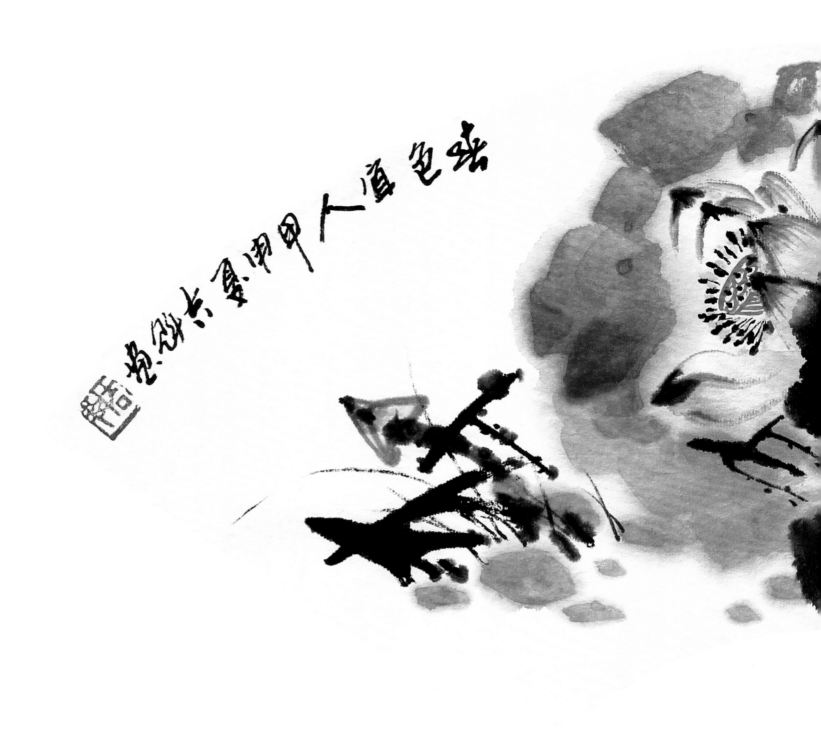

春色宜人（荷·扇面）　甲申夏吉魁画

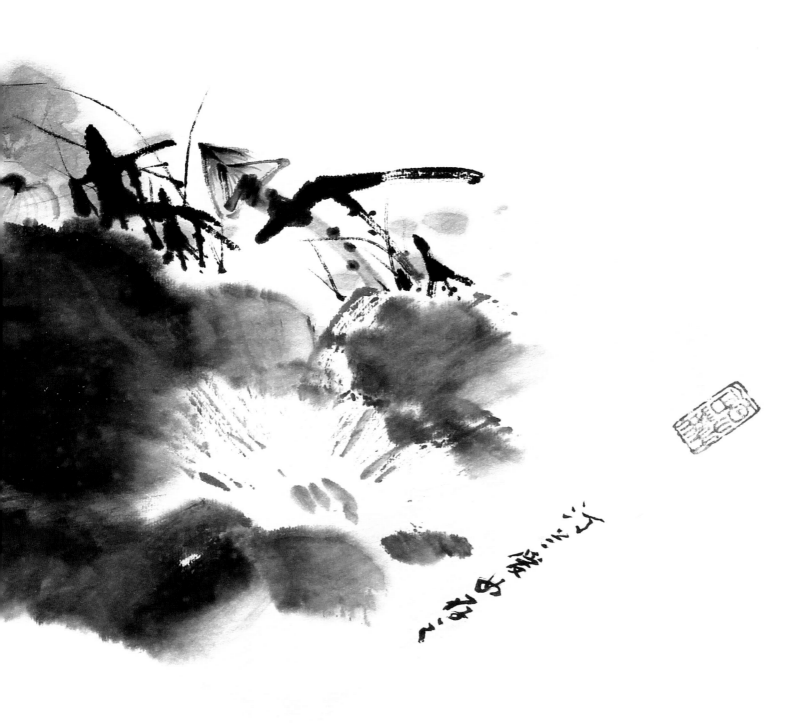

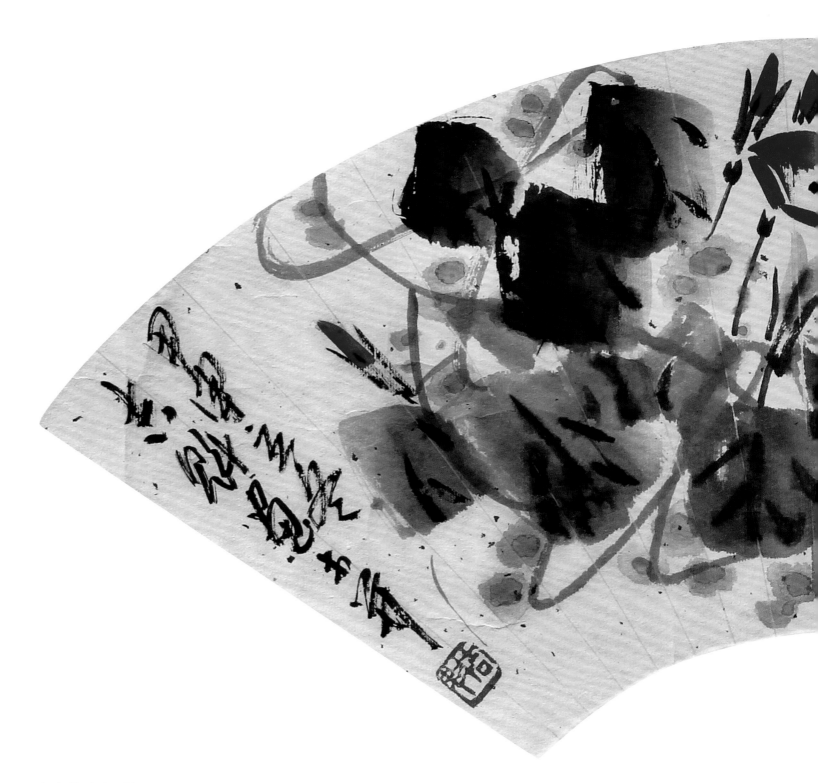

牵牛花（扇面） 甲申立冬吉魁画于并

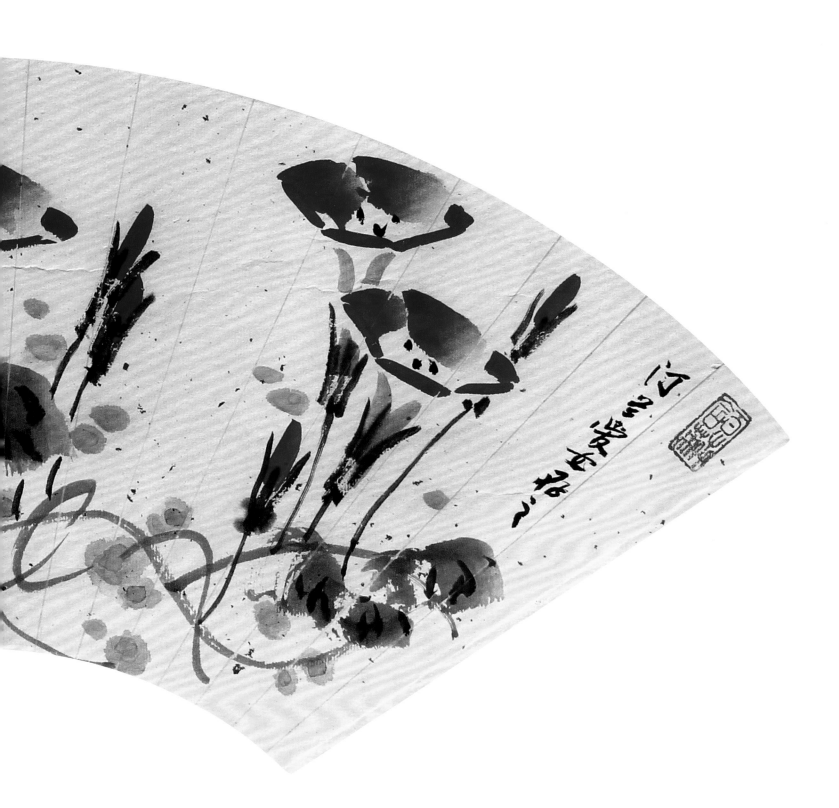

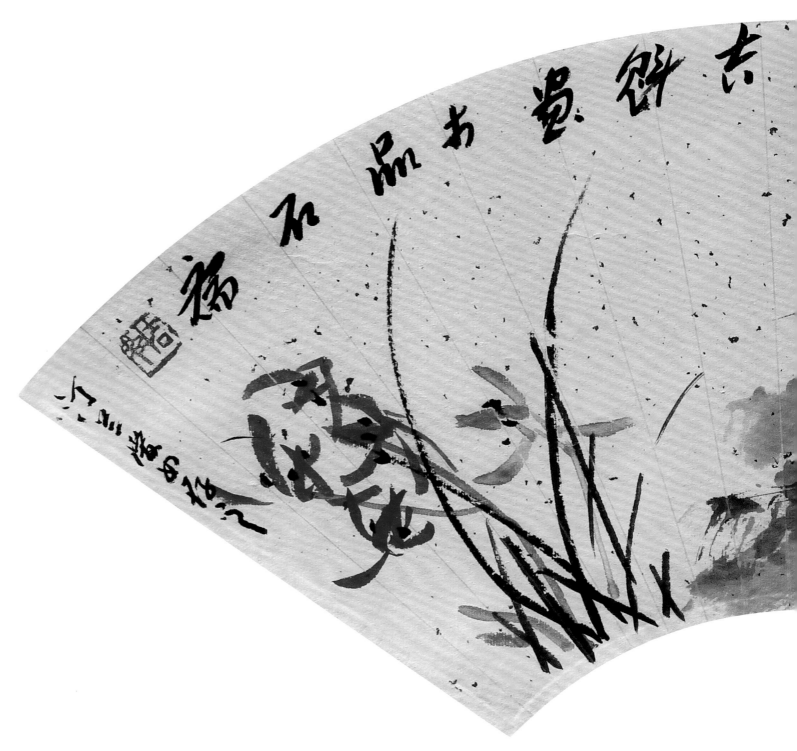

香谷清韵（扇面）　乙酉春月光斗吉魁画于品石斋

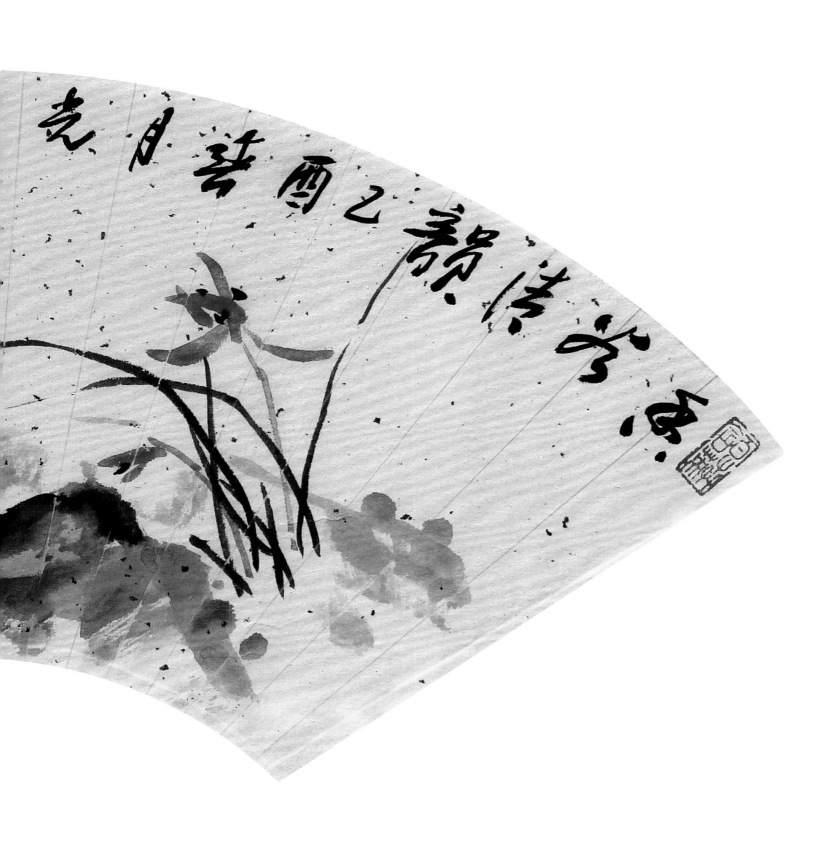

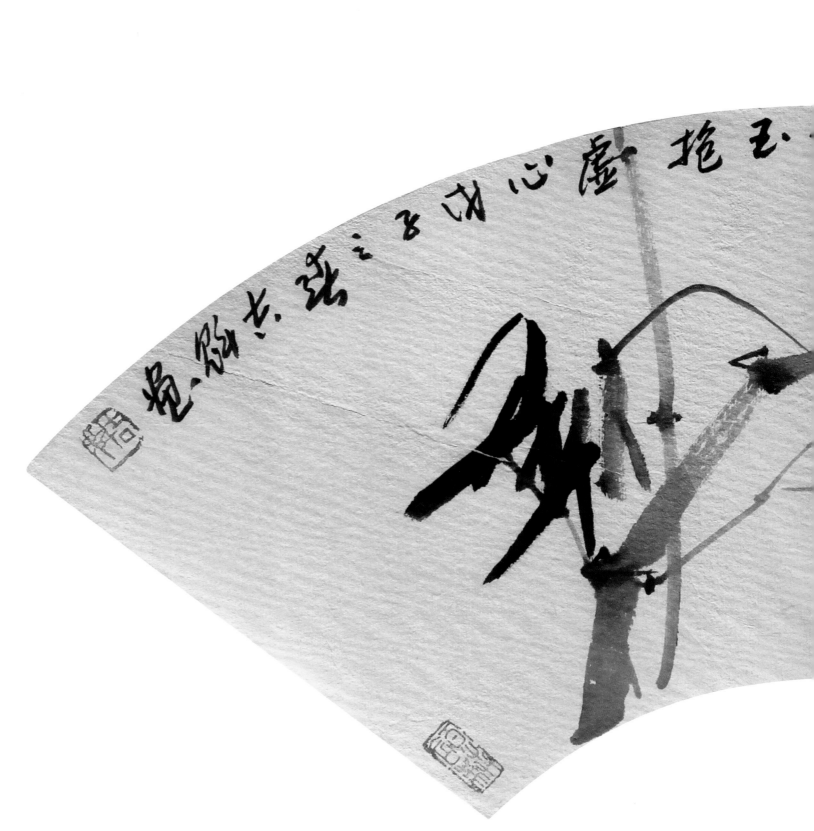

一枝寒玉抱虚心（扇面）　戊子之春吉魁画

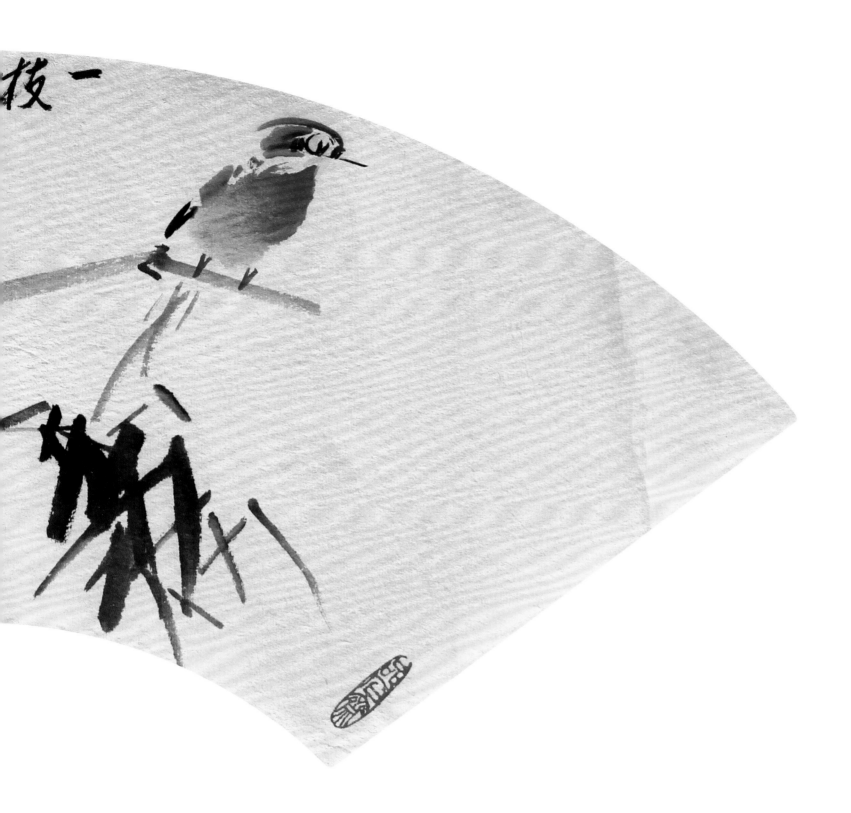

枝一

简历

杨吉魁，山西芮城人。1938 年生。1961 年在山西大学中文系学习期间，经姚奠中先生（国学大师）介绍，拜齐白石弟子杨秀珍（1909—2008）先生为师，学习中国绘画。曾是山西师范大学中文系写作教师、山西师范大学艺术系副教授，山西教育学院艺术系主任、教授。山西美协理事，山西花鸟画学会副会长、中国艺术研究院文化艺术研究中心特邀创研员、中国高校美育研究会会员、山西文史馆馆员、美国马萨诸塞州布里奇沃特大学艺术系终身名誉教授、美国普利茅斯大学客座教授、美国纽约哥伦比亚大学客座教授。1988 年赴日本举办个人画展。2000 年、2001 年、2009 年、2011 年多次赴美国讲学，举办个人画展。出版有《杨吉魁画集》（北京新世界出版社）。

Jikui Yang was born in Ruicheng,Shan'xi Province in 1938. In 1961, during his study of Chinese classic literature in Shan'xi University, his professor Dianzhong Yao introduced him to Baishi Qi's inheritor student - Xiuzheng Yang(1909-2008). Jikui Yang started his Chinese brushwork painting training with Xiuzheng Yang ever since. Jikui Yang taught writing in Shan'xi Normal University, was associate professor in Shan'xi Normal University Art Department, Dean and Professor of Art Department of Shan'xi Institute of Education, Executive board member of Shan'xi Society of Fine Art, Vice president of Shan'xi Society of Brushwork. Jikui Yang is now a member of China Research Institute of fine art and Shan'xi Research Institute of Culture and History. He was honored "Distinguish Professor of lifetime" by American Massachusetts Bridgewater State University. He was guest Professor of University of Plymouth and Columbia University. Jikui Yang solo exhibited his work in Japan in 1988. Jikui Yang also served as guest Professor in the U.S. and successfully had exhibitions in America in 2000,2001,2009,2011. He published personal art works collection "The Painting of Jikui Yang ". (Beijing New World Publisher) .

年谱

1938 年 4 月 24 日，出生于山西省芮城县。在中小学期间，开始对美术和中国绘画产生兴趣。

1961 年 7 月，考入山西大学中文系。同年 12 月，经姚奠中教授介绍，结识齐白石女弟子杨秀珍教授，并拜师学画。

1962 年 先后结识画家赵延绪、王绍尊、朱焰，并得到他们指点。

1965 年 7 月，大学毕业，被分配至山西省吉县中学担任语文教师。

1974 年 11 月，作品入选 "山西省中国画展" 后，被临汾地委发掘为 "美术人才"，调至临汾地区展览馆任美术干部。

1979 年 3 月，响应"教师归队"号召，被调至山西师范学院（今山西师范大学）中文系任写作教师，并兼任《语文教学通讯》编辑、记者。

1985 年 3 月 16 日，被批准为山西省美术家协会会员。

1987 年 9 月，被聘任中国书画函授大学临汾分校校长。

1988年 3月25日，日本《朝日新闻》发文介绍评价杨吉魁及其作品，题为《现代中国代表画家杨吉魁先生的水墨画展》。3月31日，由日本水户市中日友好协会和茨城美术振兴协会联合主办的"杨吉魁水墨画展"在水户市文化中心隆重开幕，展出作品一百幅。书画家董寿平、姚奠中、朱焰等特意为画展题写了展标。水户市市长佐川一信在画展开幕式上致辞祝贺；日本内阁自治大臣梶山静六从东京发了贺电。4月1日，《新茨城报》对画展进行了报导，题为《水墨画的神髓介绍——日中和平友好条约缔结10周年纪念第一人者杨先生的个展》；同时，《读卖新闻》对画展做了报导，并发表代表作品《螃蟹》。

1988 年　5 月，调入山西师范大学艺术教研室工作，并协助筹建艺术系。

1988 年　12 月，晋升为美术副教授。

1990 年　3 月，正式调入新成立的艺术系任教，讲授"写意花鸟画"和"中国美术史"。

1990 年　5 月，成为全国高校美育研究会会员，结识常书鸿先生。

1991 年　2 月，《杨吉魁画集》出版（北京新世界出版社）。

1995 年　3 月，经山西省教委批准，调任山西教育学院艺术系主任。

1995 年　10 月 14 日，被推选为"山西齐白石艺术研究会"副会长。

1996 年　11 月 26 日，被中国艺术研究院文化艺术研究中心聘为特邀创研员。

1997 年　5 月，被山西省高校职称评委会评聘为美术教授。

1998 年　1 月，被推选为"山西花鸟画学会"副会长。

1998 年　11 月 22 日，山西黄河电视台"都市生活"栏目播出专题片《杨吉魁先生作画》。

1998 年　12 月 18 日，获准退休；19 日，被山西省政府聘任为山西省文史研究馆馆员。5 月 10 日至 15 日，在山西省文艺大厦举办"杨吉魁画展"，展出作品一百幅。山西电视台、黄河电视台、《山西日报》等媒体做了隆重报导。9 月 8 日，山西电视台"一方水土"栏目播出专题片"诗情画意——杨吉魁"。10 月 2 日至 27 日，应美国马萨诸塞州布里奇沃特学院艺术系邀请，赴美讲学，并举办个人画展。《布里奇沃特学院学报》、《新英格兰艺术》以及其他波士顿英文报刊予以报导。

2001 年　1 月 21 日至 2 月 4 日，在美国费城中国城华光文化艺术中心举办了个人画展。费城英文报纸《费城问询者》以及中文报纸《华夏日报》、《中华周报》等做了报道。11 月 11 日，《人民日报》发表作者董其中的文章《爱之弥深，写之弥真——杨吉魁的中国画艺术》。

2003 年　4 月 10 日，作品入选《中国当代书画名家精品大典》。10 月 14 日，美国布里奇沃特学院院长达纳·莫勒·费里亚签署授予杨吉魁"美国马萨诸塞州布里奇沃特学院艺术系特等荣誉教授"称号。

2004 年　3 月 24 日，《山西日报》时代广场艺术人生版整版刊载作者李真的文章《滴水穿石见真功——记我省著名画家杨吉魁教授》。7 月 28 日，被太原晋阳书画院聘任为名誉院长。8 月，中国画《荷花》入选《纪念邓小平同志诞辰一百周年全国文史馆书画展作品集》。

2008 年　1 月 15 日，参加"山西花鸟画名家邀请展"。6 月，中国画《雄鸡报晓》入选《古韵新风——全国文史研究馆迎奥运书画集》。

2009 年　4 月，中国画《奥运之花似火红》入选《与奥运同行——山西当代书画名家作品邀请展作品集》。10 月 17 日，由美国华美协进社人文学会、哥伦比亚大学教师学院中国学生学者联谊会、哥伦比亚大学亚太发展协会共同主办，应邀在哥伦比亚大学做 "画坛巨匠齐白石的传奇人生与绘画艺术" 的专题讲座。10 月 19 日至 24 日，由美国当代艺术基金会主办、哥伦比亚大学亚太发展协会和华美协进社人文学会协办，"都市与自然的对语——著名花鸟画家、齐白石传人杨吉魁大型画展"在纽约曼哈顿亚洲文化中心隆重举行。

2010 年　12 月 6 日，中国画《富贵大吉》入选由山西省文史馆出版的 2011 年挂历《当代著名画家作品选》。

2011 年　10 月，应邀在美国新罕布什州普利茅斯大学艺术系主讲中国画艺术。

1989 年，与恩师杨秀珍合影。

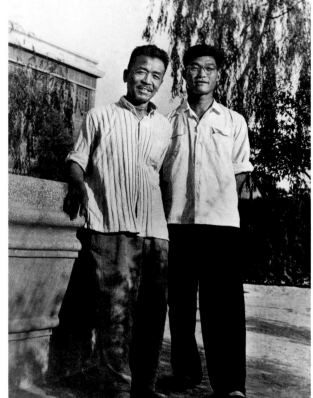

1965 年，与恩师赵延绪合影。

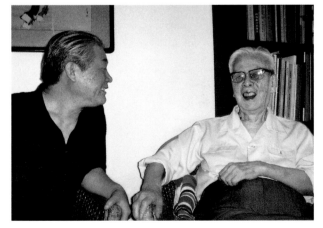

2003 年，与恩师姚奠中合影。

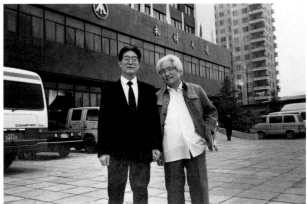

1990 年，与恩师朱焰合影。

1989 年，与陈箍咏先生合影。

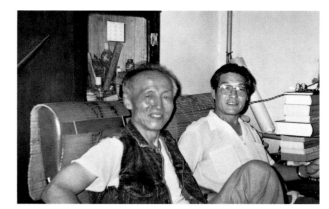

2000 年，喜听力群先生点评。

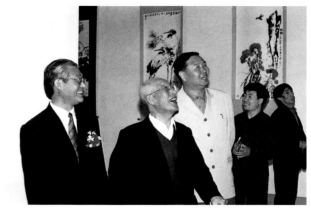

2002 年，与董其中先生、赵士瑛先生、范金鳌先生在一起。

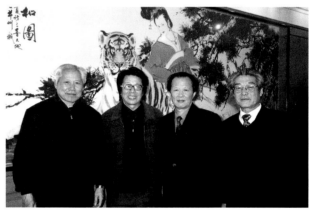

2009 年，与美国画家罗杰·邓恩先生在画展上。

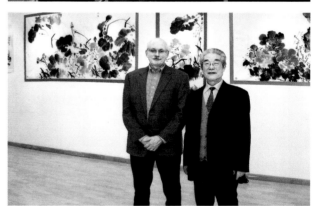

2000 年，与赵望进先生在画展上。

1997 年，拜会丁绍光先生。

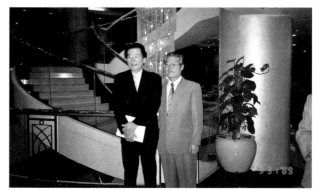

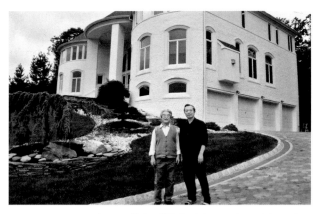

2009 年，拜会陈衍宁先生。

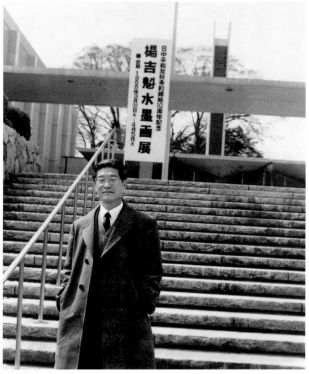

1988 年，在日本茨城县水户市举办个人画展。

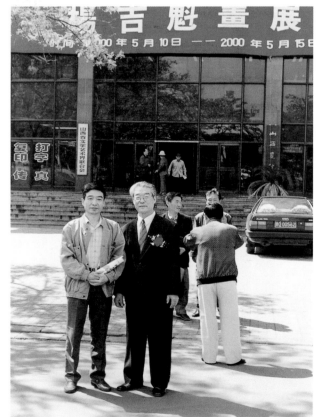

2000 年，在太原举办个人画展时，与崔俊恒好友合影。

2000 年，在美国马萨诸塞州布里奇沃特学院艺术系举办个人画展。

2000年，在美国马萨诸塞州布里奇沃特学院艺术系讲学。

2001年，在美国费城华光文化艺术中心举办个人画展。

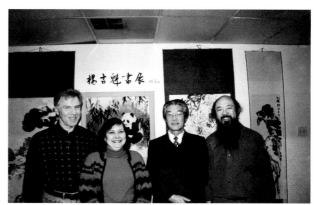

2009年，在美国哥伦比亚大学作专题讲座。

2009年，在美国纽约亚洲文化中心举办个人画展。

2011年，在美国新罕布什州普利茅斯大学艺术学院讲学。

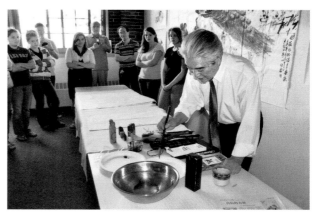

目　　录

图书在版编目（ＣＩＰ）数据

杨吉魁画集 ／ 杨吉魁绘编. ——北京：人民美术出版社，
2012.6
ISBN 978-7-102-06005-7

Ⅰ．①杨… Ⅱ．①杨… Ⅲ．①中国画－作品集－中国
－现代 Ⅳ.①J222.7

中国版本图书馆CIP数据核字 (2012) 第114491号

杨吉魁画集

编辑出版 人民美术出版社
（100735 北京北总布胡同32号）
http://www.renmei.com.cn

责任编辑　纪欣　陈林

特约编辑　范晓榆

翻　　译　杨涛

责任印制　文燕军

制版印刷　北京图文天地制版印刷有限公司

经　　销　新华书店总店北京发行所

2012年6月第1版　第1次印刷
开本：787毫米×1092毫米　1/8　印张：27
ISBN 978-7-102-06005-7
定价：380.00元